Spa
&
Wellness Hotels

teNeues

Editor in chief: Paco Asensio

Editor and texts: Cristina Montes

Editorial coordination: Cynthia Reschke

Art director: Mireia Casanovas Soley

Layout: Ignasi Gracia Blanco

Copy-editing: Francesc Bombí-Vilaseca, Sabine Würfel

German translation: Susanne Engler

French translation: Catherine Reschke

English translation: Matthew Clarke

Published by teNeues Publishing Group

teNeues Publishing Company
16 West 22nd Street, New York, NY 10010, US
Tel.: 001-212-627-9090, Fax: 001-212-627-9511

teNeues Book Division
Neuer Zollhof 1
40221 Düsseldorf, Germany
Tel.: 0049-(0)211-994597-0, Fax: 0049-(0)211-994597-40

teNeues Publishing UK Ltd.
Aldwych House, 71/91 Aldwych
London WC2B 4HN, UK

www.teneues.com

ISBN: 3-8238-5595-6

Editorial project: © 2002 LOFT Publications

Domènech 9, 2-2
08012 Barcelona, Spain
Tel.: 0034 932 183 099
Fax: 0034 932 370 060

e-mail: loft@loftpublications.com
www.loftpublications.com

Printed by: Artes Gráficas Viking. Spain

September 2002

Die Deutsche Bibliothek – CIP-Einheitsaufnahme
Ein Titeldatensatz für diese Publikation ist bei
der Deutschen Bibliothek erhältlich.

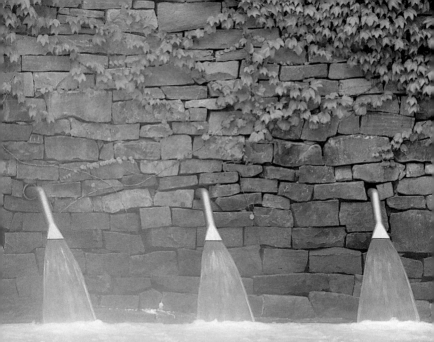

Introduction

Water is the wellspring of life, the origin of creation, the source of purity and strength. For thousands of years humanity has considered it an element beyond modification, like air. It was, quite simply, a gift from the gods. Even today we still recognize that it is an element of vital importance which it is impossible to do without.

The idea of water as a curative and beneficial element is surging back into fashion, but of course it is nothing new.

Ever since ancient times it has been customary to take advantage of "thermal water" to cure all kinds of diseases and encourage relaxation and well-being.

The oldest sites devoted exclusively to bathing that have been discovered to date are in India, and they are considered to have been built prior to 2000 BC. Baths dating from 1700-1400 BC have also been found on the Greek island of Crete and remains dating back to 1350 BC have been discovered in Egypt. Similarly, decorative paintings on ancient Greek amphorae indicate the existence of primitive apparatuses resembling showers, and Homer mentions tubs used for bathing in the "Iliad".

As for curative baths, the first ones were attached to the gimnasia but they only had cold water. Towards the end of the 5th century BC they began to establish themselves in complex, independent installations that were spread all over the cities, offering steam baths and "swimming pools" with hot, warm and cold water.

In both the Greek and Roman civilizations the baths represented a veritable ritual of body care, including physical exercise, massages with oils, a succession of baths at different temperatures and in-depth cleansing with sweat, oils and cream-based ointments. Both cultures placed a great importance on hygiene and were particularly fond of massages. They considered that there was nothing more purifying than a bath combining hot and cold and drawing on all nature's elements, the underlying components of the Cosmos: earth, water, fire and air. Massages and body-rubbing with soaps, oils and perfumes rounded off the beneficial effect of water.

Greece, with its philosophical and medical theories, was the civilization that turned the universal and primordial act – common to all cultures – of bathing in the sea or in rivers, lakes and ponds into a complex technique that required special buildings. Rome, in its turn, set about creating a more complete and definitive version of these facilities. The Romans undoubtedly surpassed even the Greeks in their love of bathing, and this led to the construction of numerous public baths. Here the public use of water took on a social and political dimension, as well as a hygienic one, but it also gradually acquired other meanings, related, for example, to leisure, playing games, resting and recovering strength. Medicinal waters (which possess various biomedical properties, according to their temperature, pressure, chemical composition, dissolved gases, bacterial flora, etc.) were considered an expression of the gods' supernatural power, and so thermal baths were originally places of worship.

Rome bestowed this culture of water, with local variations, onto other civilizations, from the Arabs to the Turks, from the Finns to the Russians.

In the Middle Ages the Christian Church – not particularly partial to water – considered cleanliness of the spirit more important than that of the body and went as far as propagating the myth that Roman baths were dens of perversion. This helped popularize the idea that public baths in cities were places of ill repute and they subsequently entered into a decline and almost fell into disuse. Personal care and hygiene was little practiced and was unknown to most people.

The Muslim invasion of Southern Europe brought with it, among other things, the creation of numerous public baths in all the cities, although the later Reconquest by the Spanish

Catholic Kings, culminating in the expulsion of the Muslims in 1492, put an end to these customs, at least in the Iberian Peninsula.

Meanwhile, the Far East also had a centuries-old culture of hygiene, with Japan in the forefront, although here cleanliness was a personal, intimate affair; there were also public baths, however, normally located at a source of hot or medicinal waters – a practice that has continued to the present.

It was not until the 18th and 19th centuries, with their reassertion of Classical culture, that the Western world changed its habits with respect to hygiene and began to consider water as a beneficial element. It was in this period that the custom of "taking the waters" in medicinal springs and spas became popular. As a result, there was an upsurge in spas, which became important centers for health and recreation. So, for example, at the beginning of the 18th century the English city of Bath was created to take advantage of a curative spring dedicated to the goddess Sul, a local divinity, while in Germany the famous spa in Baden-Baden became the favorite summer holiday resort for Europe's political classes in the 19th century.

Today, in the third millenium, the beneficial and curative effects of water – long since beyond dispute – are more fashionable than ever and have a promising future. Water is a source of health and beauty. Modern societies recognize its importance and its therapeutic effects, making water a part of our common heritage.

Thermal waters and health and beauty treatments are flourishing again and both commonplace pathologies and concerns over personal appearance are being tackled with this "old medicine" – although it now offers more possibilities than ever before.

Hotels and other places specializing in well-being are experiencing a boom. The English term "wellness" has become internationally recognized as an expression of the spirituality attained when pleasure and health are intertwined.

A new kind of spa has emerged, where the curative properties of (mineralized or natural) waters are successfully combined with other treatments and therapies – as well as enjoyable holidays.

This change of focus has led historic spas to update their facilities, as well as encouraging established hotels to install these types of services and enterprising newcomers to open their premises specifically for this purpose.

The basic offer of these health and beauty centers is wide-ranging and varied: baths with an array of techniques and elements, face and body beauty treatments, massages, alternative therapies for relaxation, specific cures, pressure showers, slimming cures, aromatherapy and new treatments, hitherto unimaginable, with fruit, wine, caviar and roses: the possibilities are endless – and extremely tempting.

Whereas spas were once considered boring places that only attracted old people and invalids, nowadays this idea has become completely outmoded.

Today's spas are aimed at all kinds of people of all different ages. Modern design has been integrated into their architecture and their services have become more extensive;

they still offer the therapeutic benefits of water and the latest in medical care, but they are also places for relaxing, enjoying cultural and leisure activities, eating good food and playing sport, as well as becoming an extremely popular holiday alternative.

Bearing in mind all these credentials, who would not want the restfulness and well-being offered by this type of center? This highly appreciated retreat to "sanctuaries" of health and pleasure is suitable for everybody. The aim is beauty, good health and total well-being.

This book offers an enticing tour of spas, hotels and health and beauty centers all over the world, of destinations that provide a refuge and an alternative to people wanting to find or reestablish their equilibrium or recover their energy. These places are welcoming, attractive, surprising and, quite simply, impressive. There is so much variety that it is difficult to know which one to choose. These pages offer an incomparable selection of irresistible spots, making this book an extremely useful guide for travelers.

Crossing the threshold of each of these centers is an experience in itself. Time seems to stand still, you feel like the most important person in the world and all your senses are soothed – complete luxury!

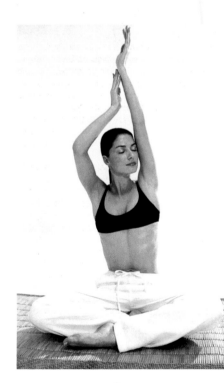

Einleitung

Wasser ist die Quelle des Lebens, der Ursprung der Schöpfung, Reinheit und Kraft ... Während Tausender von Jahren betrachtete die Menschheit es als ein unveränderliches Element, genauso wie die Luft. Es war ganz einfach eine Gabe der Götter. Heute wissen wir, dass es sich um ein lebensnotwendiges Element handelt, auf das wir nicht verzichten können.

Die Vorstellung von Wasser als heilendem und wohltuendem Element kommt mit aller Kraft zurück, obwohl es sich keinesfalls um eine Neuheit handelt.

Seit alten Zeiten wurde „Thermalwasser" zum Heilen aller Arten von Krankheiten angewendet oder um Entspannung und Wohlbefinden herbeizuführen.

Die ältesten bekannten Anlagen, die ausschließlich für das Bad bestimmt waren, entdeckte man in Indien und es wird geschätzt, dass sie noch vor dem Jahr 2000 v. Chr. errichtet wurden. Auf der Insel Kreta (Griechenland) wurden ebenfalls Anlagen gefunden, die zwischen 1700 und 1400 v. Chr. entstanden sind. Sogar in Ägypten hat man Überreste aus dem Jahr 1350 v. Chr. entdeckt. Auch die dekorativen Malereien auf den Amphoren des antiken Griechenlands weisen darauf hin, dass es primitive „Apparate" gab, die den heutigen Duschen sehr ähnlich waren, und sogar Homer erzählt in der „Ilias" von Kübeln, in denen man sich badete.

Über die Thermen kann man sagen, dass sie zunächst Abteilungen der „Turnhallen" waren, und dass es dort nur kaltes Wasser gab. Gegen Ende des 5. Jahrhunderts v. Chr. wurden daraus unabhängige und komplexere Anlagen, die sich über die ganze Stadt verteilten und in denen man auch Dampfbäder und gemischte Bassins (die Schwimmbäder jener Epoche) mit heißem, warmem und kaltem Wasser fand.

Sowohl in der griechischen als auch in der römischen Zivilisation war das Bad ein Ritual der Körperpflege, das Körperübungen, Massagen mit Öl, eine Abfolge von Bädern verschiedener Temperaturen, gründliche Reinigung von Schweiß sowie die Anwendung von Ölen und Cremes beinhaltete. Beide Kulturen liebten die Hygiene und vor allem die Massage. Für sie gab es nichts, was besser reinigte als ein Bad mit allen Elementen der Natur, wobei warm und kalt miteinander kombiniert wurden und damit auch die grundlegenden Faktoren des Kosmos: Erde, Wasser, Feuer und Luft. Die Massagen und Abreibungen mit Seifen, Ölen und Parfums ergänzten die wohltuende Wirkung des Wassers.

In Griechenland entwickelte sich eine Zivilisation, die mit ihren philosophischen und medizinischen Theorien die universelle und wesentliche Tatsache des Bades im Meer, in Flüssen, Seen und Teichen (die allen Kulturen gemeinsam ist) zu einer komplexen Technik machte, für die man spezielle Gebäude brauchte. Rom seinerseits vervollkommnete diese Art von Einrichtungen. Ganz ohne Zweifel überstieg die Begeisterung der Römer für das Bad noch die der Griechen, so dass unzählige Thermen und öffentliche Bäder entstanden. In diesen Einrichtungen hatte die öffentliche Benutzung des Wassers außerdem eine soziale und politische Dimension, und nicht nur eine hygienische. Andere Bedeutungen, wie zum Beispiel die Freizeit, das Spiel, das Ausruhen, die Erholung usw. kamen hinzu. Heilwasser (die verschiedene biomedizinische Eigenschaften besitzen, deren therapeutische Wirkung von der Temperatur, dem Druck, der chemischen Zusammensetzung, den aufgelösten Gasen, der Bakterienflora des Wassers usw. abhängt) wurden als ein Ausdruck übernatürlicher Kräfte der Götter interpretiert, weshalb die Thermen ursprünglich Orte von Kulten waren.

Rom vermachte diese Kultur des Wassers mit Varianten anderen Zivilisationen, angefangen bei den Arabern bis zu den Türken, Finnen oder Russen.

Im Mittelalter war für die christliche Kirche, die dem Wasser nicht allzu sehr zugeneigt war,

die spirituelle Reinigung wichtiger als die körperliche, so dass den römischen Thermen sogar nachgesagt wurde, dass es sich um Orte der Perversion handele. Die Idee, dass öffentliche Bäder in Städten sittenlos Orte seien, breitete sich aus und sie wurden immer weniger benutzt. Es folgte eine Zeit des Niedergangs. Die Körperpflege wurde für die Mehrheit der Bevölkerung ein wenig praktizierter und unüblicher Akt.

Das Eindringen der Moslems in den Süden Europas brachte unter anderem auch die Schaffung von zahlreichen öffentlichen Bädern in den Städten mit sich, auch wenn die Rückeroberung unter den Katholischen Königen, die im Jahre 1492 mit der Vertreibung der Moslems endete, dieser Gewohnheit wieder ein Ende setzte – zumindest auf der Spanischen Halbinsel.

Auch im Orient, und vor allem in Japan, existiert eine tausendjährige Kultur der Körperpflege, allerdings ist die Reinigung dort ein persönlicher und intimer Akt. Öffentliche Einrichtungen für das Bad befanden sich normalerweise an einer Quelle mit Thermaloder Heilwasser, was auch bis heute so geblieben ist.

Erst im 18. und 19. Jh. wurde im Zuge der Wiederentdeckung der klassischen Kultur auch die Hygiene wieder eingeführt, und das Wasser wurde in der westlichen Welt erneut als ein wohltuendes Element betrachtet. Aus dieser Epoche stammt die Sitte, im Heilwasser und in Bädern „das Wasser zu nehmen", also zu baden. Heilbäder gewannen immer mehr an Bedeutung und wurden zu Orten der Erholung und Gesundheit. So wurde zum Beispiel zu Beginn des 18. Jh. bei einer Heilquelle, welche der Göttin Sul geweiht war, die Stadt Bath in England gegründet. Das berühmte Bad Baden-Baden in Deutschland wurde im 19. Jh. zur Hauptstadt des Sommeraufenthalts der politischen Kreise Europas.

Heute, zu Anfang des dritten Jahrtausends, werden die wohltuenden und heilenden Eigenschaften des Wassers nicht mehr bestritten. Heilwasser ist mehr in Mode, als es jemals war, und diese Tendenz wird sicherlich noch zunehmen. Wasser ist eine Quelle der Gesundheit und Schönheit. Die modernen Gesellschaften kennen die Bedeutung des Wassers und seine therapeutische Bedeutung, weshalb es als ein schützenswertes Gut betrachtet wird.

Die Heilwasser, Gesundheits- und Schönheitsbehandlungen haben an Kraft gewonnen und die neuere Medizin und Schönheitspflege findet Antworten in der „alten Medizin", allerdings mit einem erneuerten Angebot.

Die Branche der Wellness Hotels und Einrichtungen erlebt einen Aufschwung. Der englische Begriff „Wellness" hat an Bedeutung gewonnen und einen Platz in unserem Vokabular und unserer Begriffswelt gefunden. Er drückt die Spiritualität aus, die im Genießen und in der Gesundheit zu finden ist, wenn beide Hand in Hand gehen.

Es gibt in der Gegenwart eine neue Art von Bädern, in denen die heilenden Eigenschaften des Wassers (mineralisiertes oder natürliches) mit einer Reihe anderer Behandlungen, Therapien und Urlaubsgenuss kombiniert werden.

Diese Veränderungen haben dazu beigetragen, dass die Heilbäder und Gesundheitszentren mit langer Tradition ihre Anlagen modernisiert haben, zahlreiche Einrichtungen neue Anlagen bauen und neue Zentren entstehen.

Das grundlegende Angebot dieser Gesundheits- und Schönheitszentren ist sehr vielfältig. Es basiert auf verschiedenen Techniken und Elementen, Gesichts- und Körperbehandlungen, Massagen, alternativen Therapien zur Entspannung, spezifischen Kuren, Druckduschen, Schlankheitsbehandlungen, Aromatherapien, und sogar auf originellen Behandlungen, die bis heute undenkbar waren, wie Behandlungen mit Früchten, Wein, Kaviar, Rosen usw... Das Angebot ist schier unendlich.

Einst betrachtete man Heilbäder als „langweilige" Orte, die nur von alten oder kranken Menschen aufgesucht wurden, aber dies hat sich radikal geändert.

Die Spas der Gegenwart werden von allen möglichen Personen jeglichen Alters besucht. Die Architektur ist von neuem Design geprägt und das Angebot wurde stark erweitert. Es werden weiterhin Therapien mit Heilwasser und fortschrittliche medizinische Betreuung angeboten, aber diese Zentren sind auch Orte der Entspannung und Freizeitgestaltung, an denen man kulturelle, kulinarische oder sportliche Angebote wahrnehmen kann. Deshalb entscheiden sich auch immer mehr Menschen dazu, ihre Ferien in einem solchen Zentrum zu verbringen.

Wer wünscht sich heutzutage nicht die Ruhe und die Entspannung, die diese Zentren anbieten? Dieser Rückzug in die „Heiligtümer" der Gesundheit und des Wohlbefindens tut jedem gut. Im Vordergrund stehen Schönheit, Gesundheit und ganzheitliches Wohlbefinden.

In diesem Führer finden Sie eine ansprechende Auswahl an Heilbädern, Hotels sowie Gesundheits- und Schönheitszentren auf der ganzen Welt. Sie sind ein Zufluchtsort und eine Alternative für all diejenigen, die ihr Gleichgewicht stärken oder wieder finden und Energien auftanken möchten. Anziehende, attraktive, überraschende und einfach beeindruckende Orte. Das Angebot ist so vielfältig, dass die Entscheidung zu einem Dilemma wird. Auf diesen Seiten haben wir eine unvergleichliche Zusammenstellung von unwiderstehlichen Orten zusammengetragen. Dieses Buch ist ein äußerst nützlicher Führer für den Reisenden.

Der Aufenthalt in jedem dieser Zentren ist eine tiefgreifende Erfahrung. Die Zeit scheint dort stillzustehen, es existiert nichts weiter als man selbst. Eine Entdeckungsreise für die Sinne.

Introduction

L'eau est à l'origine de la vie et de la création, et source de pureté et de force. Pendant des millénaires, l'humanité la considéra comme un élément impossible à modifier, tout comme l'air. C'était tout simplement un don des dieux. De nos jours également, nous savons que c'est un élément ayant une importance vitale et auquel nous ne pouvons pas renoncer.

L'eau en tant qu'élément bénéfique et curatif a une renaissance bien que cela ne soit rien de nouveau.

Dans l'antiquité déjà, on employait des eaux thermales pour traiter toutes sortes de maladies et favoriser la relaxation et le bien-être.

Les établissements les plus anciens découverts jusqu'à maintenant, et étant exclusivement consacrés aux bains, se trouvent en Inde. Leur origine est estimée à 2000 ans avant Jésus-Christ. Des thermes datant de 1700-1400 av. J.Chr. ont été découverts en Grèce sur l'île de Crète, et d'autres restes datant 1350 av. J.Chr., en Egypte. Des peintures trouvées sur d'anciennes amphores grecques, prouvent l'existence d'appareils primitifs ressemblant à des douches, de même que dans « l'Iliade », Homère mentionne l'usage de cuves destinées à se baigner.

En ce qui concerne les premiers bains thermaux, on peut affirmer qu'ils étaient rattachés à des gymnases, et ne disposaient que d'eau froide. Vers la fin du 5ème siècle av. J.Chr., ils furent convertis en établissements indépendants et se répandirent dans toutes les villes. On y trouvait des bains de vapeur et des bassins d'eau froide, tempérée ou chaude.

Tant dans la civilisation grecque que romaine, les bains représentaient tout un rituel de soins corporels comprenant de l'exercice physique, des massages aux huiles diverses, une succession de bains à des températures différentes, des nettoyages en profondeur par la transpiration en terminant par des ointements de crèmes et d'huiles. Pour ces deux cultures, l'hygiène avait une grande importance et les massages étaient très appréciés. Il n'exis-tait rien de plus purifiant qu'un bain avec tous les éléments de la nature, combinant le chaud et le froid, et étant basé sur les composants du cosmos : La terre, l'eau, le feu et l'air. Les massages et les frictions aux savons, aux huiles et aux parfums complètaient les effets bienfaisants de l'eau.

La Grèce avec ses théories médicinales et philosophiques, fût la civilisation qui convertit l'acte – commun à toutes les cultures – de se baigner dans la mer, les lacs, les étangs et les rivières, en une technique complexe requérant la construction de bâtiments spéciaux. Les Romains, sans aucun doute, surpassèrent les Grecs et leur penchant pour les bains publiques. Ils édifièrent d'innombrables thermes beaucoup plus élaborés et sophistiqués. Dans ce cadre, l'usage de l'eau par le peuple prit une dimension sociale et politique très importante, sur le plan de l'hygiène mais aussi progressivement, dans d'autres domaines tels que les loisirs, les jeux, le repos et la possibilité de reprendre des forces. Les sources thermales (possédant des propriétés biomédicales et thérapeutiques dûent à leur température, leur compositon chimique, leur pression, leur contenu en gaz, flore bactérienne, etc...) étaient considérées au départ comme des lieux sacrés de culte, témoignant des pouvoirs surnaturels des dieux. Grâce aux Romains cette culture fût propagée, parfois sous une forme légérement diffé-

rente, à d'autres civilisations: Des Arabes aux Turques et des Finlandais aux Russes.

Au Moyen Age, l'église chrétienne - n'ayant pas de grande prédilection pour l'eau – plaçant la pureté spirituelle au-dessus de la propreté du corps, répondit le mythe, que les bains romains étaient un endroit de perversion. Cela renforça la conviction du peuple quand à la mauvaise réputation des thermes et entrainat un déclin de leur popularité allant jusqu'à leur fermeture. Dans cette période de décadence, les soins du corp étaient peu pratiqués et inhabituels pour la plus grande partie de la population.

Ce n'est que lorsque les Musulmans envahirent le sud de l'Europe, que cette coutume réapparût. Cela entraîna la construction de bains publiques dans de nombreuses grandes villes. Au moment de la « reconquête » par les rois catholiques Espagnols en 1492, qui culmina par l'expulsion des Musulmans, cette coutume disparût à nouveau tout au moins sur la péninsule Ibérique.

Pendant ce temps l'Orient, le Japon en tête, avait une culture millénaire de l'hygiène, bien que cela était considéré comme un acte personnel et très intime. Les bains publiques existaient et étaient placés sur les sources d'eau thermale de même que de nos jours.

Au le 18ème-19ème siècle seulement, lors du retour à la culture classique, le monde occidental changea ses habitudes concernant l'hygiène et commença à considérer l'eau comme élément bénéfique. C'est à cette époque que le fait de « prendre les eaux » aux souces médicinales et aux bains devint plus populaire. On vit prospérer la création de centres balnéaires qui se transformèrent rapidement en importants complexes voués à la santé et à la récréation. C'est ainsi qu'au début du 18ème siècle, la cité de Bath fût crée en Angleterre. On voulait profiter de bienfaits de la source qui s'y trouvait et qui était dédiée à la déesse locale : Sul. En Allemagne, les fameux bains de Baden-Baden devenaient au 19ème siècle le centre balnéaire préféré des plus grands politiciens d'Europe, qui y passaient leurs vacances d'été.

Aujourd'hui au début de 3ème millénaire, les effets bénéfiques et curatifs de l'eau ne font plus aucun doute. Les installations balnéaires sont très à la mode et ont un futur très prometteur, l'eau est une source de santé, de jouvence et de beauté. Les sociétés modernes reconnaissent son importance et ses effets thérapeutiques. L'eau est considérée, de nos jours, comme un bien primordial appartenant à notre patrimoine commun.

Les eaux thermales et les traitements de beauté fleurissent à nouveau. Le côté médical ainsi que le fait que l'on donne plus d'importance à son aspect extérieur, nous font revenir à cette « vielle médecine » qui nous offre plus de possibilités que jamais.

Les hôtels et les centres spécialisés dans ce domaine fleurissent et le terme anglais de « Wellness » exprime une notion de spiritualité atteignable lorsque le plaisir et la santé vont de paire.

Des nouveaux bains sont apparu combinant avec succès cures et traitements au plaisir de passer de bonnes vacances.

Ce nouveau point de vue a entrainé la restauration et la mise à neuf de nombreux bains et encouragé certains hotels à installer et offrir ces nouvelles techniques.

L'offre de base de ces centres de santé et de beauté est très ample et très varié : Une grande diversité de bains ayant des techniques différentes : traitements esthétiques de la face et du corps, des massages et différentes thérapies favorisant la relaxation, des cures spéciales, des douches à pression, des cures d'amincissement, l'aromathérapie ainsi que des traitements originaux impensables jusqu'à maintenant avec la fruit, de la lie de vin, du caviar, des roses, les possibilités sont sans fin et très attrayantes.

Durant longtemps on a considéré les bains comme un endroit ennuyeux et destiné aux per-

sonnes âgées et aux invalides. De nos jours, cette idée est complètement dépassée. Les Bains actuels sont adaptés à tous, l'âge n'ayant aucune importance.

Une image très moderne a été intégrée à leur architecture et l'étendue des services offerts est très vaste. Proposant le bénéfices thérapeutiques de l'eau ainsi que des soins médicaux très poussés, ils sont également un endroit de relaxation, ayant un aspect culturel où on peut jouir de ses loisirs, en mangeant bien, en faisant du sport et même en y passant ses vacances.

Ayant cela en tête, qui n'aimerait pas profiter du bien-être offert par ce nouveau type de centre. Apprécier une retraite dans l'un de ces « sanctuaires » de la santé est un plaisir offert à tous. Les buts en sont beauté, santé et un bien-être total.

Ce livre nous permet de faire un tour très attrayant et de découvrir des Bains, des hôtels et des centres de santé et de beauté répartis dans le monde entier. Des destinations servant de refuges et d'alternatives à tous ceux qui aimeraient découvrir ou rétablir leur équilibre et retrouver leur énergie.

Ces endroits sont accueillants, attrayants, surprenants... tout simplement impressionnants. Le choix est si grand qu'il est très difficile de se décider.

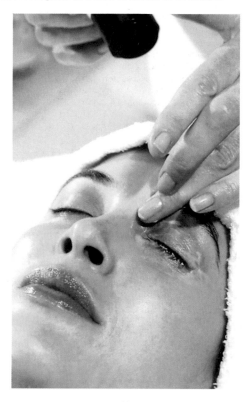

Introducción

El agua es matriz de vida, origen de la creación, pureza, fuerza... Durante milenios la humanidad la consideró un elemento no modificable, al igual que el aire. Era, sencillamente, un don de los dioses. Hoy sabemos que es un elemento de vital importancia del que es imposible prescindir.

La cultura de agua como elemento curativo y beneficioso regresa con fuerza, a pesar de no tratarse de algo nuevo.

Desde la antigüedad, el aprovechamiento del agua termal para curar toda clase de enfermedades y proporcionar relax y bienestar ha sido algo habitual.

Las estancias más antiguas dedicadas exclusivamente al baño halladas hasta el momento se encuentran en la India, y su fecha de construcción se estima anterior al 2000 a.C. En la isla de Creta (Grecia) también han aparecido instalaciones de este tipo levantadas entre 1700 y 1400 a.C. e incluso en Egipto se han encontrado restos fechados en el año 1350 a.C. Asimismo, pinturas decorativas de ánforas de la antigua Grecia indican la existencia de aparatos primitivos muy similares a las duchas e incluso Homero en "La Ilíada" habla de tinas para poder bañarse.

En cuanto a las termas, podría afirmarse que las primeras eran dependencias de los gimnasios y que sólo disponían de agua fría. A finales del siglo V a.C. empezaron a convertirse en instalaciones complejas e independientes que se repartían por toda la ciudad y en las que se ofrecían baños de vapor y albercas (piscinas de la época) mixtas de agua caliente, templada y fría.

Tanto en la civilización griega como en la romana el baño era todo un ritual de cuidados corporales e incluía la práctica de ejercicio, masajes con aceites, una sucesión de baños a diferentes temperaturas, limpieza a fondo del sudor y los aceites y un nuevo ungimiento con cremas. Ambas culturas eran amantes de la higiene y muy aficionados a los masajes; para ellas no existía nada más purificador que un baño con todos los elementos de la naturaleza combinando frío y calor y con ello los factores básicos del cosmos: tierra, agua, fuego y aire. Los masajes y fricciones con jabones, aceites, perfumes... completaban ese efecto beneficioso del agua.

Grecia fue la civilización que convirtió, con sus teorías filosóficas y médicas, el hecho universal y primario (común en todas las culturas) de los baños en el mar, ríos, lagos y estanques en una compleja técnica para la que se requerían edificios especiales. Roma, por su parte, se encargó de conseguir una versión más completa y definitiva de este tipo de instalaciones. Sin duda, la afición romana por lo baños superó a la de los griegos, lo que supuso crear infinidad de termas y baños públicos. En estos recintos el uso público del agua tenía una dimensión social y política, además de higiénica; aunque progresivamente adquirió otros significados como por ejemplo el de ocio, juego, descanso, recuperación... Las aguas medicinales (que poseen diferentes propiedades biomédicas –de hecho esa acción terapéutica de las aguas depende de su temperatura, presión, composición química, gases disueltos, flora bacteriana...–)

eran consideradas como una expresión de poder sobrenatural de los dioses, por lo que las termas fueron en sus orígenes lugares de culto.

Roma legó, con variantes, esta cultura del agua a otras civilizaciones desde los árabes a los turcos, los finlandeses o los rusos.

Durante la edad media, la Iglesia cristiana –no demasiado amiga del agua– consideró la limpieza espiritual más importante que la corporal, llegando a generar el mito de que las termas romanas eran espacios de perversión. Esto contribuyó a extender la idea de que los baños públicos de las ciudades fueran considerados lugares de mala reputación quedando casi en desuso. Lo que provocó un período de decadencia. El cuidado personal y aseo era algo poco practicado e inusual para la mayoría de la población.

La invasión musulmana en el sur de Europa trajo consigo, entre otras cosas, la creación de numerosos baños públicos en todas las ciudades, aunque la posterior reconquista bajo el reinado de los Reyes Católicos, que concluyó en 1492 con la expulsión de los musulmanes, volvió a acabar con estas costumbres, al menos, en la península Ibérica.

Por su parte en Oriente, con Japón a la cabeza, también existe una cultura milenaria con respecto al aseo, aunque allí la limpieza era un acto personal e íntimo. Por lo que los establecimientos públicos dedicados al baño solían situarse en una fuente de aguas termales o medicinales, costumbre que aún hoy se mantiene.

No será hasta los siglos XVIII y XIX, con la recuperación de la cultura clásica, que cambie la costumbre de la higiene y la concepción del agua como elemento beneficioso en el mundo occidental. Es en esta época cuando se generaliza la costumbre de "tomar las aguas" en las fuentes medicinales y los balnearios. A causa de ello, las estaciones termales afloran con fuerza y se convierten en importantes lugares de recreo y salud. Así es como a principios del XVIII se crea la ciudad de Bath, en Inglaterra, aprovechando una fuente curativa que conmemora a la diosa Sul, una divinidad local, o en Alemania el célebre balneario de Baden-Baden llega a convertirse en el siglo XIX en la capital del veraneo político de Europa.

Hoy, instalados ya en el tercer milenio, los efectos beneficiosos y curativos del agua, que ya no se discuten, están más de moda que nunca y tienen futuro. El agua es fuente de salud y belleza. Las sociedades modernas conocen su importancia y sus efectos terapéuticos por lo que el agua se considera hoy un bien patrimonial.

Las aguas termales y los tratamientos de salud y belleza fluyen con fuerza nuevamente y las patologías más recientes, así como los cuidados estéticos, encuentran respuesta en una "vieja medicina" aunque, eso sí, con una oferta renovada.

Los hoteles y recintos destinados al bienestar están en auge. El término anglosajón wellness, que ha empezado a cobrar fuerza y se ha instalado en nuestro vocabulario y nuestra mente, expresa esa espiritualidad que reside en el placer y la salud cuando ambas van de la mano.

En la actualidad existe una nueva modalidad de balnearios en los que se aúna con éxito las propiedades curativas de las aguas (mineralizadas-naturales) con otra serie de tratamientos, terapias y el disfrute vacacional.

Estos cambios han propiciado el resurgimiento de estaciones termales y centros con historia que han modernizado sus instalaciones, que numerosos recintos incorporen estos equipamientos y que nazcan nuevos espacios.

La oferta básica de estos complejos de salud y belleza es amplia y variada: baños con diferentes técnicas y elementos, tratamientos de estética facial y corporal, masajes, terapias alternativas para la relajación, curas específicas, duchas a presión,

tratamientos de adelgazamiento, aromaterapia... incluso originales tratamientos, hasta hora inimaginables, con frutas, vino, caviar, rosas... las posibilidades son generosas y atractivas.

Si durante tiempo los balnearios fueron considerados lugares aburridos a los que acudían personas de avanzada edad o enfermas, hoy esta idea ha quedado totalmente desterrada.

Los spas actuales se orientan a todo tipo de personas y todo tipo de edades. El diseño se ha apoderado de su arquitectura y la oferta se ha ampliado; siguen ofreciéndose los beneficios terapéuticos del agua y los servicios médicos más avanzados, pero también son centros de relajación y de ocio en los que disfrutar de actividades culturales, culinarias, practicar deporte... además de convertirse en una alternativa vacacional cada vez más solicitada.

Con estas credenciales, ¿quién no desea el reposo y bienestar que este tipo de centros ofrecen? Este preciado retiro a los "santuarios" de la salud y el placer está indicado para todo el mundo. El objetivo: belleza, salud y bienestar integral.

Este volumen propone un sugerente recorrido por balnearios, hoteles y centros de salud y belleza repartidos por todo el mundo. Destinos que servirán de refugio y de alternativa a todos aquellos que deseen encontrar o restablecer el equilibrio y reponer energías. Espacios acogedores, atractivos, sorprendentes... simplemente impresionantes. La variedad es tan abundante que decidirse se convierte en un dilema. Desde estas páginas se ofrece una incomparable recopilación de lugares irresistibles. Un libro que se convertirá en una guía tremendamente útil para el viajero.

Adentrarse en cada uno de estos espacios es toda una experiencia. En ellos el tiempo parece detenerse y no existir nadie más que uno. Todo un lujo para los sentidos.

Glossary

Active baths. Baths with thermal water and clay that open up the pores of the skin and have a purifying effect.

Acupressure. Technique based on the stimulation of the acupuncture points and meridians.

Acupuncture. Healing technique originating in Asia, consisting of the piercing of certain body points with one or more needles to cure specific diseases.

Aerosol. Inhalation of mineralized medicinal water, using special apparatuses that produce very fine steam particles.

Alternate baths. Jets of cold and hot water are applied in alternation over the entire body and on specific areas to stimulate the blood flow.

Aromatherapy. Literally, "therapy using aromas". These aromas come from plants, herbs, trees, flowers, which produce "essential oils" that are used to cure and maintain good health. These oils can be used in massages, immersion, inhalation, nebulization, ingestion, foot baths...
Aromatherapy is a centuries-old holistic therapeutic discipline, although it was rediscovered in the 20th century to become one of the cornerstones of alternative medicine and cosmetics.

Asian massage. Massage that makes it possible to balance the flow of energy by following the acupressure points. This relaxes the body and improves the circulation of the blood.

Ayurveda. This is a traditional Indian practice stretching back more than 5,000 years. It means knowledge or science of life. One of the most widely used therapies in Ayurveda is Panchakarma: a purifying, restorative and rejuvenating program designed to achieve a state of overall well-being. This comprises a combination of therapies that first set out to eliminate toxins from the organism. Once this has been achieved, the next objective is to reduce tiredness and stress by means of massages performed with four hands in perfect synchronization, all the while applying natural oils and essences.

Bath. Technique involving immersion in mineralized medicinal water for a specific time and at a specific temperature.

Bioslim. Anti-cellulitis creams are applied to the body, which is covered with an electric blanket. This reduces the body mass and enhances the absorption of products.

Body peeling. Exfoliation of the skin that eliminates dead cells.

Bubble bath. Immersion in a tub of mineralized medicinal water enhanced with pressurized air.

Circular shower. Application of thermal water at low pressure via multiple openings.

Clapping. Manual physiotherapeutic technique applied to the thorax to facilitate bronchial expectoration.

Cold bandages. All or part of the body is wrapped in cold bandages. These have a useful revitalizing effect and also stimulate circulation.

Crenotherapy. Treatment based on the medicinal properties of specific types of water or mud.

Electrotherapy. Treatments using various kinds of currents, taking advantage of their stimulating properties for therapeutic purposes.

Filiform bath. An extremely small jet of water projected under great pressure.

Floral elixirs. Their regenerative function unblocks both physical problems and psychological stress. They reduce wrinkles and cellulitis and serve as beauty treatments.

Foot bath. Bath for the feet and lower legs.

Frigidarium. Pool with iced water that improves the circulation in the legs.

Galvanic bath. Immersion in a tub designed to administer galvanic currents.

Hand bath. Bath for the hands and lower arms.

Holistic treatments. This concept embraces therapies such as Bach's flower remedies, chromotherapy, aromas, precious stones... They take advantage of elixirs, lotions and therapies that go beyond the scientific effect of their formulas as they act on energy imbalances and blockages.

Hot stones. The patient walks on hot stones; these produce a state of relaxation while helping to improve the circulation of the blood.

Hydrojet. The patient lies on a bed to receive jets that massage his or her back, producing total relaxation.

Hydromassage bath. Underwater massages performed manually or mechanically, by means of pressurized jets of water or air bubbles. The water is normally at a temperature of around 96.8 °F (36 °C). The water jets are used to treat joint problems, the bubbles improve the circulation and the addition of algae helps reduce the body mass.

Hydropinic cure. Oral intake of thermal water at a specific time and rhythm, as determined by a doctor, in order to achieve therapeutic effects.

Infrared rays. Administration of heat on the body surface for analgesic purposes.

Inhalation. The inhalation of steam and thermal water (lower airways).

Kinesiology. Technique based on the observation and correction of body postures. The physical and psychic state is analyzed by means of unconscious muscular tests that make it possible to locate problems and balance any alterations.

Kinesitherapy. Treatment using movement to rehabilitate patients with restricted body functions.

Kneipp therapy. Hydrotherapy treatment based on the techniques described by Sebastian Kneipp, normally accompanied by a diet, physical exercise and the use of medicinal plants.

Lomi-lomi. Asian specialty comprising a continuous progression of movements: flexions, stretching, caresses and gentle rocking intended to sooth and reinvigorate.

Lymphatic drainage. Stimulation of the lymphatic system by means of supple, gentle, slow and repetitive hand movements, helping to prevent the accumulation of lymphatic liquid in different parts of the organism. It purifies, helps to eliminate toxic substances and improves circulation.

Masotherapy. Manual massage with a physical and psychosomatic effect.

Massage. A specialist works on the entire body with his or her hands by applying pressure or rubbing. This helps to relax, tones up the muscles and improves circulation.

Mechanotherapy. Rehabilitation treatment based on manual techniques using mechanical apparatuses (pulleys, traction, etc.)

Medical hydrology. Science that studies the action of water on the organism and its application for therapeutic purposes.

Mud bath. Mixture of earth with mineralized medicinal water.

Mud therapy. Natural mud diluted with thermal water is applied over the whole body, which is then wrapped in plastic and a heat blanket. It revitalizes and softens the skin, relaxes the body and enhances sweating.

Ozone bath. Bubble bath in which the air used to create bubbles is enriched with ozone.

Paraffin. Product used for its great ability to accumulate and transmit heat when applied locally.

Paraffin mud bath. A plate with mud and paraffin at 113 ºF (45 ºC) is applied locally.

Passive gymnastics. Electrodes are put on the abdomen and gluteal area; these emit faradic currents that contract and relax the musculature. This combats flabbiness, strengthens the muscles and helps lose weight in specific areas.

Phototherapy. Application of various types of light for therapeutic purposes.

Presotherapy. This comprises boots that inflate and deflate to reproduce the effects of a lymphatic drainage. It is recommended when there is any retention of liquids or peripheral alterations to the blood flow. It is purifying, combats cellulitis and enhances diuresis.

Pressure jet. Manual application of mineralized medicinal water, with varying degrees of pressure and continuity

Pulverizations. Technique involving the inhalation of steam and thermal water (upper airways).

Rasul. Traditional Arab technique to clean the body and spirit, using masks and aromatic steam.

Rebalancing. In-depth massage that reestablishes the body's natural equilibrium.

Reflexology. Manual technique involving pressure on the reflex points of the foot to bring equilibrium to the nervous system.

Reiki. Alternative medicine based on a traditional Asian therapy that cures by means of each person's vital energy. It makes it possible to recover emotional, mental, physical and spiritual equilibrium.

Sauna. Dry heat in a cabin.

Scottish hose. Pressurized jets of thermal water at around 95 ºF (35 ºC) applied from head to foot, on the front and back, before finish-ing off with cold

water. It is invigorating, relaxing and improves the circulation of the blood.

Seaweed wrap. The body is daubed with a preparation made from algae and thermal water and is then wrapped in plastic and a heat blanket. This purifies the organism, enhances perspiration and stimulates a loss of body mass.

Shiatsu. Despite being more fashionable than ever, this Asian therapy – a Japanese version of the Chinese acupressure massage that follows the body's energy lines – it is a very ancient practice. It acts by reestablishing the equilibrium of the body's energy and setting in motion its own mechanisms of defense and recovery. It restores the patient physically and psychically, reenergizing to achieve greater inner peace, physical well-being and powers of concentration.

Spa. Establishment aimed at improving health and physical condition by means of water, heat, massages and treatments.

Steam bath. The entire body, apart from the head, is subjected to moist heat at around 113 º F (45 ºC). The effect is similar to that of a sauna but as the heat is humid it is harder to tolerate. It enhances sweating and produces a loss of water.

Steam shower. This enhances the passage through the skin of the active elements in the thermal water. The jet of steam applied to the parts of the body indicated by the doctor produce an immediate vasodilatory effect.

Thalassotherapy. Hydrotherapy treatment using sea water, taking advantage of all this medium's beneficial properties.

Thermalism. Specially indicated for diseases of the motor, respiratory and digestive systems; it uses mineralized medicinal water.

Thermal swimming pool. Thermal swimming pool equipped with bars, handrails, and underwater steps. It has a mechanical effect, due to the apparent loss of weight after immersion, stimulates the senses, due to the resistance to movement in the water, and relaxes the muscles through the heat of the water.

Thermojet. Osmotic wrap with infrared strips to combat cellulitis.

Turkish bath. Bath with heat and humidity.

Vaporarium. Facilities providing the steam that is applied to the body for therapeutic purposes.

Vichy (horizontal) shower. General body massage which the patient receives stretched out on a bed under a shower.

Watsu. Relaxation technique practiced in water, using the principles of shiatsu.

Yoga. Oriental discipline based on the control of five sources of energy: breathing, diet, sleeping, relaxation and a positive mental attitude. Both the mind and body are intrinsically involved in its practice. The most well known and widely practiced form is hatha yoga (physical yoga), which is based on the assumption of various postures (asanas), combined with breath control and relaxation, which exert an influence on the organism and its functions.

Glossar

Aerosol. Inhalationen von Mineral- und Heilwasser mittels spezieller Geräte, die feinste Dampfpartikel erzeugen.

Aktivierende Bäder. Bäder mit Thermalwasser und Ton, die die Hautporen öffnen und entschlackend wirken.

Akupressur. Eine Technik, die auf der Stimulierung der Meridiane und Akupressurpunkte beruht.

Akupuntur. Fernöstliche Heiltechnik, die darin besteht, dass eine oder mehrere Nadeln in bestimmte Punkte des Körpers gestochen werden, um Krankheiten zu heilen.

Algenpackungen. Der Körper wird mit einem Präparat aus Algen und Thermalwasser bestrichen und anschließend mit Folie und einer Wärmedecke bedeckt. Reinigt den Organismus, wirkt schweißtreibend und reduzierend.

Aromatherapie. Aromatherapie bedeutet wortwörtlich, „Therapie, die Aromen benutzt". Diese Aromen stammen von Pflanzen, Kräutern, Bäumen, Blumen usw., aus denen ätherische Öle erzeugt werden, die zum Heilen und Vorbeugen benutzt werden. Diese Öle können für Massagen, Bäder, Inhalationen, Vernebelungen, Einnahmen, medizinische Fußbäder usw. verwendet werden.
Die Aromatherapie ist eine jahrtausende-alte, holistische Therapieform, die im letzten Jahrhundert wieder entdeckt und zu einer der Grundlagen der alternativen Medizin und Kosmetik wurde.

Asiatische Massage. Massage, die ein Gleichgewicht des Energieflusses herstellt, indem sie den Akupressur-punkten folgt. Sorgt für bessere Durchblutung und Entspannung.

Ayurveda. Ayurveda stammt aus der indischen Tradition und existiert schon seit über 5000 Jahren. Das Wort bedeutet „Kenntnis oder Wissen vom Leben". Eine der in Ayurveda am meisten benutzten Therapien ist Panchakarma, ein Programm zur Reinigung, zum Wiederaufbau und zur Verjüngung, mit dem man ein allgemeines Wohlbefinden erreicht. Es besteht aus kombinierten Therapien, die mit einer Entgiftung des Organismus beginnen. Nach der Entgiftung werden Erschöpfung und Stress mittels Massagen reduziert, mit vier Händen synchron durchgeführt, wobei natürliche Öle und Essenzen verwendet werden.

Bad. Technik, die aus dem Eintauchen in Mineral- und Heilwasser während einer bestimmten Zeit und bei einer bestimmten Temperatur besteht.

Bioslim. Es werden Antizellulitiscremes angewendet und der ganze Körper mit einer Heizdecke bedeckt. Wirkt reduzierend und die Produkte ziehen besser ein.

Clapping. Manuelle Technik der Physiotherapie, die auf dem Brustkorb angewendet wird, um die Bronchien zu befreien.

Dampfbad. Es wird Dampf erzeugt, der auf den Körper zu therapeutischen Zwecken einwirkt.

Dampfdusche. Die aktiven Elemente des Thermalwassers können leichter in die Haut eindringen. Der Dampfstrahl, der nach ärztlicher Anweisung auf bestimmte Körperteile gerichtet wird, führt zu einer augenblicklichen Gefäßerweiterung.

Dampfofen. Der ganze Körper außer dem Kopf wird einer feuchten Hitze bei ca. 45 ºC ausgesetzt. Die Wirkung ist der der Sauna ähnlich, aber die feuchte Hitze ist anstrengender. Wirkt schweißtreibend und der Körper gibt viel Wasser ab.

Druckdusche. Manuelle, kontinuierliche Anwendung von Mineral- und Heilwasser mit mehr oder weniger Druck.

Drucknebeldusche. Aus feinsten Düsen wird Wasser mit hohem Druck gesprüht.

Elektrotherapie. Behandlungen, die verschiedene Arten von Strom benutzen und so die stimulierende Wirkung zu therapeutischen Zwecken nutzen.

Fangotherapie. Es wird natürlicher, in Thermalwasser aufgelöster Schlamm auf den ganzen Körper aufgetragen, mit Folie und einer Wärmedecke bedeckt. Revitalisiert, die Haut wird weich, wirkt entspannend und schweißtreibend.

Frigidarium. Becken mit eiskalten Wasser, das die Durchblutung der Beine fördert.

Fußreflexzonenmassage. Manuelle Technik, bei der durch Druck auf die Reflexzonen an den Füßen das Nervensystem ausgeglichen wird.

Galvanisches Bad. Eintauchbad in einer Badewanne, die galvanische Strömungen auf den Patienten einwirken lassen kann.

Heilbad. Einrichtung zur Verbesserung der Gesundheit und des Aussehens mithilfe von Wasser, Wärme, Massagen und Behandlungen.

Heilwassertrinken. Orale Einnahme von Heilwasser während einer bestimmten Zeit und in einer bestimmten Menge, die von einem Arzt verschrieben wird, um eine therapeutische Wirkung zu erzielen.

Heiße Steine. Durch Gehen über heiße Steine wird die Entspannung und Durchblutung gefördert.

Holistische Behandlungen. In dieses Konzept sind Therapien wie Bachblüten, Farbtherapie, Aromatherapie, Edelsteine usw. eingeschlossen. Es werden Elixiere,

Lotionen und Behandlungen angewendet, die nicht nur einen wissenschaftlich nachweisbaren Effekt haben, sondern die Gleichgewichtsstörungen und energetischen Störungen ausgleichen.

Hydrojet. Der Patient liegt auf einer Liege und wird mit Wasserstrahlen auf dem Rücken massiert, was eine sehr entspannende Wirkung hat.

Hydromassagebecken. Unterwassermassagen, die manuell oder mechanisch mit Druckwasserstrahl oder Luft (Luftblasen) durchgeführt werden. Das Thermalwasser ist ungefähr 36 °C warm. Die Wasserstrahlen helfen bei Gelenkproblemen und die Blasen verbessern die Durchblutung. Mit Algenzusatz wird eine Reduzierung erreicht.

Inhalationen. Technik, bei der Dampf und Thermalwasser inhaliert wird (über die unteren Atemwege).

Infrarotbehandlung. Verabreichung von äußerlicher Wärme zur Schmerzlinderung.

Infrarotumschläge. Osmotische Umschläge mit Infrarotstreifen zur Verminderung der Zellulitis.

Kalte Umschläge. Der ganze Körper oder einzelne Körperteile werden in kalte Umschläge gewickelt. Die Umschläge stärken und fördern die Durchblutung.

Kinesiologie (Bewegungstherapie). Eine Technik, die auf der Beobachtung und Korrektur von Körperhaltungen basiert. Der physische und psychische Zustand wird über unbewusste Muskeltests analysiert, die es ermöglichen, Probleme zu finden und Veränderungen auszugleichen.

Kinesitherapie. Behandlung durch Bewegung zur Rehabilitation von Patienten mit funktionellen Störungen.

Kneipp*Anwendungen. Wasseranwendungen mit Techniken, die von Sebastian Kneipp entwickelt wurden und normalerweise von Diäten, Gymnastik und der Anwendung von Heilpflanzen begleitet werden.

Körperpeeling. Exfoliation der Haut, die toten Zellen werden abgestoßen.

Krenotherapie. Behandlung, die auf den heilenden Kräften bestimmter Heilwasser oder Fangos beruht.

"Lomi Lomi". Asiatische Therapie, die aus einer kontinuierlichen Ausführung von Bewegungen besteht, Beugen, Strecken, Streicheln und sanftes Wiegen. Wirkt schmerzlindernd und kräftigend.

Lymphdrainage. Stimulierung des lymphatischen Systems durch zarte, sanfte, langsame und wiederholte Streichmassage, die einen Lymphstau in verschiedenen Bereichen des Organismus verhindert. Reinigt, eliminiert toxische Substanzen und verbessert den Kreislauf.

Masotherapie. Manuelle Massage, die physische und psychosomatische Wirkung hat.

Massage. Ein Masseur bearbeitet mit den Händen den ganzen Körper mittels Reibung und Druck. Entspannt, stärkt die Muskulatur und fördert die Durchblutung.

Mechanotherapie. Behandlung zur Rehabilitation, die auf manuellen Techniken mit mechanischen Apparaten beruht (Rollen, Ziehen...)

Medizinische Fußbäder. Bäder der Füße und Teilen der Beine.

Medizinische Handbäder. Hand- und Unterarmbäder.

Medizinische Hydrologie. Wissenschaft, die die Wirkung des Wassers auf den Organismus und dessen Einsatz für therapeutische Zwecke studiert.

Ozonbäder. Sprudelbad, in dem Luft zugesetzt wird, um Luftblasen mit zusätzlichem Sauerstoff zu erzeugen.

Parafango. Es wird lokal ein Umschlag aus Fango oder Schlamm und Paraffin bei einer Temperatur von ungefähr 45 °C angewandt.

Paraffin. Dieses Produkt wird benutzt, da es ausgezeichnet Wärme bei lokalen Anwendungen akkumuliert und überträgt.

Passive Gymnastik. Es werden Elektroden am Abdomen und an den Gesäßmuskeln befestigt, die Stromschläge in Farad austeilen, welche die Muskulatur zusammenziehen und entspannen. Führt zu einer Straffung der Muskeln und lokalem Gewichtsverlust.

Pflanzenelixiere. Die regenerierende Wirkung wirkt enthemmend bei physischen oder psychischen Problemen. Falten, Zellulitis und andere ästhetische Probleme werden gelöst.

Phototherapie. Verschiedene Arten von Licht werden zu therapeutischen Zwecken eingesetzt.

Presstherapie. Es handelt sich um Gefäße, die schwellen und abschwellen und so den Effekt einer Lymphdrainage erzeugen. Wird bei Stau von Flüssigkeit und Durchblutungsstörungen angewendet. Wirkt entschlackend und harntreibend und vermindert die Zellulitis.

Pulverisierungen. Technik, bei der Dampf und Thermalwasser inhaliert wird (über die oberen Atemwege).

Rasul. Reinigung von Körper und Geist nach arabischer Tradition mithilfe von Masken und aromatischen Dämpfen.

Rebalancing. Tiefgehende Massage, durch die das natürliche Gleichgewicht des Körpers wieder hergestellt wird.

Reiki. Alternative Medizin, die auf einer traditionellen, fernöstlichen Therapie beruht und die Heilung über die Lebensenergie des Individuums erreicht. Das emotionale, mentale, physische und seelische Gleichgewicht wird wieder hergestellt.

Runddusche. Anwendung von Thermalwasser mit niedrigem Druck über viele Duschdüsen.

Sauna. Trockene Hitze in einer Kabine.

Schlammpackungen. Schlamm, der durch das Vermischen von Erde mit Mineral- und Heilwasser entsteht.

Schottische Dusche. Druckwasserstrahlen mit Thermalwasser bei einer Temperatur von 35 °C, die von den Füßen bis zum Kopf, vorne und hinten angewendet werden; das letzte, angewandte Wasser ist kalt. Wirkt kräftigend, entspannend und fördert die Durchblutung.

Shiatsu. Diese östliche Therapie, eine japanische Version der chinesischen Akupressur, die den Energielinien des Körpers folgt, resultiert aus einer uralten Tradition. Das energetische Gleichgewicht wird wieder hergestellt und die körpereigenen Abwehr- und Erholungsmechanismen aktiviert. Der Patient gewinnt sein physisches, psychisches und energetisches Gleichgewicht zurück, findet innere Ruhe, physisches Wohlbefinden und die Konzentrationsfähigkeit wird erhöht.

Sprudelbäder. Eintauchen in eine Badewanne mit Mineral- und Heilwasser, dem Druckluft zugesetzt wird.

Thalassotherapie. Meerwasserbehandlung. Die wohltuende Wirkung des Meerwassers wird zu therapeutischen Zwecken eingesetzt.

Thermalbad. Bad zur Rehabilitation mit Schlamm, Handlauf, Griffen und Stufen unter Wasser, die einen mechanischen Effekt haben. Durch das Eintauchen wird Gewicht vermindert, die Sinnesorgane werden angeregt, und der Wasserwiderstand und die Temperatur entspannen die Muskulatur.

Thermalbäder. Besonders geeignet für Erkrankungen des Bewegungsapparates, der Atemwege und Verdauungsorgane. Anwendung von Mineral- und Heilwasser.

Türkisches Bad. Feuchte Wärme.

Vichy-Dusche (oder horizontale Dusche). Eine Ganzkörpermassage unter der Dusche, bei der der Patient sich auf eine Liege legt.

Watsu. Entspannung im Wasser, die den Prinzipien des Shiatsu folgt.

Wechselbäder. Es wird abwechselnd kaltes und heißes Wasser auf den ganzen Körper oder auf bestimmte Körperteile gespritzt, um die Durchblutung zu fördern.

Yoga. Fernöstliche Disziplin, die auf der Kontrolle der fünf Energiequellen beruht: Atmung, Ernährung, Schlaf, Entspannung und eine positive Einstellung. Körper und Geist werden auf natürliche Weise eingesetzt. Die bekannteste Form ist das Hatha Yoga (physisches Yoga), bei dem verschiedene Positionen (Asanas) eingenommen werden, die mit einer Kontrolle der Atmung und Entspannung kombiniert werden und so den Organismus und seine Funktionen beeinflussen.

Glossaire

Acupressure. Technique basée sur la stimulation des points d'acupuncture et des méridiens.

Acupuncture. Traitement médical d'origine asatique, qui consiste à piquer des aiguilles en certains points du corps afin de guérir maladies.

Aerosol. Inhalation d'eau minérale médicinale employant un appareil, la dispersant en particules très fines.

Aromathérapie. Litéralement « thérapie usant des arômes ». Ces arômes provenant de plantes, d'herbes, d'arbres, de fleurs dont sont extraits des « huiles essentielles », utilisées pour traiter et maintenir la santé. Ces huiles sont utilisées pour des massage, des immersions, des inhalations, des nébullisations, des ingestions et bains de pieds.
L'aromathérapie est une thérapie vielle de plusieurs centaines d'années, qui fût redécouverte au 20ème siècle, devenant l'un des support de la médecine alternative et cosmétique.

Ayurveda. Pratique originaire de l'Inde et datant de quelques 5.000 ans. Comprenant la conaissance et la science de la vie. L'une des thérapies les plus employée de l'ayurveda étant le Panchakarma: un programme de purification, de rajeunissement et réparateur, destiné à achever un état de bien-être complet. Cela comprend une combinaison de thérapies destinées tout d'abord à éliminer les toxines de l'organisme. L'objectif suivant étant de réduire la fatigue et le stress par des massages à 4 mains parfaitement synchrones, en appliquant des essences et des huiles naturelles.

Bain. Technique comprenant l'immersion dans une eau minérale médicinale pendant un temp déterminé et à une température déterminée.

Bain avec hydromassage. Massages en étant immergé, fait à la main ou machinellement au moyen de jets d'eau ou d'air pressurisés. L'eau est en général à une températue 96,8 °F(36 °C). On emploie ces jets pour traiter der problèmes articulaires. Les « bulles » améliorent la circulation et l'adjonction d'algues marines a un effet amincissant.

Bain de boue. Mélange de terre ou de glaise avec de l'eau minérale médicinale.

Bain de boue à la paraffine. Plaque de boue et paraffine chauffée à 113 °F (45 °C) pour application locale.

Bain de mains. Bains pour les mains et la partie inférieure des bras.

Bain d'ozone. Bain moussant. L'air employé pour faire des bulles est enrichi avec de l'ozone.

Bain de pieds. Bains pour les pieds et la partie inférieure des jambes.

Bain de vapeur. Le corps entier, sauf la tête, est soumis à une chaleur humide d'environ 113 °F (45 °C). L'effet est comparable à celui du sauna, étant plus difficile à supporter à cause de l'humidité. Cela provoque de la transpiration et une perte d'eau.

Bain filiforme. Un jet d'eau projeté à très grande pression.

Bain galvanique. Immersion dans un bassin sous l'action de courants électriques.

Bain moussant. Immersion dans un bassin d'eau minérale médicinale enrichie d'air sous pression.

Bain Turc. Bain avec chaleur et humidité.

Bains actifs. Bains d'eau thermale ouvrant les pores et purifiant la peau.

Bains alternants. Jets d'eau froide et chaude appliqués alternativement sur le corps entier et à des endroits déterminés afin de favoriser la circulation sanguine.

Bioslim. Après avoir appliqué une crème anti-cellulite sur le corps, on le recouvre d'une couverture chauffante, ce qui permet une bonne absorption des produits et une diminution des dimmensions du corps.

Body peeling. Exfoliation de la peau éliminant les cellules mortes.

Clapping. Technique manuelle de physiothérapie appliquée au thorax pour faciliter une expectoration bronchiale.

Crénothérapie. Traitement par les eaux de source, à la source elle-même.

Cure hydropinique. Prise orale d'eau thermale à un moment et à un rythme spécifique déterminé par le médecin, dans le but d'obtenir un effet thérapeutique.

Douche de vapeur. Favorise le passage à travers la peau, des éléments actifs de l'eau thermale. Le jet de vapeur appliqué sur la partie du corps indiquée par le médecin, a un effet vasodilatateur immédiat.

Douche Ecossaise. Jets sous pression d'eau thermale à une température de 95 °F (35 °C), pratiqués de la tête aux pieds, de face et de dos, avant de terminer par une douche froide. Cela stimule, relaxe et améliore la circulation.

Douches circulaires. Application d'eau thermale à base de pression, provenant d'ouvertures multiples.

Douche Vichy (horizontale). Massage corporel général que le patient reçoit alongé sous une douche.

Drainage lymphatique. Stimulation du systeme lymphatique au moyen de mouvements doux, souples, lents et répétés fait avec les mains. Cela empêche l'accumulation du liquide lymphatique dans différentes parties du corps et aide à éliminer les toxines en améliorant la circulation.

Electrothérapie. Traitement de maladies par l'électricité. On a recour à différents courourants usant de leurs propriétés stimulantes.

Elixires floraux. Leur fonction régénérative débloque aussi bien les problèmes physiques que le stress psychologique. Ils permettent de faire diminuer les rides et la cellulite et sont considérés comme traitements de beauté.

Enveloppements à froid. Tout le corps ou une partie seulement vient enveloppé dans un bandage froid. Cela ayant un effet revitalisant et stimulant pour la circulation du sang.

Enveloppement aux algues. Le corps est enduit d'une préparation d'algues et d'eau thermale et enveloppé dans une feuille de plastic et une couverture chauffante. Cela purifie l'organisme, favorise la transpiration et une perte de poid.

Equilibrage. Massage en profondeur rétablissant l'équilibre naturel du corps.

Frigidarium. Bassin contemant de l'eau glacée destiné à améliorer la circulation dans les jambes.

Gymnastique passive. Electrodes placées sur l'abdomen. Elles émettent un courent faradique, qui contracte et relaxe

la musculatue. Cela raffermit les zones flasques, renforce les muscles et permet de perdre du poid à certains endroits.

Hydrojet. Le patient est allongé sur un lit et vient massé par des jets d'eau, ce qui produit une relaxation totale.

Hydrologie médicinale. Science qui étudie l'action de l'eau sur l'organisme ainsi que leur application dans un but thérapeutique.

Inhalation. Absorption par les voies respiratoires, de vapeur ou d'eau thermale.

Jets à pression. Application manuelle d'eau minérale médicinale à des degrés différents de pression et de continuité.

Kinésiologie. Technique basée sur l'observation et la correction de postures du corps. L'état physique et psychique étant analysé au moyen de tests musculaires inconcients, permettant de localiser les problèmes et de rééquilibrer toute altération.

Kinésithérapie. Technique de mouvements de réhabilitations pour des patients ayant des fonction corporelles restraintes.

Lomi-lomi. Spécialité asiatique, comprenant une succession de mouvements continus: flexions, étirements, caresses, balancements en douceur, dans le but de calmer et revitaliser.

Masothérapie. Massage manuel ayant un effet physique et psychosomatique.

Massage. Travail exécuté par des spécialistes sur le corps entier avec leurs mains, par pression et friction.

Cela aide à se relaxer, tonifie les muscles et améliore la circulation.

Massages asiatiques. Massages permettant d'équilibrer les courents énergétiques en suivant les points d'acupressure. Cela relaxe le corps et améliore la circulation du sang.

Méchanothérapie. Traitement de réhabilitation basé sur une technique manuelle en employant différents appareils et engins (poulies, traction etc.)

Paraffine. Produit utilisé à cause de sa grande aptitude à emagasiner et transmettre la chaleur en application locale.

Photothérapie. Application de divers type de lumière à des fins thérapeutiques.

Pierres chaudes. Les patients marchent sur des pierres chaudes, cela améliore la circulation et leur procure un état de relaxation.

Piscine thermale. Piscine équipée de barres, de main courant et d'escaliers. L'effet d'apesanteur dû à l'immersion produit un effet méchanique. La résistance de l'eau au mouvement stimule les sens et relaxe les muscles de par la chaleur de l'eau.

Presothérapie. Vient pratiquée avec des « bottes » qui se gonfles et se dégonfles produisant le même effet qu'un drainage lymphatique. Elle est recommendée lors de rétention de liquide et lors d'altération du flux sanguinet. Elle purifie, combat la cellulite et a un effet diurétique.

Pulvérisation. Technique comprenant l'inhalation de vapeur et d'eau minérale (voies respiratoires supérieures).

Rasul. Technique Arabe traditionelle de

purifier le corps et l'esprit par des masques et des bains de vapeur aromatisés.

Rayons infrarouges. Administration de chaleur sur la surface du corps dans un but analgésique.

Réflexologie. Technique manuelle sur les points de réflex du pied afin de rééquilibrer le système nerveux.

Reiki. Médecine alternative basée sur une thérapie asiatique traditionelle guérissant les patient au moyen de leur propre énergie. Cela permet de retrouver son équilibre émotionel, mental, physique et spirituel.

Sauna. Cabine de chaleur sèche.

Shiatsu. Bien qu'étant plus en vogue que jamais, cette thérapie asiatique – une version Japonaise de l'acupressure Chinoise suivant les lignes énergétiques du corps – est pratiquée depuis très longtemps. Elle agit en rétablissant l'équilibre énergétique et en remettant en marche les méchanismes de défence du corps. Elle redonne au patient son équilibre physique et psychique, procurant une paix intérieure, un bien-être physique et augmentant la concentration.

Spa. Etablissement visant à améliorer la santé et la condition physique au moyen de l'eau, de la chaleur, de massages et de traitements.

Thalassothérapie. Traitement hydro-thérapique employant de l'eau de mer profitant de ses propriétés bénéfiques.

Thérapie à la boue. Boue naturelle diluée avec de l'eau thermale et appliquée sur le corps entier. On enveloppe ensuite le corps dans du plastique et des couvertures chauffantes. Cela revitalise et adoucit la peau, relaxe le corps et augmente la transpiration.

Thérapie selon Kneipp. Traitement hydrothérapique basée sur des techniques décrites par Sébastien Kneipp, souvent accompagné d'un régime, d'exercices phisiques et l'usage de plantes médicinales.

Thermalisme. Spécialement indiqué pour les maladies touchant à la motricité, à l'appareil respiratoir et au système digestif, en employant de l'eau minérale médicinale.

Thermojet. Enveloppement osmotique avec bandes infrarouges contre la cellulite.

Traitements holistiques. Ce concept comprend des traitements avec des remèdes aux fleurs de ruisseau, chromothérapie, aromathérapie, aux pierres précieuse. Ils prennent leurs avantages d'elixirs, de lotions et de thérapies allant au dela des effets scientifiques de leurs formules en agissant sur l'énergie, le déséquilibre et les bloquages.

Vaporarium. Instalation produisant de la vapeur à des fins thérapeuthique.

Watsu. Technique de relaxation pratiquée dans l'eau, selon les principes du shiatsu.

Yoga. Discipline orientale basée sur le control des cinq sources de l'énergie : la respiration, le régime nutritionel, le repos, la relaxation et une attitude mentale positive. Dans cette pratique, le corps et l'esprit sont associés de façon intrinsèque. La forme la plus pratiquée étant le hata yoga (yoga physique). Pratique de divers exercices (asanas), associée avec le control de la respiration et la relaxation, qui exercent une influence sur l'organisme et ses fonctions.

Glosario

Acupresura. Técnica basada en la estimulación de los puntos de acupuntura y meridianos.

Acupuntura. Técnica curativa de origen oriental que consiste en clavar una o más agujas en determinados puntos del cuerpo para curar determinadas enfermedades.

Aerosol. Aplicaciones inhalatorias de agua mineromedicinal mediante aparatos especiales que producen finísimas partículas de vapor.

Aromaterapia. Literalmente significa terapia que usa aromas. Estos aromas proceden de plantas, hierbas, árboles, flores... con los que se producen aceites esenciales que se emplean para curar y preservar. Estos aceites pueden emplearse en masajes, baños de inmersión, inhalación, nebulización, ingestión, pediluvio...
La aromaterapia es una disciplina terapéutica holística milenaria, aunque ha sido redescubierta en este siglo y se ha convertido en uno de los pilares de la medicina y cosmética alternativas.

Ayurveda. Procede de la tradición hindú y cuenta con más de 5.000 años de existencia. Significa conocimiento o ciencia de vida. Una de las terapias más utilizadas en el Ayurveda es el "Panchakarma": un programa de purificación, rehabilitación y rejuvenecimiento destinado a lograr un bienestar global que consiste en terapias combinadas que empiezan por desintoxicar el organismo. Una vez conseguido, se intenta reducir la fatiga y el estrés mediante masajes realizados a cuatro manos de forma sincronizada y aplicando aceites y esencias naturales.

Balneario. Instalación destinada a mejorar la salud y el aspecto físico mediante el agua, el calor, los masajes y otros tratamientos.

Bañera de hidromasaje. Masajes subacuáticos efectuados de forma manual o mecánica mediante chorros de agua a presión o aire (burbujas). El agua termal suele estar a unos 36º C. Los chorros permiten tratar problemas articulatorios, las burbujas mejoran la circulación y con algas se consigue reducir el volumen.

Baño. Técnica que consiste en la inmersión en el agua mineromedicinal durante un tiempo y una temperatura determinados.

Baño de burbujas. Inmersión en una bañera con agua mineromedicinal a la que se añade aire a presión.

Baño de ozono. Baño de burbujas en el que el aire empleado para producir burbujas está enriquecido con ozono.

Baño filiforme. Finísima salida de agua proyectada a gran presión.

Baño galvánico. Baño de inmersión en una bañera equipada para aplicar corrientes galvánicas al paciente.

Baño turco. Calor húmedo.

Baños activos. Baños con agua termal y arcilla que abren los poros de la piel y son depurativos.

Baños alternos. Se aplican alternativamente chorros de agua fría y caliente sobre todo el cuerpo o en determinadas zonas para estimular la circulación sanguínea.

Bioslim. Se aplican cremas anticelulíticas y se cubre el cuerpo con una manta eléctrica. Consigue reducir volumen y favorece la absorción de los productos.

Cinesiterapia. Tratamiento por el movimiento para la rehabilitación de pacientes con limitaciones funcionales.

Chorro a presión. Aplicación de agua mineromedicinal de forma manual con más o menos presión y continuidad.

Clapping. Técnica manual de fisioterapia que se aplica en el tórax para facilitar la expectoración bronquial.

Crenoterapia. Tratamiento basado en las propiedades medicinales de determinadas aguas o fangos.

Cura hidropínica. Ingestión oral de agua termal a un tiempo y ritmo determinados por un médico a fin de lograr efectos terapéuticos.

Drenaje linfático. Estimulación del sistema linfático a través de manipulaciones sutiles, suaves, lentas y repetitivas que contribuye a evitar la acumulación de líquido linfático en diferentes zonas del organismo. Depura, ayuda a eliminar sustancias tóxicas y mejora la circulación.

Ducha circular. Aplicación de agua termal a baja presión con salida por múltiples orificios.

Ducha escocesa. Chorros a presión con agua termal a unos 35º C que se aplica de pies a cabeza, por delante y por detrás, y se termina con agua fría. Es tonificante, relajante y favorece la circulación.

Ducha Vichy (u horizontal). Masaje general bajo ducha que el paciente recibe tumbado en una camilla.

Ducha vapor. Favorece el paso transcutáneo de los elementos activos del agua termal. El chorro de vapor dirigido a las partes del cuerpo indicadas por el médico provoca una vasodilatación inmediata.

Electroterapia. Tratamientos que utilizan la aplicación de diversos tipos de corrientes eléctricas aprovechando sus propiedades estimulantes con fines terapéuticos.

Elixires florales. Su función regeneradora desbloquea problemas físicos como los conflictos anímicos o psíquicos. Reducen las arrugas, la celulitis y resuelven problemas de tipo estético.

Envoltura de algas. Se embadurna el cuerpo con un preparado a base de algas y agua termal y, posteriormente, se envuelve con un plástico y una manta de calor. Depura el organismo, ayuda a sudar y estimula la pérdida de volumen.

Estufa de vapor. Se somete todo el cuerpo excepto la cabeza a calor húmedo a unos 45º C. El efecto es parecido al de la sauna, pero al ser calor húmedo es menos tolerable. Favorece la sudoración, por lo que se pierde agua.

Fangoterapia. Se aplica barro natural diluido con agua termal por todo el cuerpo y se envuelve con un plástico y una manta de calor. Revitaliza, suaviza la piel, relaja y favorece la sudoración.

Fototerapia. Aplicación de diversos tipos de luz con fines terapéuticos.

Frigidarium. Piscina de agua muy fría que ayuda a mejorar la circulación de las piernas.

Gimnasia pasiva. Se colocan en el abdomen y los glúteos unos electrodos que emiten unas corrientes farádicas que contraen y relajan la musculatura. Combate la flaccidez, refuerza la

musculatura y ayuda a perder centímetros a nivel local.

Hidrojet. Estirado sobre una camilla el paciente recibe unos chorros que masajean su espalda, lo que permite una completa relajación.

Hidrología médica. Ciencia que estudia las acciones de las aguas sobre el organismo y su aplicación con fines terapéuticos.

Inhalaciones. Técnica inhalatoria de vapor y agua termal (vías respiratorias bajas).

Kinesiología. Técnica basada en la observación y corrección de posturas corporales. Se trata de analizar el estado físico y psíquico a través de pruebas musculares inconscientes que permiten localizar problemas y equilibrar las alteraciones.

Kneippterapia. Tratamiento de hidroterapia basado en técnicas descritas por Sebastian Kneipp y que suelen acompañarse de dieta, ejercicio y uso de plantas medicinales.

Lodos. Barros que se forman al mezclar tierra con agua mineromedicinal.

Loomi-loomi. Especialidad asiática que consiste en una continua progresión de movimientos: flexiones, estiramientos, caricias y suaves balanceos con una finalidad sedante y reconstituyente.

Maniluvios. Baño de las manos y parte de los brazos.

Masaje. Un especialista trabaja con las manos por todo el cuerpo practicando fricciones o presiones. Ayuda a relajar, tonificar la musculatura, favorecer la circulación.

Masaje asiático. Masaje que permite un equilibrio del flujo de energía siguiendo los puntos de acupresura. Mejora la circulación sanguínea y relaja.

Masoterapia. Masaje manual con efecto físico y psicosomático.

Mecanoterapia. Tratamiento de rehabilitación basado en técnicas mecánicas manuales con aparatos mecánicos (poleas, tracciones...).

Parafangos. Se aplica localmente una placa de fango o lodo y parafina que está a unos 45º C.

Parafina. Producto utilizado por su gran capacidad de acumular y transmitir calor en aplicaciones locales.

Pediluvios. Baño de pies y parte de las piernas.

Peeling corporal. Exfoliación de la piel que elimina las células muertas.

Piedras calientes. Se camina sobre unas piedras calientes que resultan relajantes a la vez que contribuyen a mejorar la circulación.

Piscina termal. Piscina de rehabilitación dotada de barras, barandillas, asideros y escalones sumergidos que tiene un efecto mecánico por la disminución aparente de peso por la inmersión, de estímulo sensorial, debido a la resistencia al movimiento en el agua, y térmico, relajando la musculatura.

Presoterapia. Se trata de unas botas que se hinchan y deshinchan reproduciendo los efectos de un drenaje linfático. Conviene cuando hay retención de líquidos y alteraciones circulatorias periféricas. Es depurativo, combate la celulitis y favorece la diuresis.

Pulverizaciones. Técnica inhalatoria de vapor y agua termal (vías respiratorias altas).

Rasul. Limpieza del cuerpo y espíritu de tradición árabe, mediante mascarillas y vapores aromáticos.

Rayos infrarrojos. Administración de calor superficial con fines analgésicos.

Rebalancing. Masaje profundo que consigue restablecer el equilibrio natural del cuerpo.

Reflexología. Técnica manual que presiona los puntos reflejos del pie para equilibrar el sistema nervioso.

Reiki. Medicina alternativa basada en una terapia tradicional oriental que logra la sanación por medio de la energía vital de cada individuo. Permite recuperar el equilibrio emocional, mental, físico y espiritual.

Sauna. Calor seco en cabina.

Shiatsu. A pesar de estar más vigente que nunca, esta terapia oriental –versión japonesa del masaje de acupresura chino siguiendo las líneas energéticas del cuerpo– es una práctica antigua y actúa restableciendo el equilibrio energético del cuerpo y haciendo que se pongan en marcha sus propios mecanismos de defensa y recuperación. Reequilibra al paciente física, psíquica y enérgicamente, lo que permite conseguir mayor tranquilidad interior, bienestar físico y poder de concentración.

Talasoterapia. Tratamiento de hidroterapia mediante el uso de agua de mar. Se aprovechan todos los beneficios que el medio marino posee.

Termalismo. Especialmente indicado para enfermedades del aparato locomotor, respiratorio y digestivo mediante la utilización de aguas mineromedicinales.

Termojet. Envoltura osmótica con bandas de infrarrojos que combate la celulitis.

Tratamientos holísticos. Este concepto incluye terapias como las flores de Bach, la cromoterapia, los aromas, las piedras preciosas… Emplean elixires, lociones y tratamientos que van más allá del efecto científico de sus fórmulas ya que actúan sobre los desequilibrios y bloqueos energéticos.

Vaporario. Producción de vapor que se aplica al cuerpo con fines terapéuticos.

Vendas frías. Se envuelve todo el cuerpo o una zona de éste con vendas frías. Estas tienen un efecto reafirmante útil a la vez que estimulan la circulación.

Watsu. Relajación dentro del agua utilizando los principios del shiatsu.

Yoga. Disciplina oriental que parte del control de cinco fuentes de energía: respiración, alimentación, sueño, relajación y actitud mental positiva. En su desarrollo se implican cuerpo y mente de forma natural. El más conocido y practicado es el "hatha yoga" (yoga físico), que se desarrolla con la práctica de distintas posturas (asanas) combinadas con el control respiratorio y la relajación, que influyen en el organismo y sus funciones.

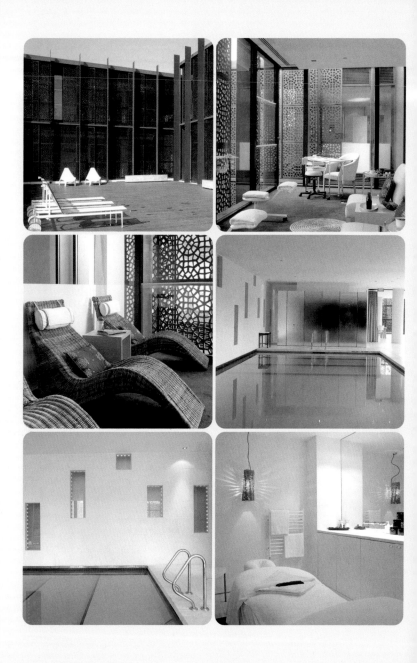

Aurora Spa Retreat

Opening date: 2000
Address: 2 Acland Street. St. Kilda 3182
Victoria. Australia
Tel.: +03 95361130
Fax: +03 95253729
info@aurorasretreat.com
www.aurorasparetreat.com
Services: This spa boasts an extensive range of totally natural health
and beauty products especially created by Lyndall Mitchell (the spa's
founder), called Li'tya and Phytomer. "Kitya Karnu", a unique relaxing
and reinvigorating experience, yoga, reiki, acupuncture, reflexology,
naturopathy, massages (facial, anti-stress, relaxing, reaffirmative...). All
kinds of body treatments, face care, water therapies, hairdresser's and
beauty parlor.
There are 40 rooms. The spa functions from 7 a.m. to 9 p.m. from
Monday to Friday, and from 10 a.m. to 7 p.m. at weekends.
It is open every day of the year, except Christmas day.

Architect: Wood March Architects
Photographer: Shania Shegedyn

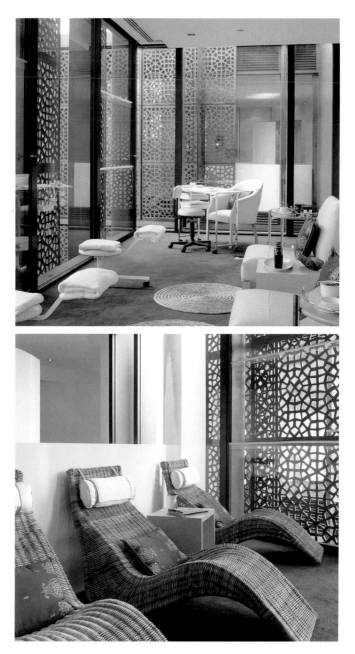

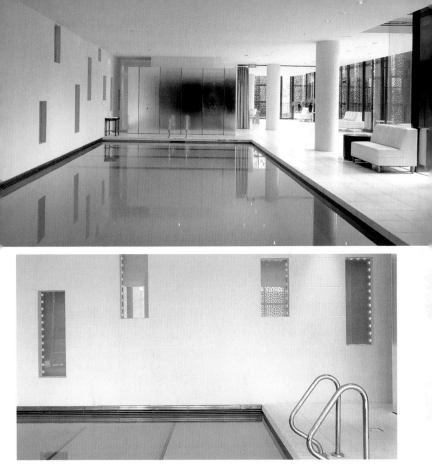

This urban spa, complete with soothing lighting and relaxing music, offers a wide range of services exclusively designed for total relaxation and well-being. The ideal space for taking refuge from day-to-day stress, quietly resting and acquiring new energy.

In diesem Heilbad mitten in der Stadt mit sanfter Beleuchtung und entspannenden Klängen findet der Besucher ein reiches Serviceangebot für Entspannung und Wohlbefinden. Ein idealer Ort, um dem Alltagsstress zu entrinnen, sich auszuruhen und jünger zu fühlen.

Ce complexe citadin baigne dans une lumière douce et une musique relaxante. Il offre une grande gamme de services conçus pour la relaxation et le bien-être. C'est un refuge idéal pour échapper au stress de tous les jours, et refaire un plein d'énergies nouvelles.

Bañado de una luz pacífica y música relajante, este balneario urbano ofrece una extensa gama de servicios diseñados exclusivamente para la relajación y el total bienestar. El lugar idóneo para tomarse tiempo y refugiarse del estrés diario, reposar tranquilamente y rejuvener.

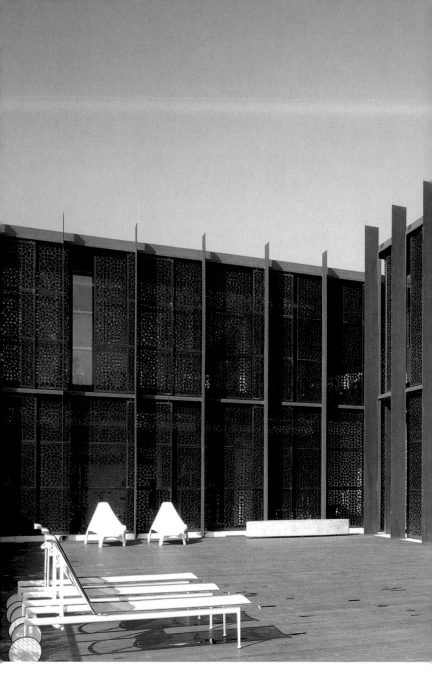

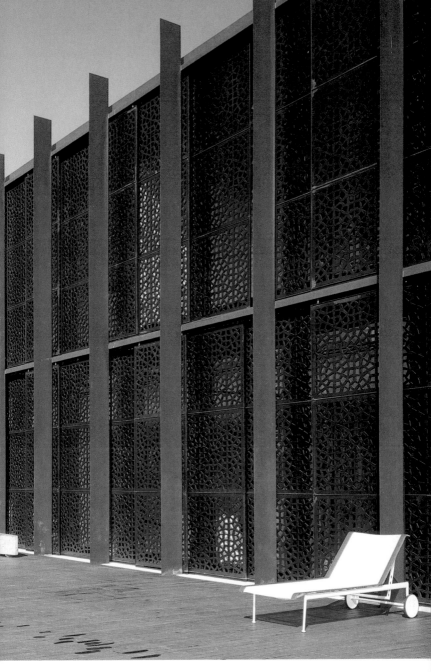

Les Sources de Caudalie

Address: Chemin de Smith Haut-Lafitte
Bordeaux-Martillac, France
Tel.: +33 5 57 83 82 82 (spa)
+33 5 57 83 83 83 (hotel)
Fax: +33 5 57 83 82 81
sources@sources-caudalie.com
www.source-caudalie.com
www.caudalie.com
Services: Beauty institute, black-grape mud bath (an enormous tunnel-shape jacuzzi with bubbling water taken from a 1,770-foot deep hot spring and enriched with atomized fresh grape liquor and essential oils), body wraps with wine yeast, Gironde honey, oils and water rich in iron and fluoride. Swimming pool, thermal baths, hammam, massages, treatments for aging, stress, insomnia, cellulitis, circulation problems and skin complaints, slimming cures and shiatsu, reiki and reflexology. The facilities also include a gym, golf courses, tennis courts, a jogging circuit, cookery school and courses on wine.
Sale of products that are totally pure, natural and free of coloring (creams, body milks, gels, masks...)

Photographer: Montse Garriga

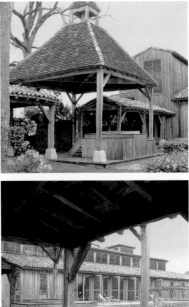

This balneotherapy center, set in peaceful natural scenery, offers attractive treatments based on the harmonious combination of hot mineral water and the properties of wine. It is one of the first centers in the world to use grape polyphenols in its therapies.

Dieses Heilbad inmitten einer von Ruhe und Gelassenheit regierten Landschaft bietet interessante Behandlungsmethoden, die Mineralwasser und Wein kombinieren. Es ist eines der ersten Zentren, in dem die Polyphenole der Traube therapeutische angewendet werden.

Ce centre de balnéothérapie se trouve dans un site paisible et naturel. Il offre des traitements très intéressants à base d'eau minérale chaude combinés harmonieusement aux propriétés bénéfique du marc de raisin. C'est l'un des premiers centre au monde à employer les polyphénols du raisin dans ses thérapies.

Enclavado en un entorno natural inspirador donde reina la calma y la serenidad, este centro de balnoterapia ofrece atractivos tratamientos basados en la armónica combinación del agua mineral caliente con las propiedades del vino. Es uno de los primeros centros del mundo en emplear los polifenoles de la uva en sus terapias.

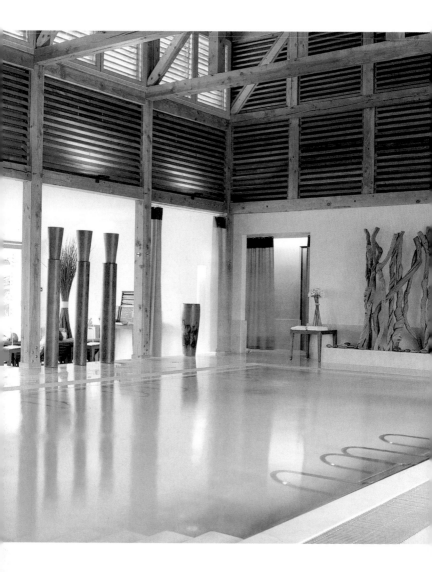

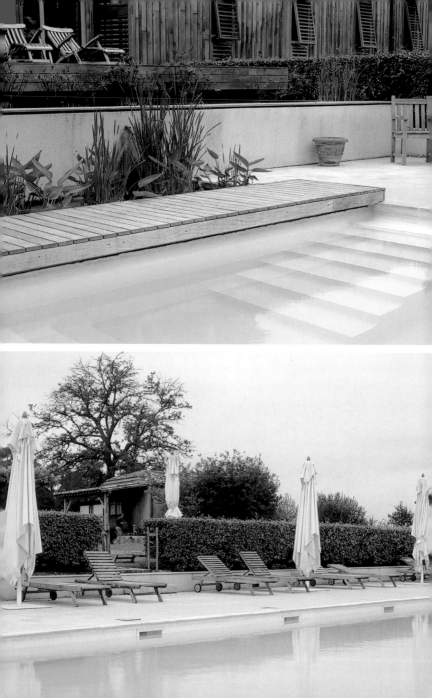

Hotel Rey Juan Carlos I

Opening date: 1992
Address: Avda. Diagonal, 661-671
Barcelona, Spain
Tel.: +34 93 364 40 40
Fax: +34 93 364 42 64
www.theroyalfitness.com
www.hrjuancarlos.com
info@theroyalfitness.com
hotel@hrjuancarlos.com
Services: It offers most of the specialties and services typical of a thermal spa, as well as providing the facilities of a fitness center of the highest quality. Thermal baths, saunas, two heated swimming pools, physiotherapy, a center with nutritional and beauty-based medicinal programs (specializing in face and body, post-natal and vascular treatments, definitive "photo"-depilation, dental and fashion programs, diets for eating disorders and metabolic diseases under the specialized supervision of a medical team...)

Architect: C. Ferrater y J. M. Cartañá
Photographer: Jordi Miralles

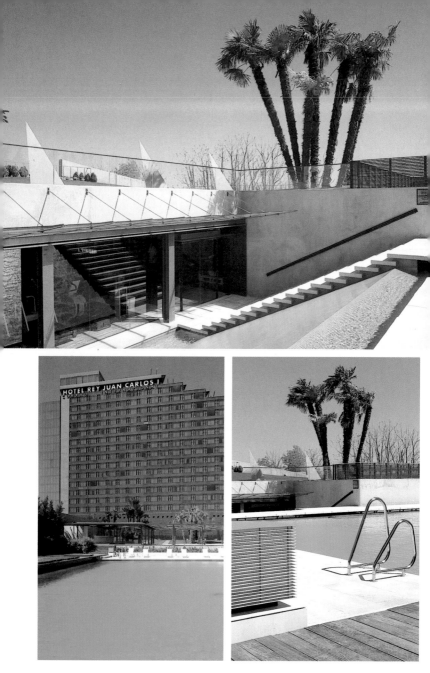

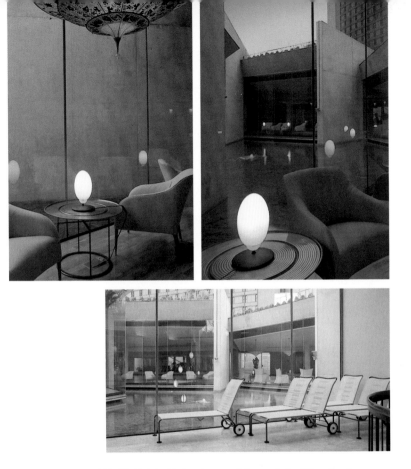

The Royal Fitness and Health Club in this hotel – one of the symbols of Barcelona's Olympics in 1992 – is one of the most complete centers in Europe. It provides a space in which relaxation and comfort combine to create a setting designed for pleasure.

Der Royal Fitness und Health Club dieses Hotels sind ein Symbol für das Barcelona des Jahres 1992 und eines der umfassendsten Zentren Europas. Hier findet der Besucher Ruhe, Eleganz und Komfort in einer entspannenden und angenehmen Umgebung.

Le Club Royal de fitness et de santé de cet hôtel – symbole du Barcelone des années 92 – est considéré comme l'un des centres les plus complets d'Europe. En y pénétrant on trouve le calme, l'élégance et le confort, dans une ambience plaisante et relaxante.

El Royal Fitness y Health Club de este hotel –símbolo de la imagen de la Barcelona del 92– están considerados como uno de los centros más completos de Europa. Penetrar en él es acceder a un espacio en el que el sosiego, la elegancia y el confort se unen en aras de una relajante y placentera sensación ambiental.

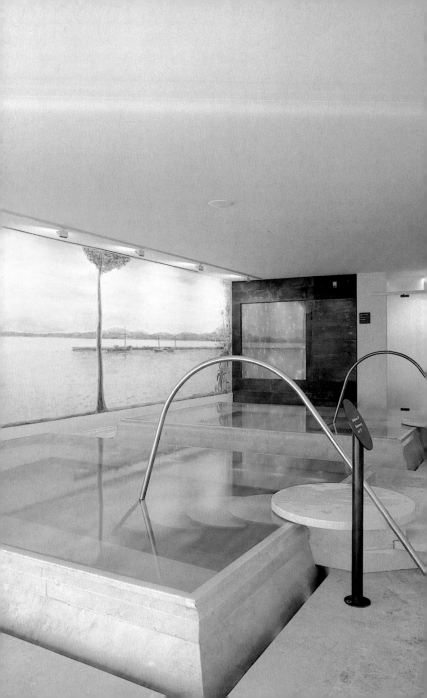

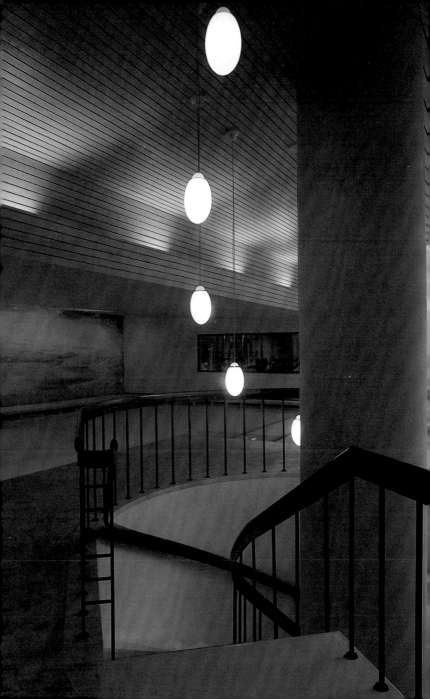

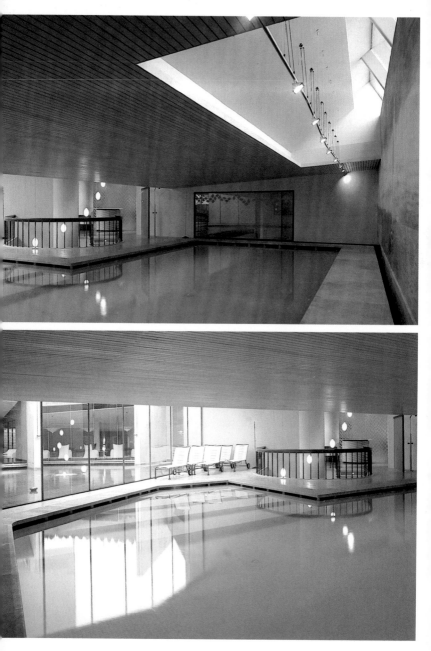

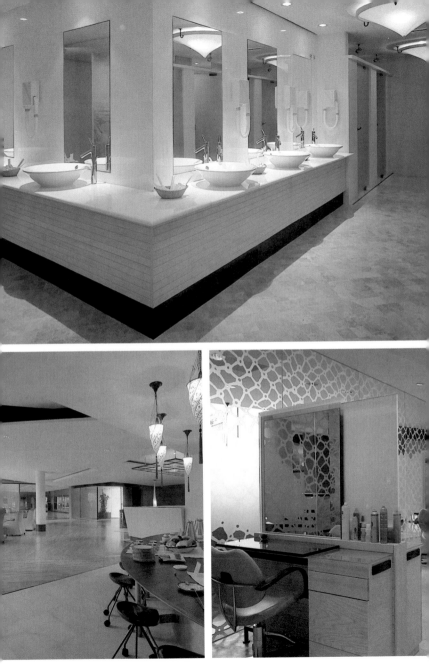

Palace Hotel Gstaad

Address: 3780 Gstaad, Switzerland
Tel.: +41 33 748 50 00
Fax: +41 33 748 50 01
www.palace.ch
palace@gstaad.ch
Services: Face and body health and beauty treatments with La Prairie products, personalized programs, hydrotherapy, ozone showers, steam baths, anti-stress and anti-cellulitis treatments, treatments with mud, massages (sports, Swedish, classical, underwater...), lymphatic drainage, aromatherapy, reflexology, sauna, solarium, swimming pools (indoor and outdoor), fitness center, squash courts, golf, skiing...

Photographer: Montse Garriga

Gstaad is synonymous with sophistication and good taste. This mountain hotel is a prime example of these qualities. Anybody who revels in luxury, relaxation and wellness cannot fail to be charmed; the magic of the Alps is all-embracing.

Gstaad ist ein Synonym für Eleganz und guten Geschmack. Dieses Berghotel ist einzigartig. Wer sich von Wohlbefinden, Luxus und Entspannung angezogen fühlt, sollte das Hotel kennen lernen. Die Magie der Alpen bezaubert den Besucher.

Gstaad est synonyme d'élégance et de bon goût. Cet hôtel de montagne est unique en son genre. Celui qui est attiré par le confort, le luxe et la détente devrait en faire connaissance. La magie des Alpes charme tout visiteur.

Gstaad es sinónimo de sofisticación, elegancia y buen gusto. Este hotel de montaña no podría representar mejor estas cualidades. Los que sientan una fascinación irresistible por el bienestar, el lujo y el sosiego no pueden olvidarse de conocerlo. La magia de las montañas, en el corazón los Alpes, los envolverá.

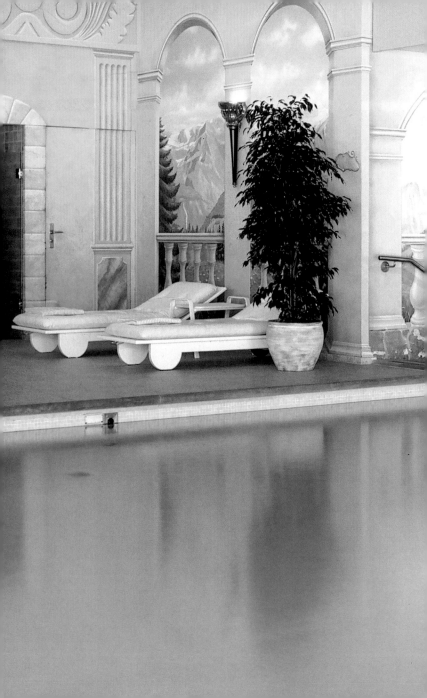

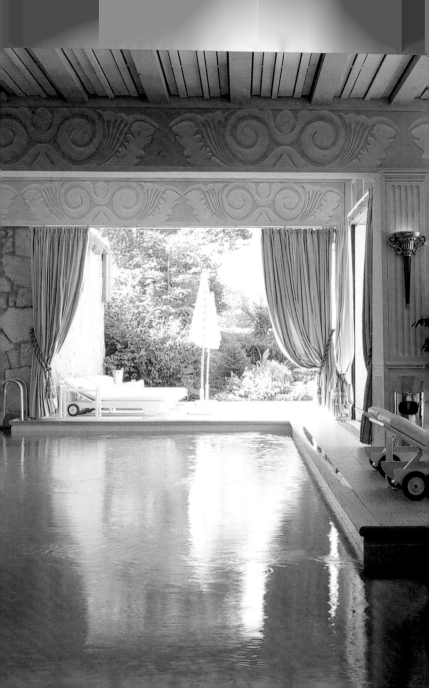

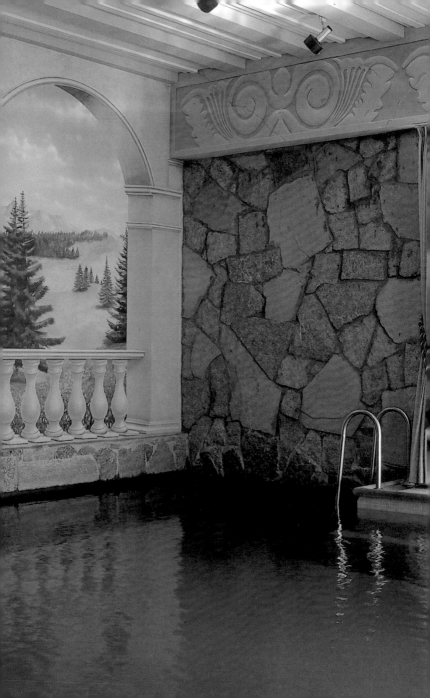

The Lausanne Palace & Spa Wellness Center

Address: Grand-Chêne, 7-9
Lausanne, Switzerland
Tel.: + 41 21 331 31 61
+41 21 331 31 04
Fax: + 41 21 323 25 71
+ 41 21 323 18 29
www.lausanne-palace.com
cbe@lausanne-palace.ch
reservation@lausanne-palace.ch
Services: Treatments for cellular regeneration of the skin. Beauty clinic
(AVEDA). Face and body treatments. Massages (neuromuscular, four-
hand, sports, anti-cellulitis, calming, energizing, relaxing, thai, shirod-
hara, Ayurveda...), shiatsu, lymphatic drainage, treatments with oils
and essences. Thermal swimming pools, jacuzzi, sauna, sanarium,
rasul, steam baths (Moroccan hammam), meditation room,
thalassotherapy treatments, Vichy shower, hydrotherapy, alternative
treatments (Bach flowers, physiotherapy...), reflexology, yoga, tai-chi,
qui-gong, aqua-gym, dance, gym. Dietary treatments and weight con-
trol. Individualized programs of services. Hairdresser's, make-up...

Photographer: Montse Garriga

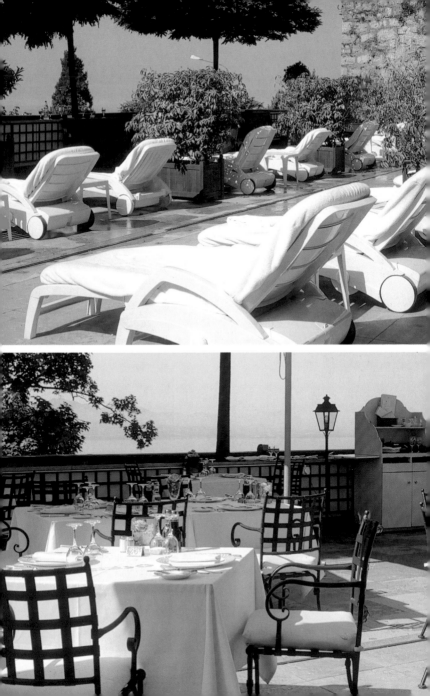

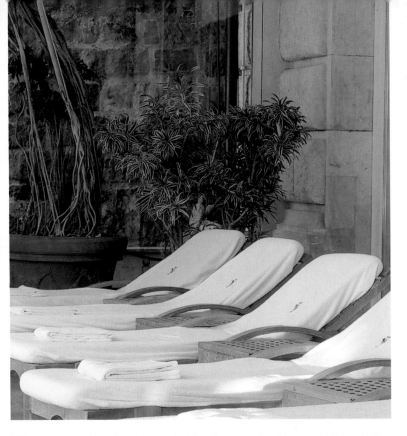

With an exceptional location in the heart of the Olympic capital, this spa and fitness center is the ideal place to find harmony, equilibrium and inner peace. Today's most advanced treatments and facilities are put at the service of health and well-being.

Inmitten einer wundervollen Landschaft im Herzen der Olympiahauptstadt ist dieses Heilbad und Fitnesszentrum der ideale Ort, um Harmonie, Gleichgewicht und inneren Frieden zu finden. Die neusten Methoden und modernen Anlagen stehen im Dienst des Wohlbefindens und der Gesundheit.

Un emplacement exceptionel au cœur de la capitale olympique. Ce bain et centre de fitness est un endroit idéal por trouver l'harmonie, l'équilibre et la paix intérieure. Des traitements et installations de haut niveau sont mis au service de la santé et du bien-être.

Situado en un paraje excepcional, en el corazón de la capital olímpica, este balneario y centro de fitness es el lugar idóneo en el que encontrar la armonía, el equilibrio y la paz interior. Los tratamientos y las instalaciones más modernas y avanzadas se ponen al servicio del bienestar y la salud.

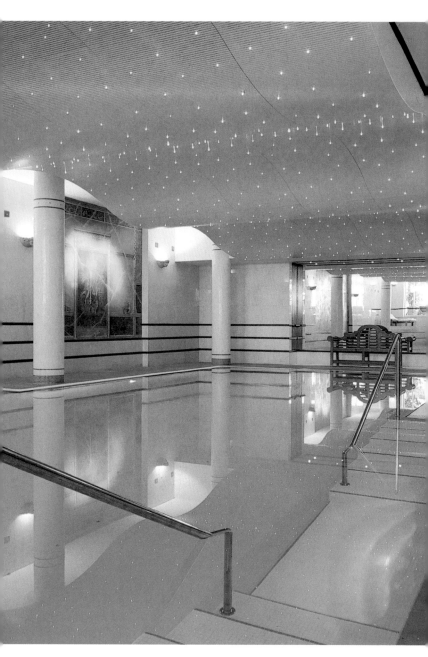

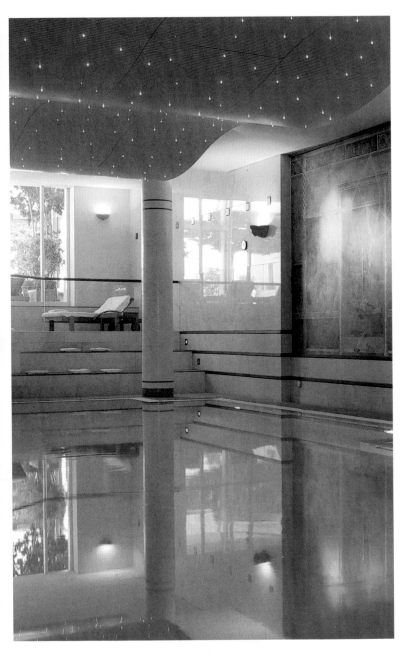

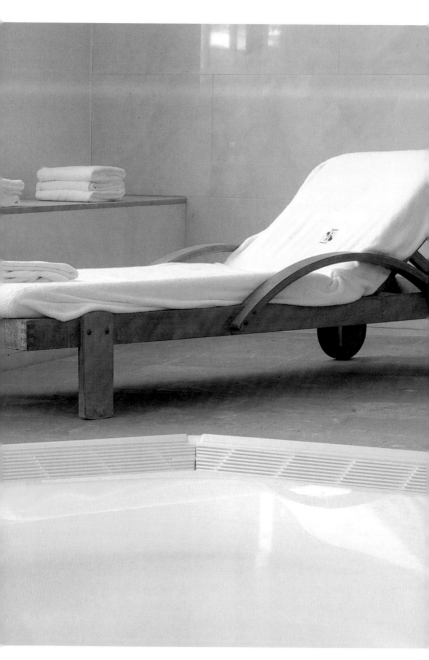

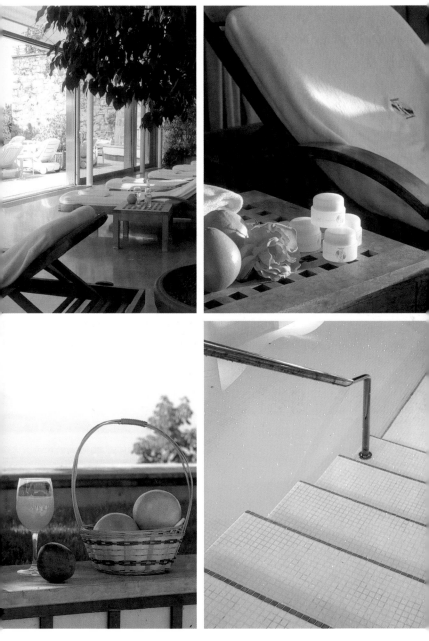

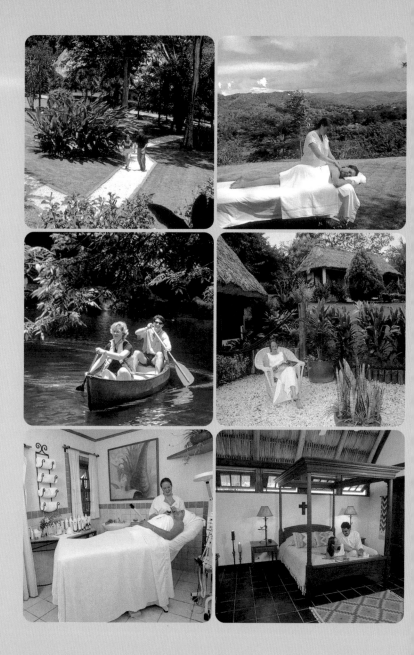

Chaa Creek Belize Adventure Centre, Rainforest and Spa

Address: San Ignacio, Cayo District
Belize
Tel.: 501 824 2037
Fax: 501 824 2501
www.chaacreek.com
www.belizespa.com
reservations@chaacreek.com
Services: Massages (therapeutic, relaxing...), numerous face and body health and beauty treatments, anti-cellulitis treatments, mud treatments, alternative therapies, Vichy shower, aromatherapy, hydrotherapy, beauty parlor, manicure, pedicure.

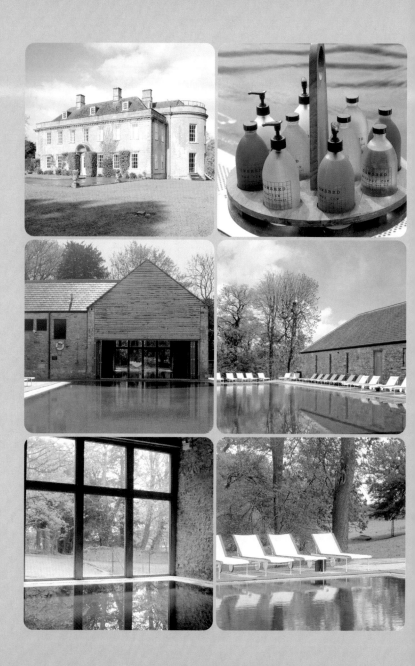

Babington House

Opening date: 1997
Address: Babington, near Frome, Somerset
England
Tel.: +44 13 73 81 22 66
Fax: +44 1373 81 2112
enquiries@babingtonhouse.co.uk
www.babingtonhouse.co.uk
Services: Cowshed, the spa belonging to Babington House, occupies an old stable building; it offers treatments geared to health, beauty and relaxation. It has two swimming pools, one indoors and one outside. Yoga and self-defense classes, massages (facial, body, for babies...), sauna, gym, aromatherapy...

Photographer: Montse Garriga
(Stylist: Geeta Aiyer)

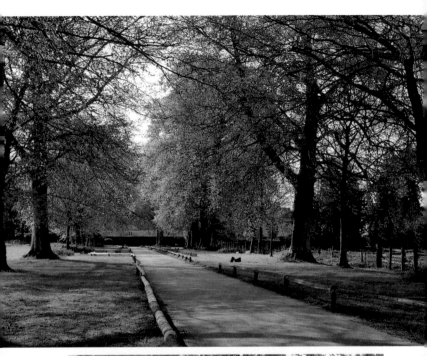

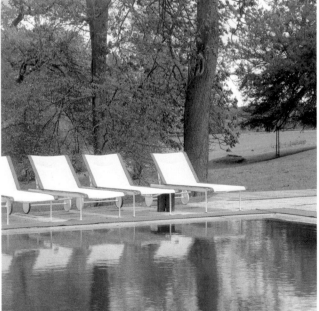

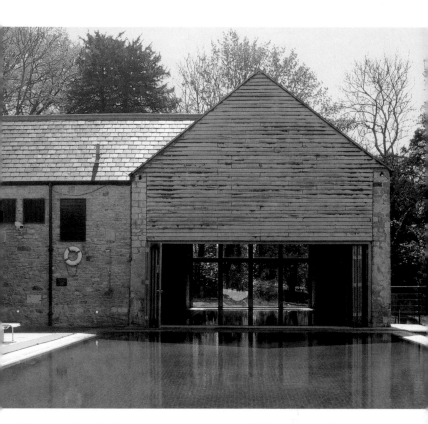

An 18th-century Georgian stone house, tucked into a beautiful landscape, provides the setting for this rural hotel-spa. It is the perfect antidote to stress. The key to its success is the mixture of a rustic yet elegant style with modern touches.

Inmitten einer atemberaubenden Landschaft liegt dieses Hotel mit Spa aus dem 18. Jahrhundert im georgianischen Stil, ganz aus Stein. Ein perfekter Ort, um sich vom Alltagsstress zu erholen. Ländliche Einfachheit und Eleganz mit zeitgenössischen Elementen machen den Reiz dieser Anlage aus.

L'emplacement de ces bains situés en campagne est marqué par une construction de pierre stylegéorgien du 18ème siècle, logé dans un paysage magnifique. C'est l'antidote parfait au stress. La clé de son succès est le mélange du « champêtre » et d'un style élégant aux notes modernes.

Enclavado en un privilegiado paraje natural, una construcción georgiana levantada en piedra en el siglo XVIII, acoge las instalaciones de este hotel-spa rural. Es el antídoto perfecto para recuperarse del estrés. La mezcla de un estilo campestre y elegante con toques contemporáneos es la clave de su éxito.

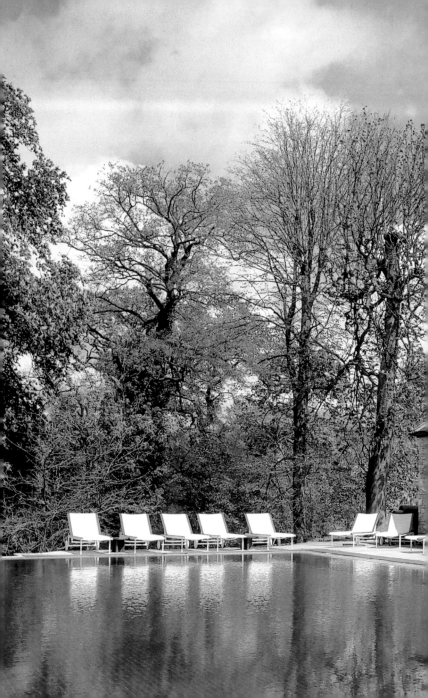

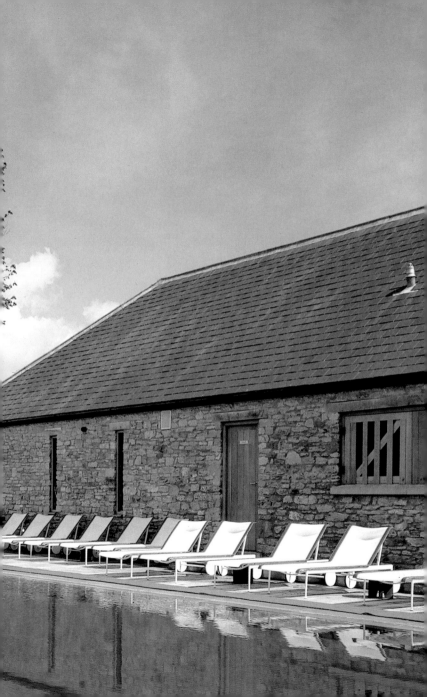

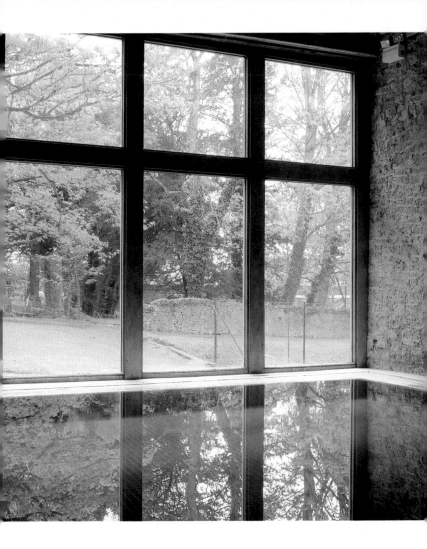

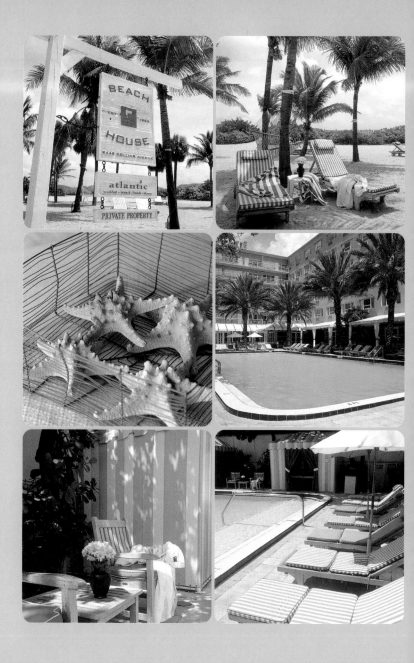

Beach House

Opening date: 1999
Address: 9449 Collins Avenue, Bal Harbour
Miami Beach, Florida, USA
Tel.: +1 305 535 8600
Fax: +1 305 535 8601
reservations@rubellhotels.com
www.rubellhotels.com
Services: Beauty, health and relaxation treatments and therapies, for
both the face and the body. Massages, swimming pool, private
beach, beauty parlor (manicure, pedicure, hairdresser's...) gym, golf,
tennis, fishing, volleyball...

Interior designer: Scott Sanders (of the Ralph Lauren Residential
Design Team)
Photographer: Pep Escoda

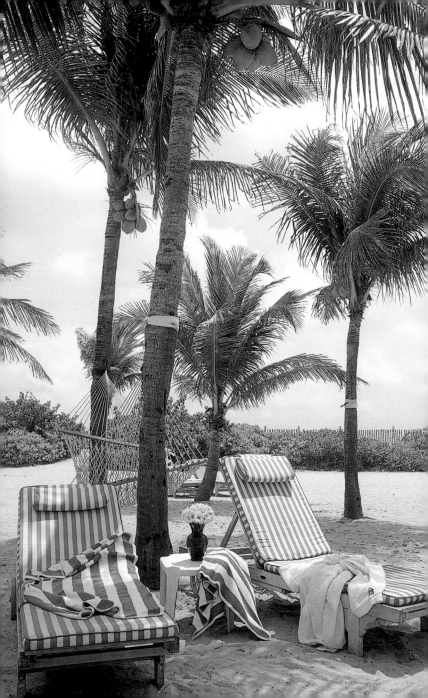

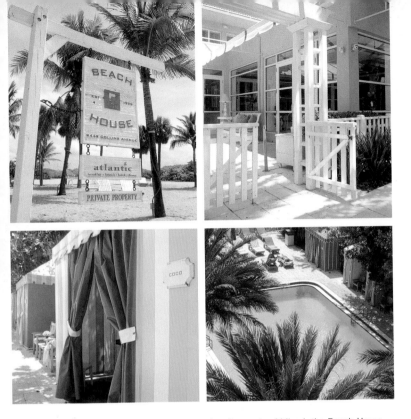

On the edge of the Atlantic, in one of the most bustling parts of Miami, the Beach House – the work of Ralph Lauren's design team – is a tribute paid by its owners, the Rubell family hotel chain, to the charming coastlands of the Hamptons, Nantucket and Maine.

Mit dem am Atlantik, in einer geschäftigen Gegend von Miami gelegenen Beach House, entworfen vom Designteam Ralph Laurens, zollt die Familie Rubell (Inhaber der Hotelkette), den wundervollen Küstenlandschaften von Hampton, Nantucket und Maine Ehrerbietung.

Au bord de l'Atlantique, dans l'une des zones les plus bruyantes de Miami, le « Beach House », (projet réalisé par l'equipe de designers de Ralph Lauren), est un tribut de la famille Rubell (chaine hotelière à laquelle il appartient) à la charmante région côtière du Hamptons, Nantucket et Maine.

Con el océano Atlántico a los pies y situado en una de las zonas más bulliciosas de Miami, Beach House –proyectado por el equipo de diseño de Ralph Lauren– es un tributo de la familia Rubell (cadena hotelera a la que pertenece) a las espléndidas tierras costeras de Hamptons, Nantucket y Maine.

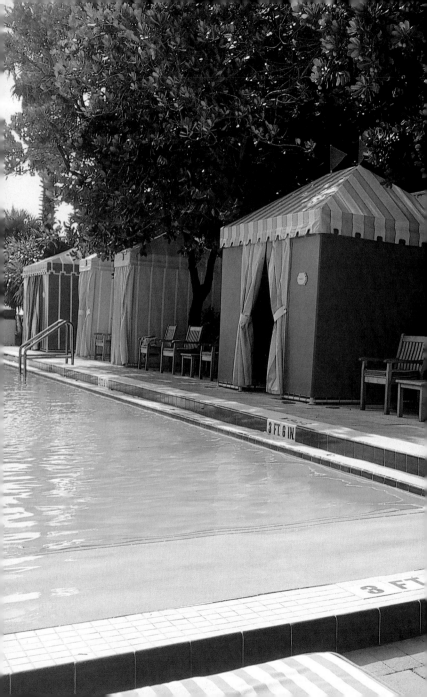

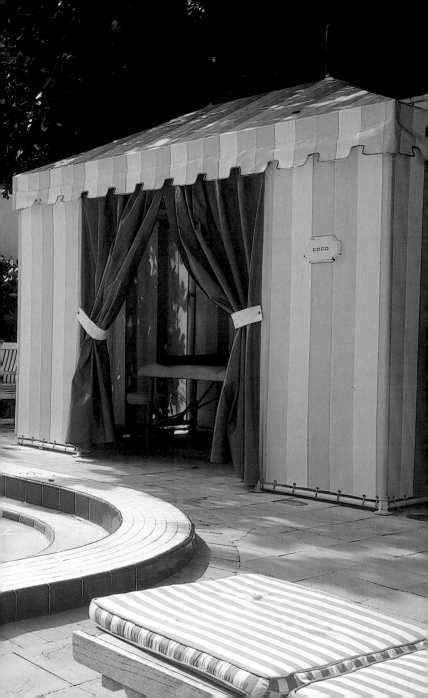

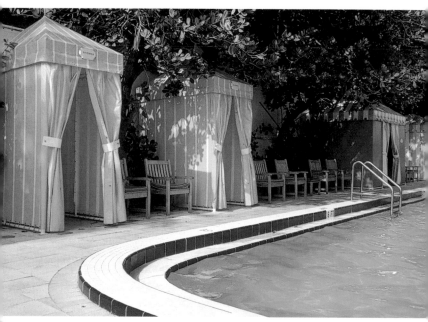

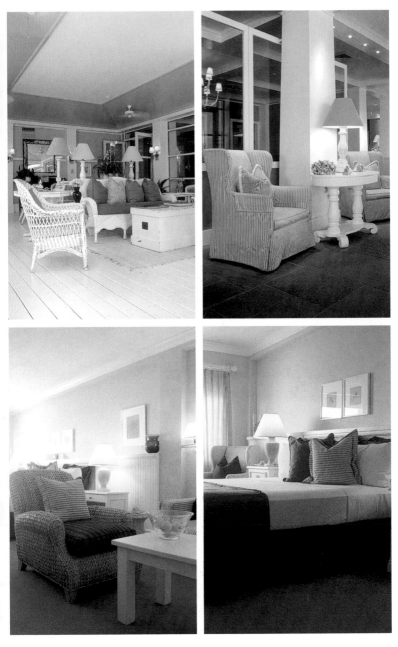

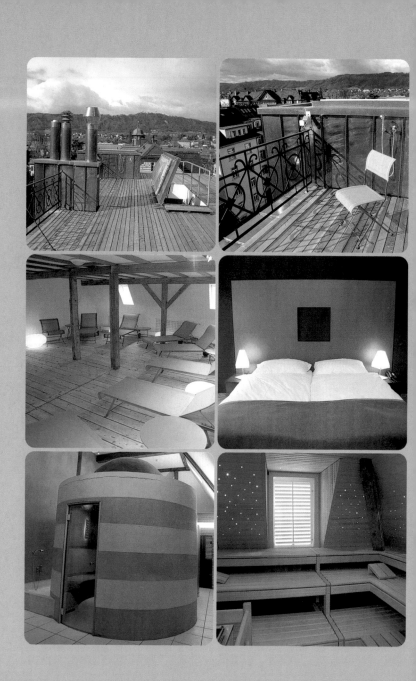

Lady's First

Opening date: 1999
Address: Mainaustraße 24, 8008 Zürich, Switzerland
Tel.: + 41 1 380 80 10
Fax: + 41 1 380 80 20
info@ladysfirst.ch
www.ladysfirst.ch
Services: face treatments and health and beauty therapies for the body,
natural sauna, Finnish sauna, energizing showers, steam bath, jacuzzi,
Kneipp baths, massages (classical, Hawaiian, Ayurvedic, reflexology,
craneosacral...) solarium, shiatsu, reiki.
The hotel has 28 rooms. The spa's treatments and services are also
available to women who are not hotel guests. The charges depend on
the type of service and the time taken.

Architect: Pia Schmid
Photographer: Miquel Tres

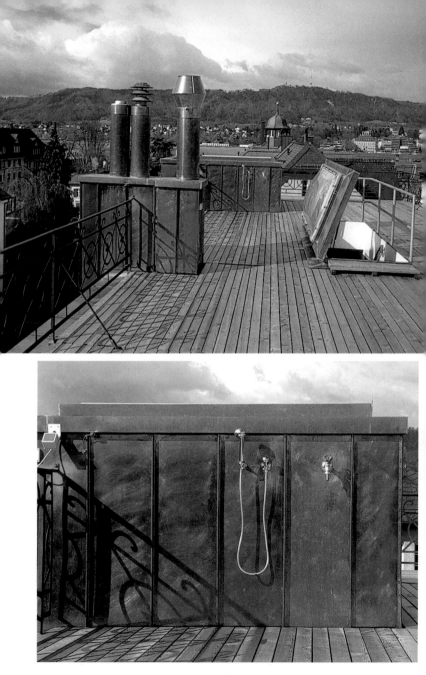

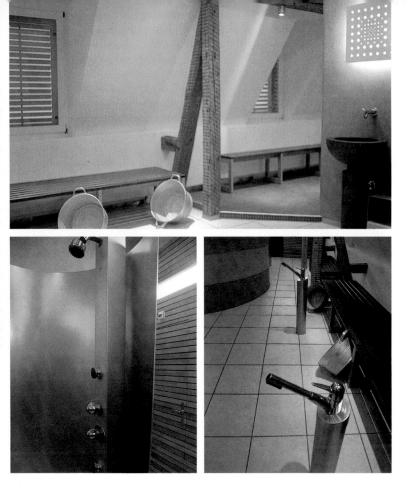

As its name suggests, this establishment is devoted exclusively to women. It is an oasis in the heart of Zurich; women are its raison d'être, and it provides a whole series of health and beauty treatments especially catering to their needs.

Diese Einrichtung, die, wie der Name schon sagt, ausschließlich Frauen vorbehalten ist, ist eine Oase im Herzen von Zürich. Die Frau ist Mittelpunkt und eine ganze Reihe von Dienstleistungen, Heil- und Schönheitsbehandlungen werden hier speziell für sie angeboten.

Comme son nom l'indique, cet établissement est uniquement réservé aux femmes. C'est une oasis au cœur de Zürich et les femmes en son la raison d'être. Toute une gamme de soins de beauté et de santé adaptés à chaque besoin leur est proposée.

Este establecimiento, destinado exclusivamente a mujeres tal y como su nombre indica, es un oasis en el corazón de Zurich. La mujer es el eje central al ofrecerle toda una serie de servicios y tratamientos de salud y belleza especialmente indicados para ella.

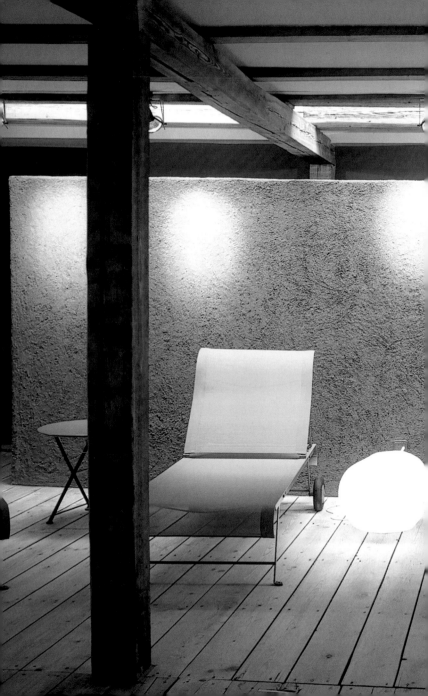

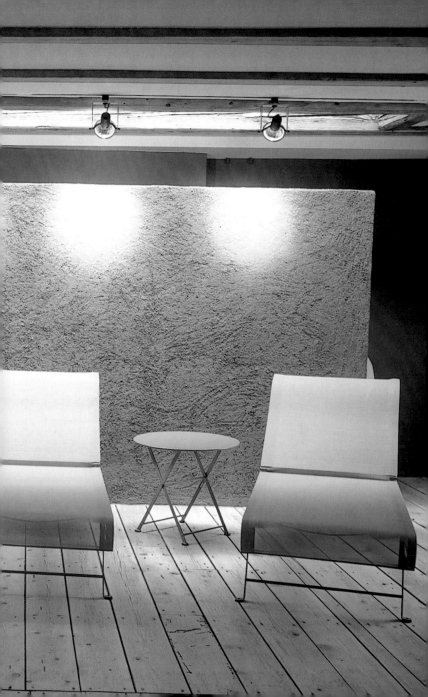

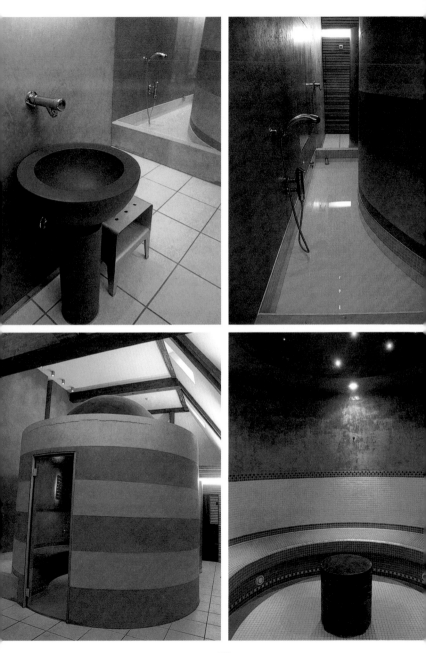

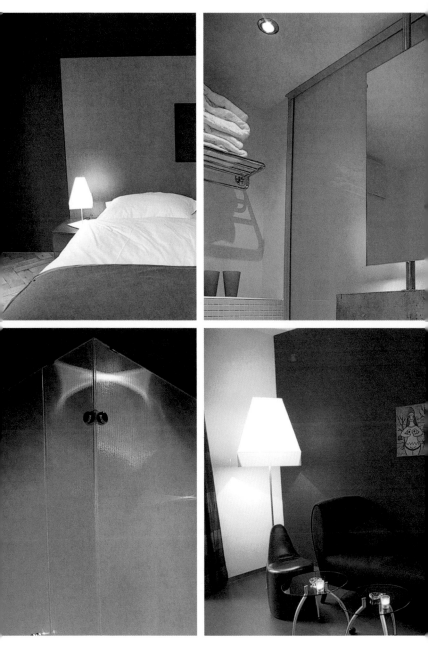

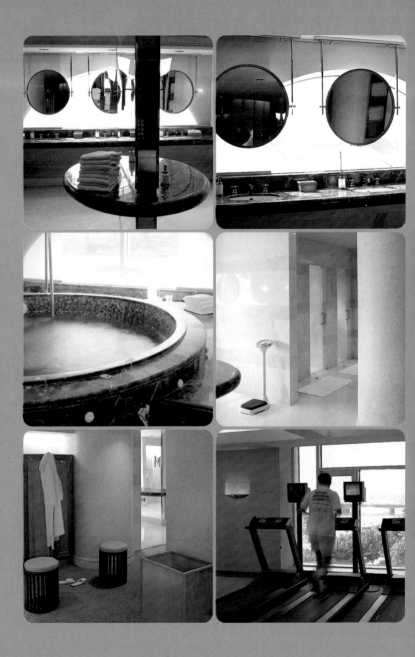

Four Seasons Cairo at the First Residence

Address: 35 Giza Street
Giza, Cairo, Egypt
Tel.: +20 2 573 12 12
Fax: +20 2 568 1616
www.fourseasons.com
Services: Face and body health and beauty treatments. Sauna, jacuzzi, milk baths (like the ones enjoyed by Cleopatra), a balanced selection of massages (relaxation, Swedish...), reflexology, digitopuncture. Therapies and treatments with natural products and ingredients from the Dead Sea in Jordan. Hydrotherapy, mud baths, exfoliation and skin care. Relaxation areas, gym, fitness, swimming pool and beauty parlor.

Photographer: Ricardo Labougle

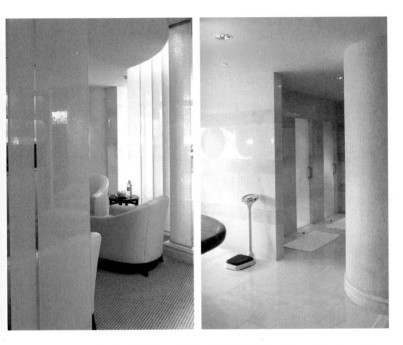

A haven of tranquillity beside the Nile, set in beautiful botanical gardens with a view of the Pyramids. An oasis of peace in which the senses are stirred and relaxation is the order of the day. The philosophy of well-being practiced by the ancient Egypts provides the inspiration and guiding principles.

Eine Insel der Ruhe am Nil, mit Blick auf die Pyramiden, den Fluss und die wundervollen botanischen Gärten der Umgebung. Eine Insel der Ruhe und des Friedens, in der die Sinne geweckt werden. Inspiriert von der Philosophie des Wohlbefindens der alten Ägypter.

Ce lieu de paix au bord du Nil est entouré d'un jardin botanique magnifique avec vue sur les pyramides. Dans cette oasis de tranquilité, les sens sont stimulés et la relaxation est garantie. On s'est inspiré de la philosophie du bien être pratiqué dans l'Egypte antique.

Una isla de tranquilidad junto al Nilo, con vistas a las Pirámides, al río y a los espléndidos jardines botánicos que lo rodean. Un oasis de calma en el que los sentidos se despiertan y el relax y el sosiego son la única ley imperante. La filosofía del bienestar practicada por los antiguos egipcios lo inspira y guía.

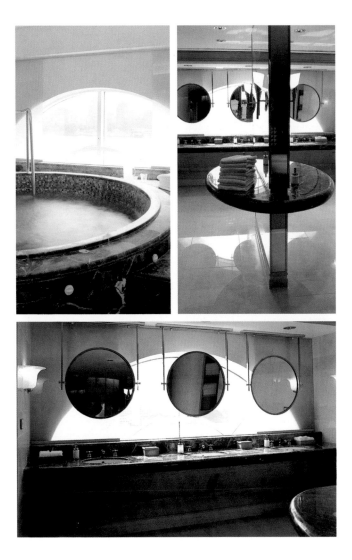

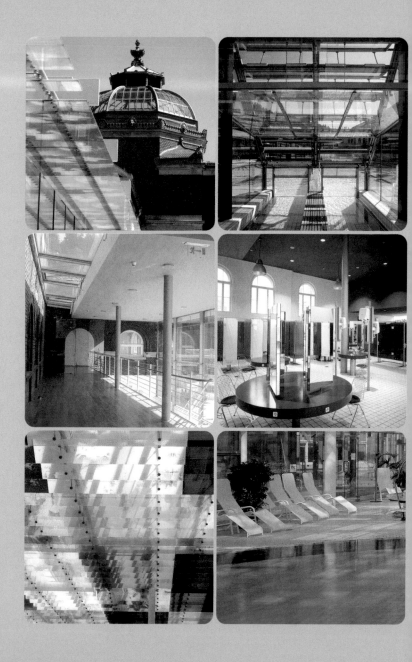

Bad Elster

Opening date: 1999
Address: Sächsische Staatsbäder GmbH
Badstraße 6, Bad Elster, Saxonia, Germany
Tel.: +49 37 43 77 11 11
Fax: +49 37 43 77 12 22
info@bad-elster.de
www.bad-elster.de
Services: Heat treatments with mud, bubble and foam baths, sauna, Kneipp hydrotherapy, massages, fitness. Therapy and beauty treatments (for both the body and face), swimming pool, relaxation area...

Architect: Behnisch & Partner
Photographer: Christian Kandzia

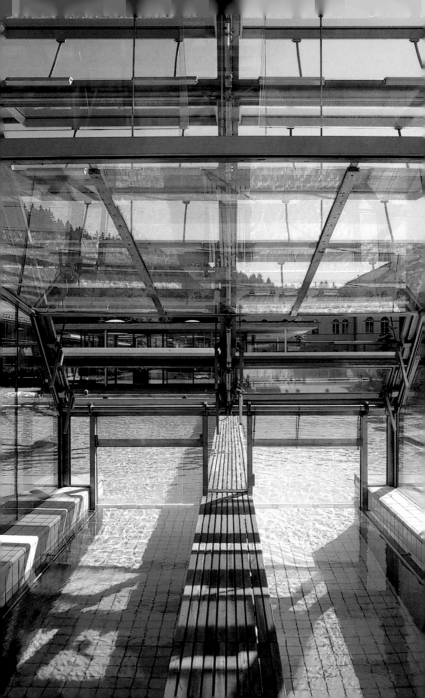

This spa, specializing in treatments with mud, is one of the oldest in Germany. The imposing historic buildings are characterized by a harmonious blend of architectural styles, resulting from their recent enlargement and refurbishment.

Eines der ältesten Heilbäder Deutschlands, das auf Schlamm- und Fangotherapie spezialisiert ist. Die historischen, herrschaftlichen Bauten verschiedener Stile sind zur Unterbringung neuer Einrichtungen harmonisch kombiniert, umgebaut und erweitert worden.

Ces bains spécialisés dans le traitement à base de boue sont parmi les plus anciens d'Allemagne. Les bâtiments historiques et imposants sont charactérisés par le mélange hamonieux d'architectures dû à la restauration et aux agrandissements faits récemment.

Es uno de los balnearios más antiguos de Alemania especializados en tratamientos con lodos y fango. Una armónica convivencia de estilos arquitectónicos recorre las históricas y señoriales construcciones en las que se ubica; remodeladas y ampliadas para adaptar las instalaciones a nuevos usos.

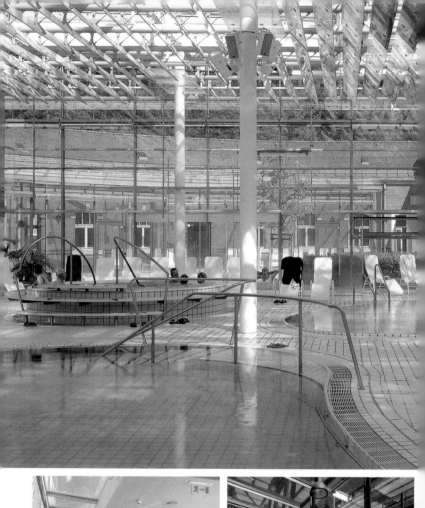

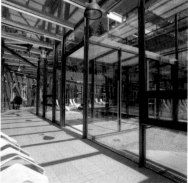

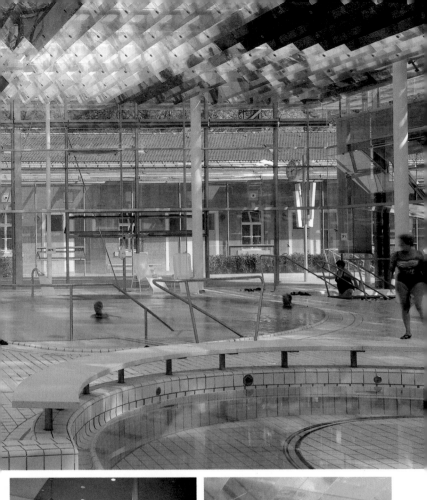

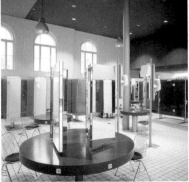

Byblos Andaluz

Opening date: 1986
Address: Urbanización Mijas Golf, Mijas Costa
Málaga, Spain
Tel.: +34 95 247 30 50
Fax: +34 95 247 67 83
www.byblos-andaluz.com
comercial@byblos-andaluz.com
Services: This spa offers slimming and fitness treatments, therapies
to combat osteoarthritis, rheumatism, stress... programs to help re-
vitalize and relax the muscles, nervous system and treat problems
with circulation and the joints and back.
Massages (facial, for the legs, relaxing, anti-cellulitis, lymphatic
drainage...) hydromassage under hot water, bubble bath with algae
and volatile oils, alternating ultrasonic frequencies in the water, gym
in the swimming pool, infra-red thermotherapy adduction with algae.
Underwater and pressure showers, steam bath, bubble bath, ma-
rine ultrasund or cavitation, presotherapy, aromatherapy, passive
gymnastics, sauna, face and body treatments with La Prairie prod-
ucts, pedicure, manicure, hairdresser's.
Its waters (sea water at 98.6 °F/37 °C) are characterized by the high
levels of iodine, sulfur, calcium and magnesium. They are ideal at
high temperatures for revitalizing the body and restoring energy.

Photographer: Pere Planells

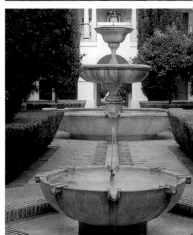
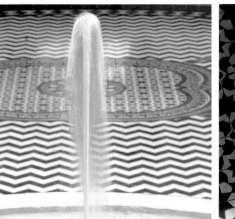
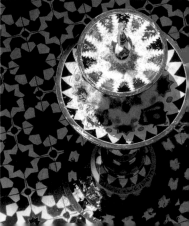

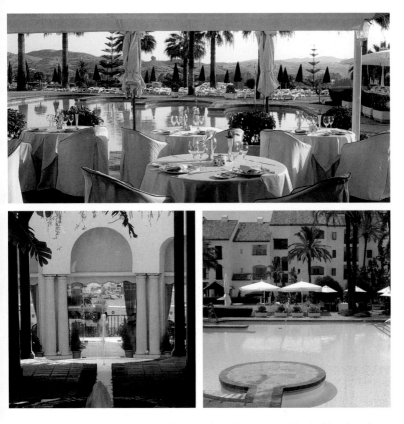

This oasis of sun and peace – a veritable haven for epicures created by the French cyclist Louis Bobet – is one of the most sophisticated thalassotherapy centers in Europe, offering the benefits of hot sea water, algae and sun in luxurious surroundings.

Eine Oase der Sonne und Stille, ein Heiligtum für Genießer, geschaffen von dem französischen Radrennfahrer Louis Bobet. Eines der fortschrittlichsten Thalassotherapie-Zentren in Europa. Entdecken Sie die wundervolle Kombination aus Meerwasser, Algen und Sonne.

Une oasis de soleil et de paix – un paradis créé par le cycliste francais Louis Bobet – est l'un des centres de thalassotherapie les plus sophistiqués d'Europe. On peut y bénéficier, de bain de mer thermiques, et de traitements aux algues marines, dans un cadre luxurieux.

Este oasis de sol y calma -todo un santuario para sibaritas creado por el ciclista francés Louis Bobet- es uno de los centros de talasoterapia más avanzados de Europa. Descubrir los beneficios que se asocian al agua de mar caliente, las algas y el sol es todo un lujo en sus instalaciones.

Grotta Giusti Spa and Hotel

Address: Via Grotta Giusti, 1411
Monsumano Terme,Tuscany, Italy
Tel.: +39 0572 90771
Fax: +39 0572 9077300
www.grottagiustispa.com
info@grottagiustispa.com
Services: Medical care, thermal steam bath with underwater massage, treatments with mud, massages and jet hydromassages under a shower, dermatological and face and body beauty treatments with exclusive thermal cosmetics especially adjusted to different skin types. Massages, aquatic gym, steam baths in the grotto at a temperature of 34 ºC (93 ºF), alternative therapies inspired by Oriental disciplines, anti-stress treatments, aromatherapy, slimming and anti-cellulitis programs... Golf club, private gardens, tennis courts.

Photographer: Roger Casas

The idyllic scenery of Tuscany is the ideal setting for this complex, whose main attraction is a thermal grotto discovered in 1849. This is a natural treasure stretching for 1,000 feet; its water has created a perfect microclimate for healthy relaxation.

Die idyllische Toscanalandschaft ist ideal für diesen Komplex, dessen größte Attraktion eine Thermalgrotte ist, die im Jahr 1849 entdeckt wurde. Ein wahres Naturschauspiel, wo das Wasser die perfekte Umgebung für Gesundheit und Entspannung geschaffen hat.

Le paysage idyllique de la Toscane offre un cadre idéal à ce complexe, dont la principale attraction est une grotte thermale découverte en 1849. Ce trésor de la nature s'étand sur plus de 300 mètres. Son eau crée un microclimat très favorable à la santé et à la relaxation.

El paisaje idílico de la Toscana se convierte en el escenario ideal que acoge este complejo cuyo mayor atractivo es una gruta termal descubierta en 1849. Se trata de toda una joya natural: 300 metros repletos de vida en los que el agua ha creado el ambiente perfecto para disfrutar de manera saludable y relajada.

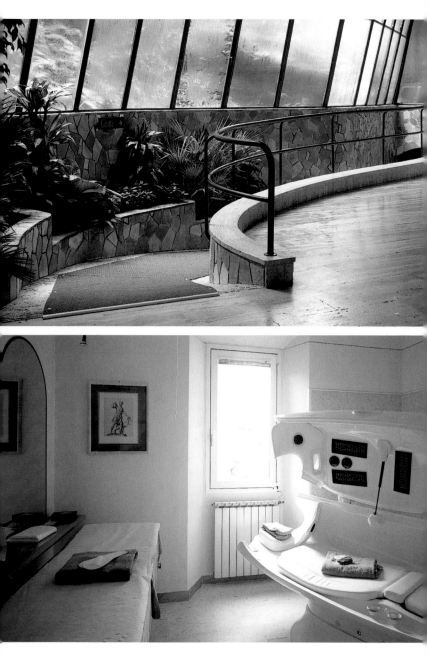

Termes de Montbrió

Early 20th-century Modernist (Catalan Art Nouveau) building
Address: Nou, 38. Montbrió del Camp
Tarragona, Spain
Tel.: +34 977 81 40 00
Fax: +34 977 82 62 51
hoteltermes@gruprocblanc.com
www.gruprocblanc.com/hoteltermesmontbrio/
Services: This spa offers programs for total relaxation and slimming, therapeutic treatments for obesity, stress, rheumatic processes, osteoarthritis, respiratory and circulatory problems and smoking. Beauty treatment for the face and body (cosmetic medical services such as: liposuction, removal of wrinkles, permanent make-up, as well as preventive medicine and plastic surgery), massages (manual and underwater), reflexology, mud therapy, hydromassage, electrotherapy, Scottish hose, inhalations , aerosols, oxygen therapy, foot baths, hand baths, sauna, Turkish bath, giant jacuzzi, mud jacuzzi, underfloor bubbles, aquadrome, hot/cold baths...
The hypertermal waters in this spa, which pour out at 105.8 or 177.8 ºF (41 or 81 ºC), depending on the spring, are classified as being rich in sodium chloride, ions, bicarbonate, sulfate, chloride, sodium, potassium and magnesium. The hotel lies next to the thermal center, alongside two swimming pools, and it boasts 214 thoroughly equipped room and thematic suites, in which visitors can enjoy thermal water and a hydromassage bath in a Tuscan, Arab, Japanese, colonial or British setting. It is open all year round.

Photographer: Pere Planells

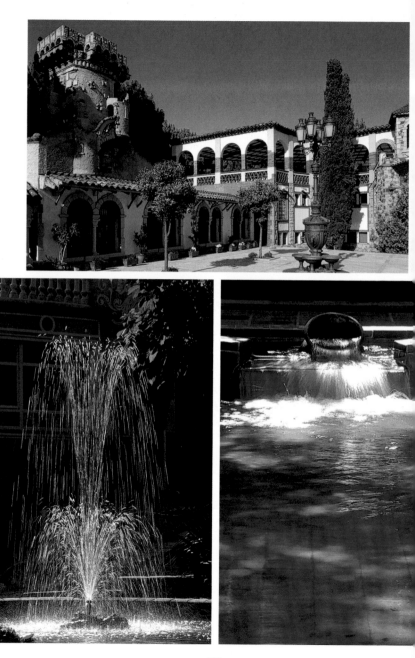

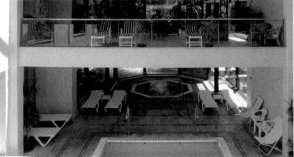

The various buildings in this complex – one of the pioneers of the resort-spa formula in Spain – offer a harmonious blend of the distinctive early 20th-century Modernist style and more recent architectural ideas.

Diese Einrichtung war eine der ersten mit der Formel Resort & Spa in Spanien. Die verschiedenen Gebäude kombinieren harmonisch die einzigartige Architektur des Modernismus zu Beginn des letzten Jahrhunderts mit moderneren, architektonischen Konzepten.

Les différents bâtiments de ce complexe – l'un des premiers de ce genre en Espagne – offrent un mélange harmonieux d'un style du début du 20ème siècle parfaitement combiné avec des idées architecturales plus récentes.

El complejo, uno de los pioneros en establecer la fórmula resort & spa en España, está formado por diversos edificios en los que se combina armónicamente la singularidad de la arquitectura modernista de principios de siglo con concepciones arquitectónicas más modernas.

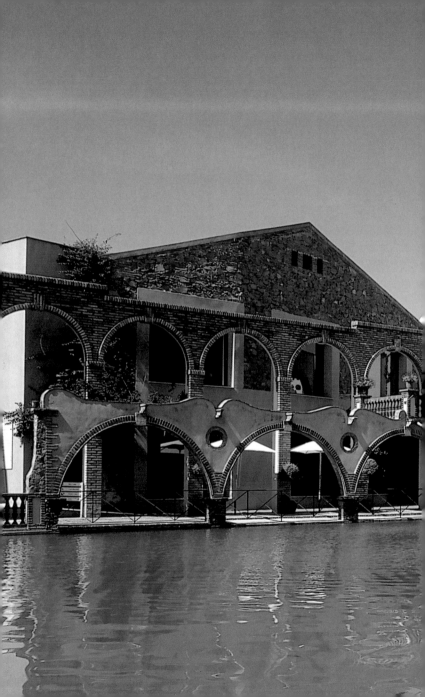

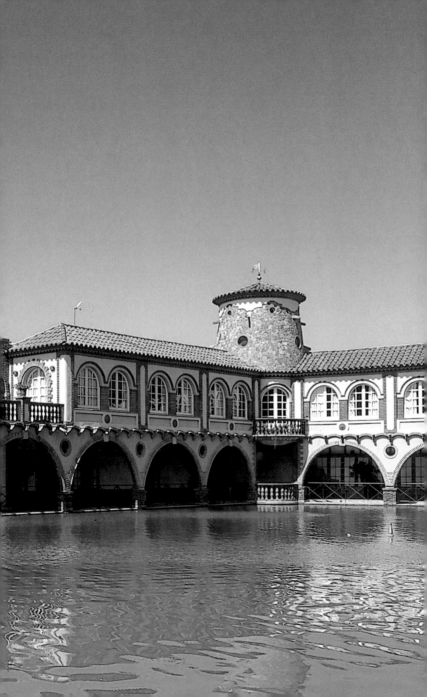

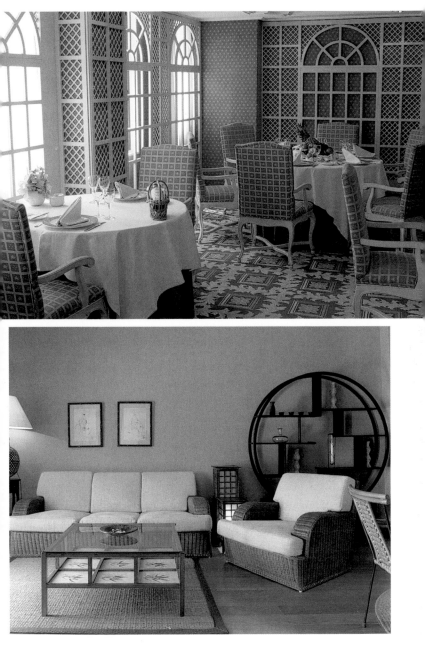

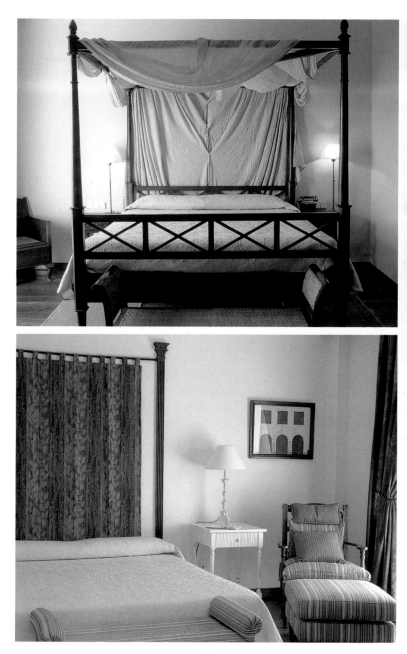

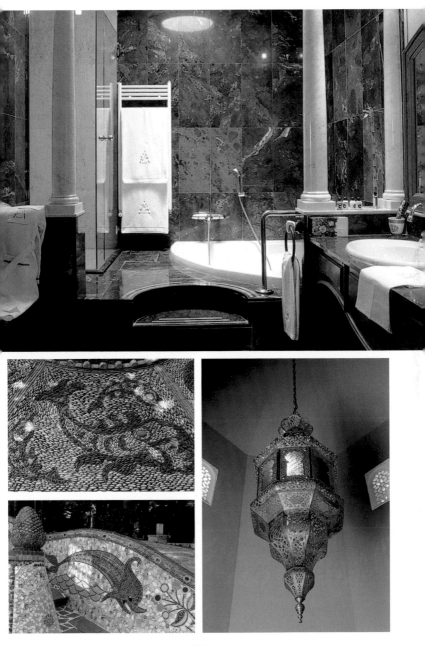

The Peak Health Club

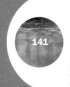

Address: Cadogan Place
London, England
Tel.: +44 20 7235 1234
Fax: +44 20 7235 9129
contact@carltontower.com
www.carltontower.com
Services: Yoga, tai-chi, fitness center, gym, aerobics hall, saunas,
Turkish baths, massages (Swedish, therapeutic, sports...), treatments
with water, mud, mineral salts, oils and natural essences. Lymphatic
drainage in the face, arms, hand, legs and feet, treatments that are
personalized according to the type of skin, reaffirmative treatments
that reduce cellulitis to the minimum, eliminate toxins and redefine
the body shape. All the face and body services make use of Sisley
products and treatments.
The center also organizes horse rides in Hyde Park, while the grounds
also boast tennis courts and private gardens.

Photographer: Montse Garriga
(Stylist: Geeta Aiyer)

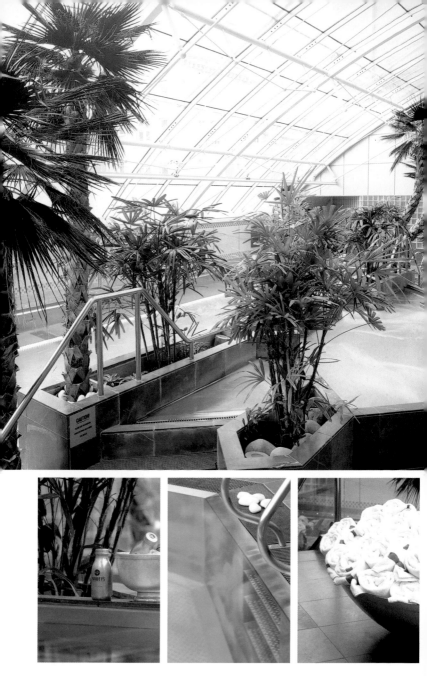

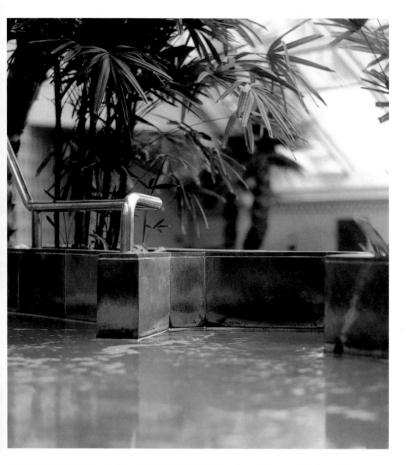

The Peak Health Club, on the ninth floor of the Carlton Tower Hotel, in the heart of Knightsbridge, is an ideal spot for those seeking a respite from day-to-day hassles and a return to peacefulness, well-being and beauty.

Der im Herzen von Knightsbridge, im neunten Stock des Carlton Tower Hotels, gelegene Peak Health Club ist der ideale Ort, um sich vom Alltagsstress zu erholen, zur Ruhe zu kommen, die Schönheit zu pflegen und sich wohl zu fühlen.

Le Peak Health Club, au 9ème étage de la tour de l'Hotel Carlton, au centre de Knightsbridge, est un endroit idéal pour ceux qui cherchent à échapper au stress quotidien et qui aiment à retrouver la paix, le bien-être et la beauté.

Ubicado en el corazón de Knightsbridge, The Peak Health Club –situado en la novena planta del Carlton Tower Hotel– es la dirección perfecta para los que deseen reponerse del ajetreo diario y recuperar la calma, el bienestar y la belleza.

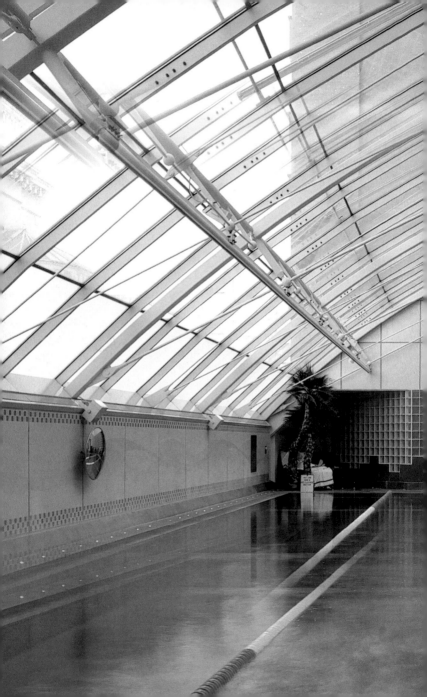

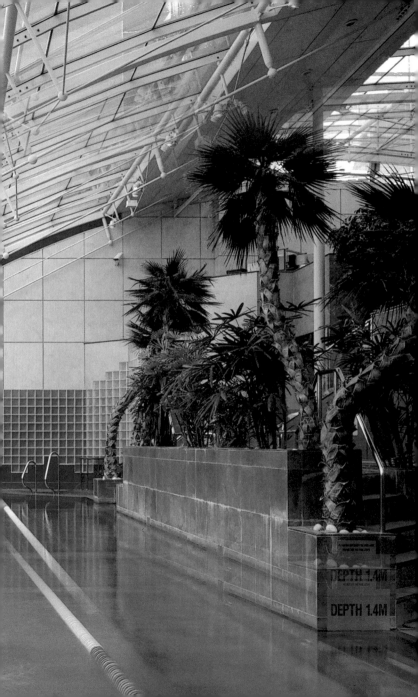

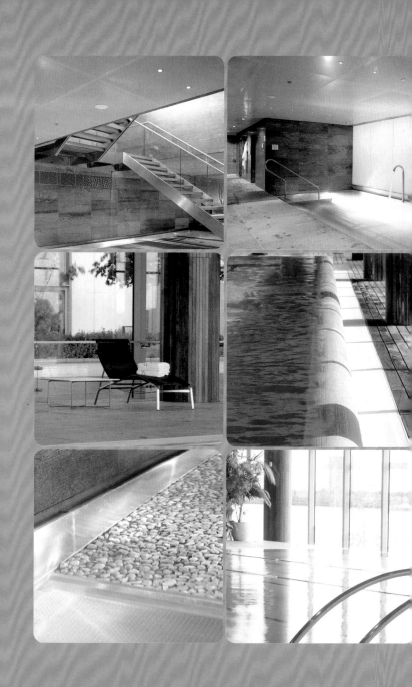

Holmes Place

Address: Westferry Circus, Canary Wharf
London, England
Tel.: +44 20 7513 2999
Fax: +44 20 7513 2992
info@holmesplace.com
www.holmesplace.com
Services: Yoga, tai chi, aerobics, aquatic aerobics, fitness, gym, personal training, static bicycles, dance classes (classical, jazz...), solarium, hypnotherapy, psychotherapy and other relaxation techniques. The spa area offers hydrotherapy, swimming pools, saunas, steam baths, pressure showers, massages, tennis courts. A wide range of health and beauty therapies and treatments, hairdresser's.

Photographer: Montse Garriga
(Stylist: Geeta Aiyer)

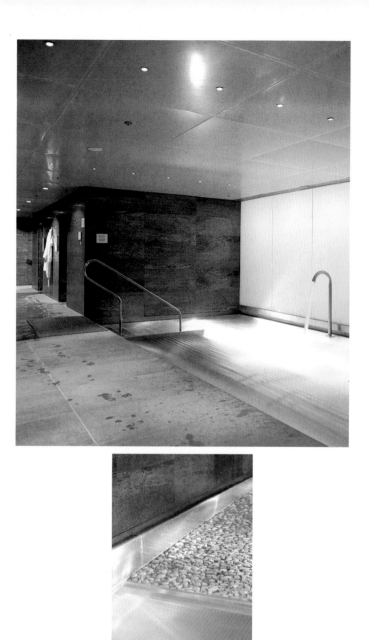

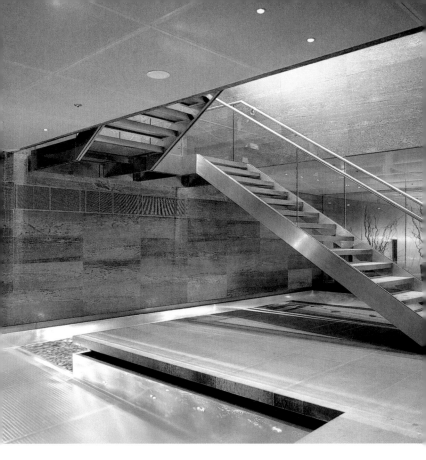

The large windows tracing the contours of the swimming pool in the new Holmes Place Health Club look out onto the river Thames and provide stunning views. The club has called on the latest technology to help visitors escape from the stress of the city.

Die großen Fenster um den Swimmingpool des neuen Holmes Place Health Club öffnen sich auf den Thames und dessen Uferlandschaft. Dieses Zentrum ist eine avantgardistische Oase der Entspannung, in der man sich von dem Großstadtstress zurückziehen kann.

Les grandes baies vitrées entourant la piscine du nouveau Holmes Place Health Club, donnent sur la Tamise, offrant une vue étonnante sur les alentours. Le club a été concu selon les technologies de pointe, permettant aux visiteurs d'echaper au stress de la ville.

Los grandes ventanales transparentes que dibujan el contorno de la piscina del nuevo Holmes Place Health Club se abren al río Támesis invitando a contemplar el paisaje que lo envuelve. El centro se ha concebido como un espacio relajante y vanguardista en el que escapar del estrés de la ciudad.

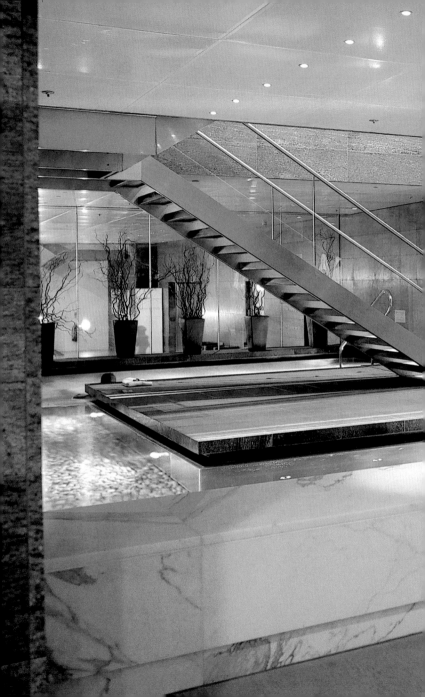

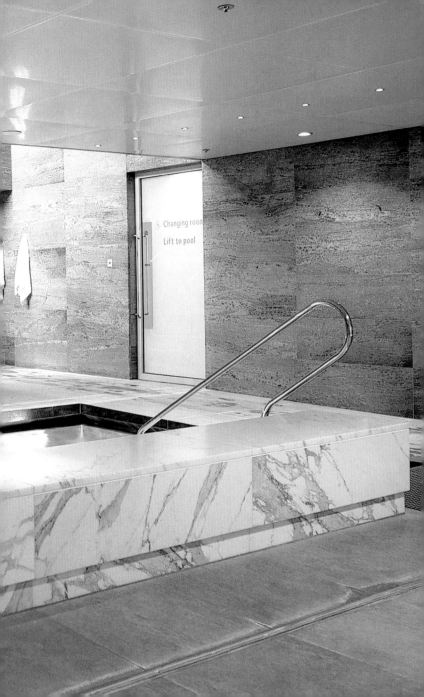

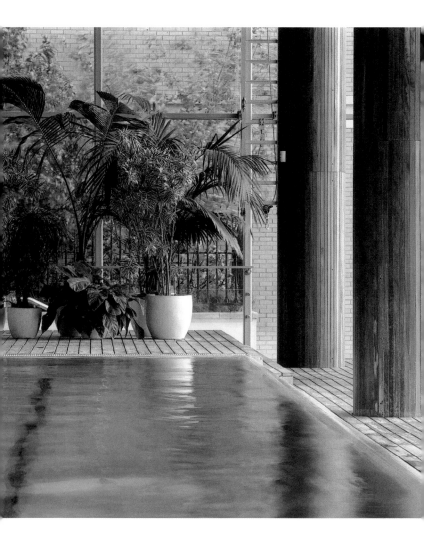

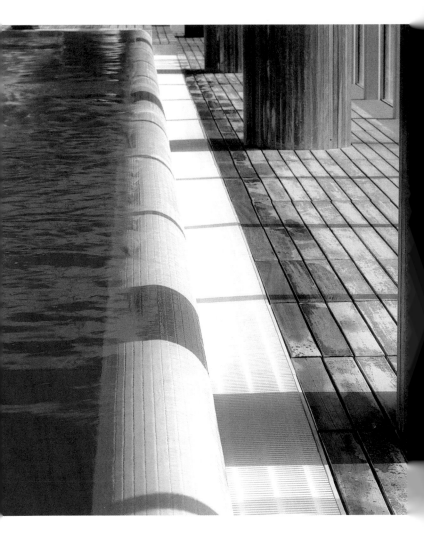

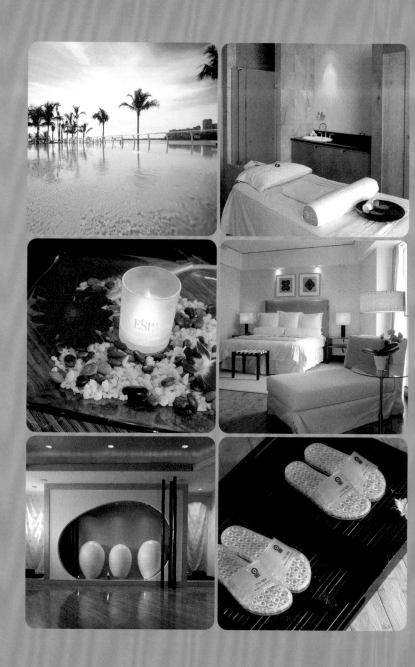

Mandarin Oriental

Address: 500 Brickell Key Drive
Miami, Florida, USA
Tel.: +1 305 913 8288
Fax: +1 305 913 8300
www.mandarinoriental.com
momia-reserve@mohg.com
Services: Alternative therapies based on ancient Oriental techniques
(from China, Bali, India, etc.) combined with more Western-based
concepts. Relaxation, yoga, shiatsu, classes in the Pilates tech-
nique. Massages (Balinese, Thai, traditional...), Ayurveda, aromather-
apy, hydrotherapy, pre- and post-natal treatments. Health and beauty
treatments for the face and body with products from the ESPA range
(lotions, oils, creams, balsams, mud, essences, also on sale in the
center's store), anti-stress programs, anti-cellulitis treatment, hot
stones, fitness center, steam baths, special programs adapted to
the needs of each customer (ESPA ritual, total relaxation, Balinese
influence, for brides), sauna, manicure, pedicure, make-up, hair-
dresser's, swimming pool, golf, tennis courts.

Photographer: Pep Escoda

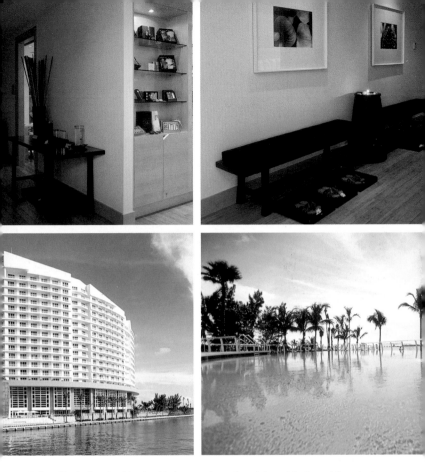

The vitality of Latin America blends with the serenity and exoticism of Eastern philosophy in this complex devoted to health and beauty, overlooking the sea in the heart of Miami. A luxurious sanctuary given over to physical and spiritual well-being.

Die Frische und Lebenskraft Lateinamerikas und östliches Gleichmut, Exotik und Philosophie, so könnte man dieses Gesundheits- und Schönheitszentrum am Meer mitten in Miami definieren. Ein luxuriöses Heiligtum des körperlichen und seelischen Wohlbefindens.

Un sanctuaire luxurieux voué à la santé, à la beauté et au bien-être physique et spirituel. La vitalité de l'Amérique Latine y est en symbiose avec l'exotisme de la philosophie orientale. Ce complexe donne sur la mer et se trouve au cœur de Miami.

La frescura y vitalidad de América Latina unida a la serenidad, exotismo y la filosofía oriental. Así podría definirse este complejo dedicado a la salud y la belleza situado frente al mar y en pleno corazón de Miami. Un lujoso santuario dedicado al bienestar físico y espiritual.

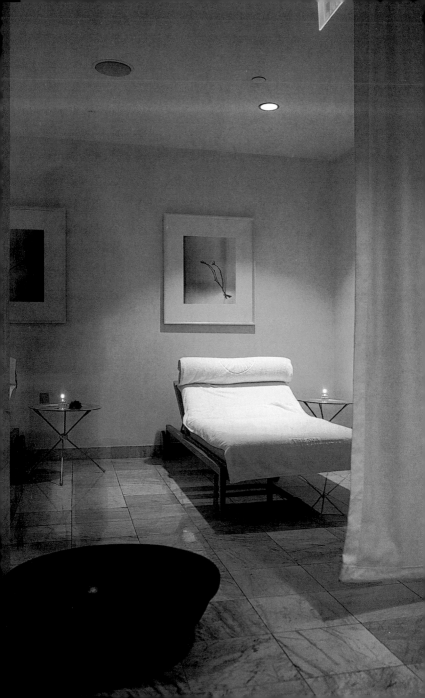

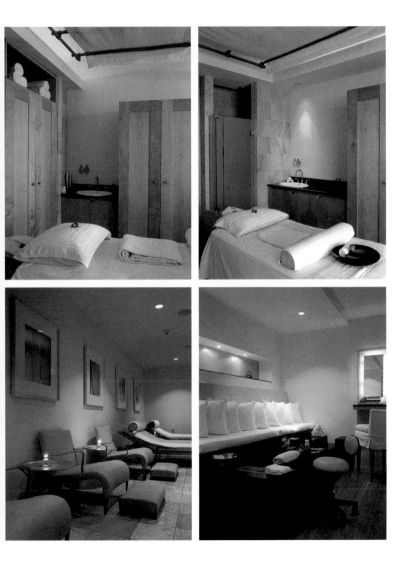

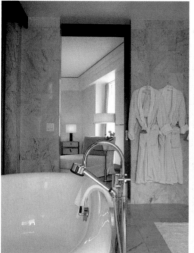

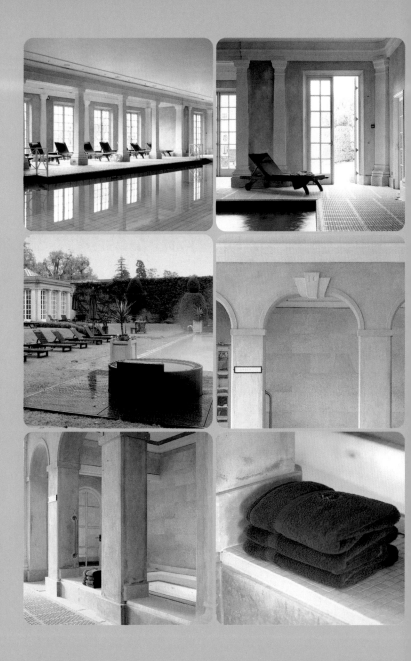

Cliveden House Hotel

Address: Cliveden Road, Taplow
Berkshire, England
Tel.: +44 1 628 668 561
Fax: +44 1 628 661 837
www.clivedenhouse.co.uk
reservations@clivedentownhouse.co.uk
Services: A wide range of health, beauty and relaxation treatments
and therapies. Steam baths, jacuzzis, saunas, massages, swimming
pools (two outdoors and one indoors), tennis courts, fitness center,
gym, squash courts, horse riding, hairdresser's, store with beauty
products...

Photographer: Montse Garriga
(Stylist: Geeta Aiyer)

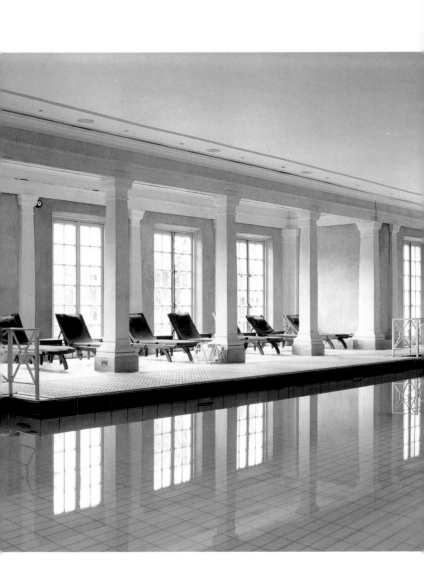

The installations of this renowned and exclusive English spa adjoin the main building of the Cliveden Hotel – an impressive mansion dating back centuries, set in an idyllic rural landscape.

Angrenzend an das Cliveden Hotel, eine beeindruckende alte Villa in einer idyllischen, ländlichen Umgebung, befindet sich dieses bekannte und exklusive englische Heilbad.

Les installations de ces bains anglais prestigieux et exclusifs sont adjacentes au bâtiment principal de l'hôtel Cliveden – une maison impressionnante dattant de plusieurs siècles, située dans un cadre idyllique et champêtre.

Adyacente al edificio principal del Cliveden Hotel –una imponente masión con siglos de historia enclavada en un idílico paisaje campestre– se encuentran ubicadas las instalaciones de este prestigioso y selecto balneario inglés.

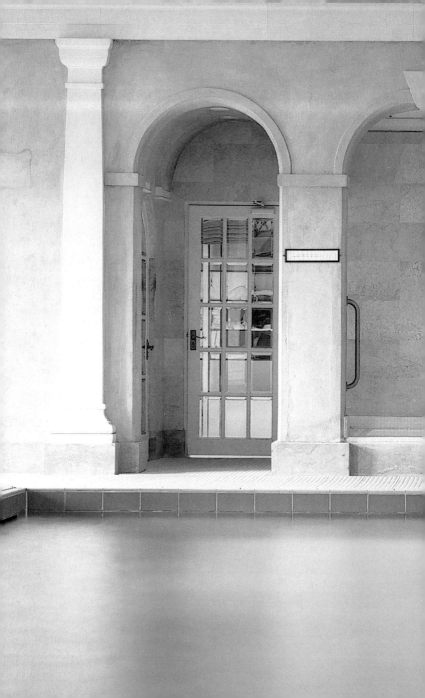

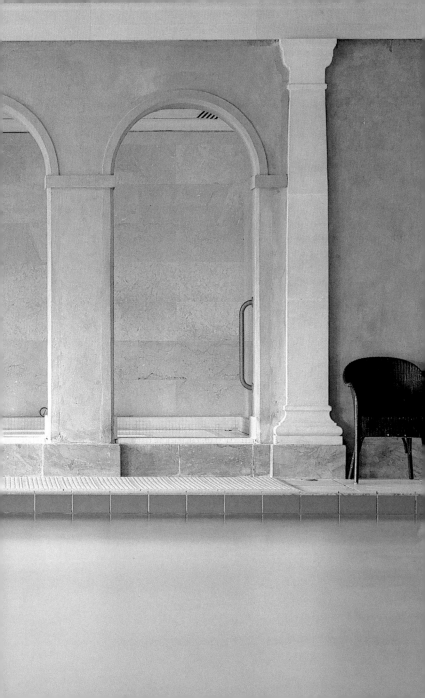

Terme di Saturnia

Opening date: 2001 (the new installations)
Address: Saturnia, Tuscany, Italy
Tel.: + 39 564 601061
Fax: +39 5 64 60 1266
www.termedisaturnia.it
info@termedisaturnia.it
Services: The therapeutic properties of the water in these thermal
baths are indicated for skin problems (acne, eczema, psoriasis, skin
allergies, mycosis...), respiratory diseases (chronic pharyngitis, hay
fever, asthma, bronchitis, emphysema...), motor system complaints
(arthritis, rheumatism), migraines, gynecological, digestive, vascular
and metabolic disorders, overweight, diabetes...
All kinds of thermal treatments and hydrotherapy: steam baths, mud
treatments, hydromassages, aerosols, inhalations... Medical, derma-
tological, dietary and anthropomedical check-up... kinesiology, pre-
sotherapy, ultrasounds, nebulization...
Face and body beauty treatments, collagen implants, lymphatic
drainage, various types of massages, shiatsu, relaxation therapies to
combat fatigue, stress, relieve tension, stimulate circulation, reflex-
ology, anti-cellulitis treatments, aromatherapy.
Aquatic gymnastics, aerobics, fitness, yoga...
4 open-air heated swimming pools (3 for adults and one for children)

Photographer: Roger Casas

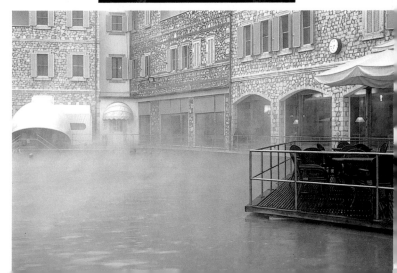

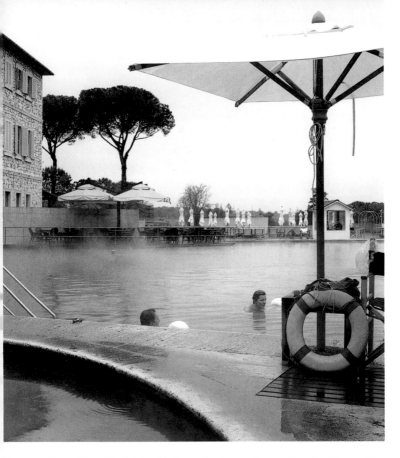

The properties and benefits of Saturnia's thermal waters are famous throughout the world. Eight hundred liters pour out every second at a constant temperature of 37 °C (99 °F), allowing bathers to rediscover the pleasure of feeling healthy, relaxed and happy.

Die wohltuenden Eigenschaften des Thermalwassers der Termas de Saturnia sind weltbekannt. 800 Liter pro Sekunde strömen mit einer konstanten Temperatur von 37 °C aus. Jeder, der „dieses Wasser genießt", fühlt sich gesund, entspannt und glücklich.

Les propriétés bénéfiques des eaux thermales du Saturnia sont réputés dans le monde entier. Huit cents litres à la seconde sont déversés à une température constante de 37 °C (99 °F) permettant aux baigneurs de redécouvrir le plair de se sentir sain, relaxé et heureux.

Las propiedades y beneficios de las aguas termales de las Termas de Saturnia son conocidas en todo el mundo. 800 litros por segundo emanan a una temperatura constante de 37 °C permitiendo descubrir el placer de sentirse sano, relajado y feliz a todo aquel que acude a tomar sus aguas.

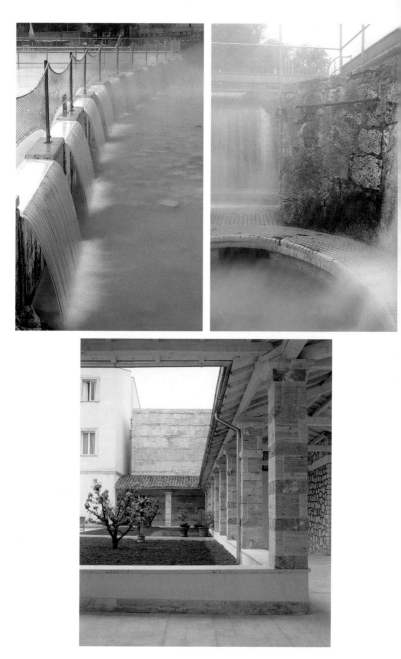

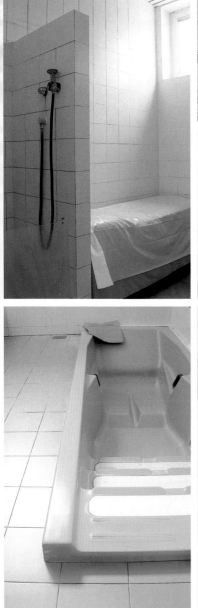

179

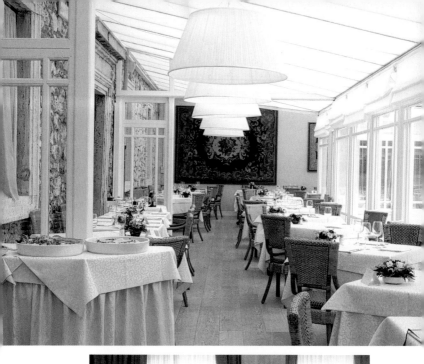

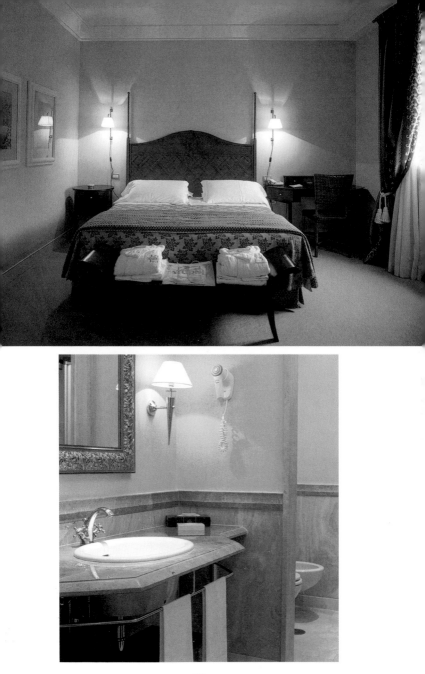

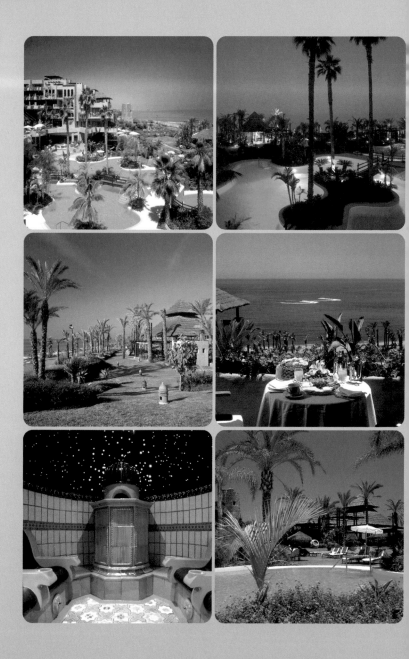

Polly Mar Beauty Spa in Kempinski Resort Hotel

Address: Ctra. de Cádiz, Km. 159, Playa El Padrón
Estepona, Malaga, Spain
Tel.: + 34 952 80 83 99
Fax: +34 952 79 20 89
www.polly-vital.com
www.kempinski-spain.com
pollymar@ari.es
agp.reservations@kempinski.com
Services: More than 10,700 square feet devoted to health, beauty and relaxation. In-house natural products. Thermal and aromatic baths, thalassotherapy, indoor swimming pool. Anti-stress and face and body beauty treatments. Relaxation packs, active wraps, lotus dream (to open up the body's points of energy), body relaxation, Asian massage, shiatsu, rasul, manual jet-stream hydromassage, steam bath, body sprinkling, aromatic massage, underwater massage, complete body massage, therapeutic massage, lymphatic drainage, sauna, slimming treatments. Classic face treatment, facial vitalization, facial regeneration, facial cleansing, facial relaxation, facial refreshing, curing of blisters, facial massage, facial peeling, tensile treatment of the chin, neck, cheeks and upper lip, energetic facial stretching, wraps and massages for the hands, pedicure, manicure, hairdresser's, make-up, depilation, gym, golf, tennis, horse riding school and adventure sports.

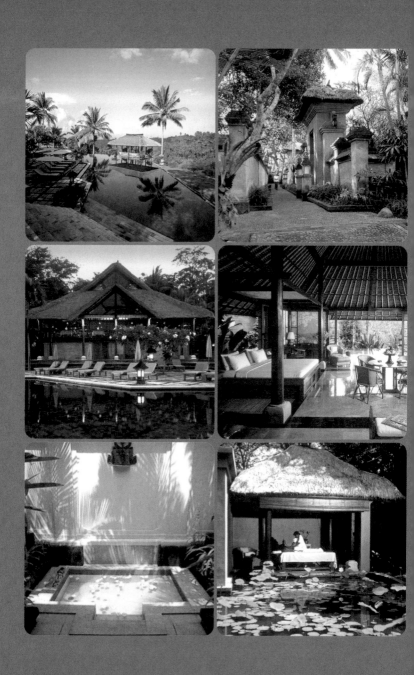

Amandari Resort

Address: Kedewatan, Ubud
Bali, Indonesia
Tel.: +62 361 975 333
Fax: +62 361 975 335
amandari@amanresorts.com
www.amanresorts.com
Services: Health and beauty center with a large number of treatments and programs. Various types of massages, swimming pools (some of them private), steam baths, saunas, fitness center, golf, tennis, store.

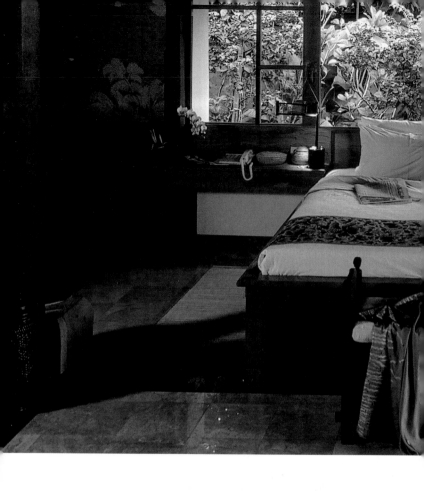

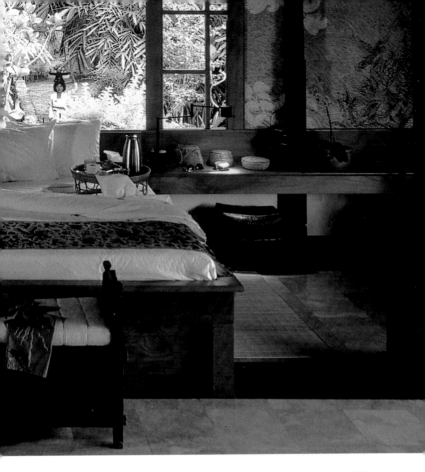

The locals believe that the path leading to Amandari is holy ground: an open-air corridor touched by divinity. The complex – with a design based on traditional Balinese hillside villages – is a sublime refuge where peace and silence reign.

Die Anwohner glauben, dass der Weg nach Amandari heilig ist. Ein Weg, der von Göttlichkeit berührt wurde. Der auf einer Steilküste gelegene Komplex ist ein von den traditionellen Dörfern Balis inspirierter Zufluchtsort, an dem Frieden und Stille regieren.

Les indigènes prétendent que le chemin menant à l'almandari est sacré. Une sorte de corridor en contact avec les dieux. Ce complexe conçu dans un style traditionnel Balinais, est un refuge où règnent la paix et le silence.

Los habitantes de la zona creen que el trayecto que conduce hasta Amandari es tierra sagrada: un pasillo al aire libre tocado por la divinidad. El complejo –proyectado basándose en el diseño de las tradicionales aldeas de Bali sobre un acantilado– es un sublime refugio en el que reinan la paz y el silencio.

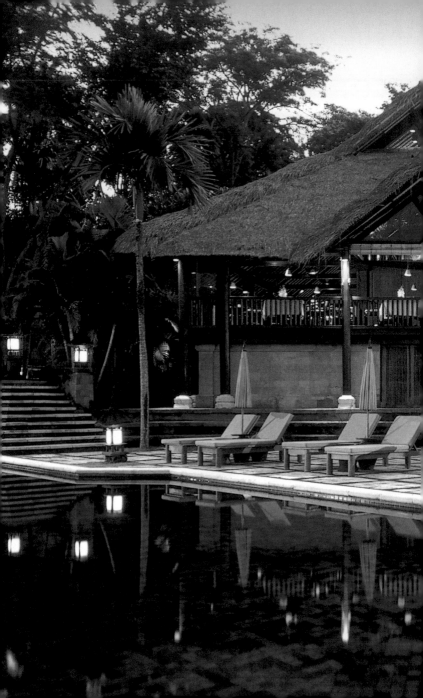

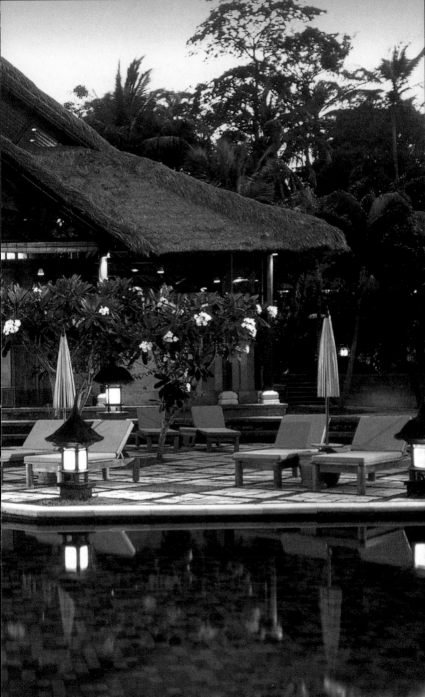

Atoll Hotel Helgoland

Opening date: 1999
Address: Lung Wai 27
27498 Helgoland, Germany
Tel.: +49 4 725 8000
Fax: +49 4 725 800 444
www.atoll.de
atollinfo@atoll.de
Services: Health and beauty treatments, swimming pool, sauna, steam baths, Turkish baths, massages (medical, relaxing...), lymphatic drainage, relaxation, reflexology, treatments with algae and mud, reiki, fitness center, gym.

Photographer: Alison Brooks

An avant-garde spa, inspired by the sea and devoted to beauty and well-being, has been created opposite the island of Helgoland. An evocative and peaceful atmosphere has been achieved by using colors and textures to provide attractive futuristic touches.

Auf der Insel Helgoland wurde dieser vom Meer inspirierte, avantgardistische Ort der Ruhe, Schönheit und des Wohlbefindens geschaffen. In einer ansprechenden und gelassenen Umgebung schaffen Töne, Texturen und Stil eine attraktive, futuristische Atmosphäre.

Un centre balnéaire d'avant garde, inspiré par la mer et voué à la beauté et au bien-être. Il est situé en face de l'île d'Helgoland. Une atmosphère paisible a été obtenue utilisant des textures et des couleurs particulières, lui donnant une note futuriste.

Enclavado ante la isla de Helgoland e inspirándose en el mar, se ha creado un espacio vanguardista y acogedor dedicado al descanso, la belleza y el bienestar. El logro ha sido conseguir una sugerente y sosegada atmósfera en la que las tonalidades, texturas y estilo evocan unos atractivos aires futuristas.

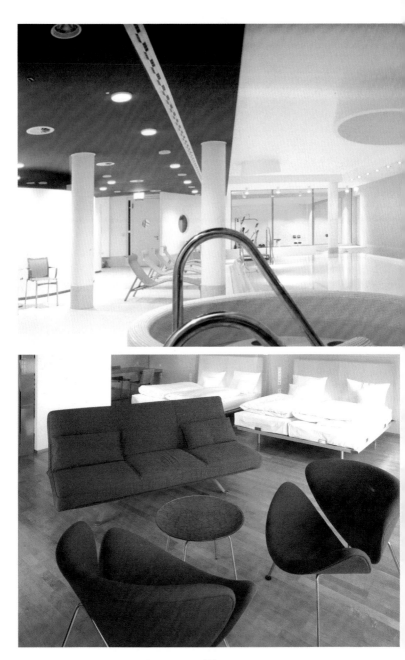

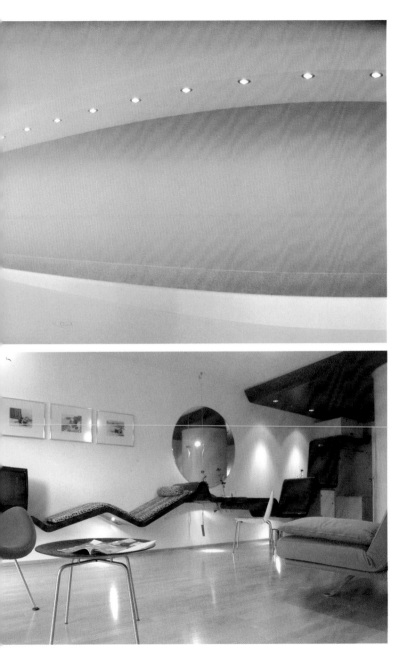

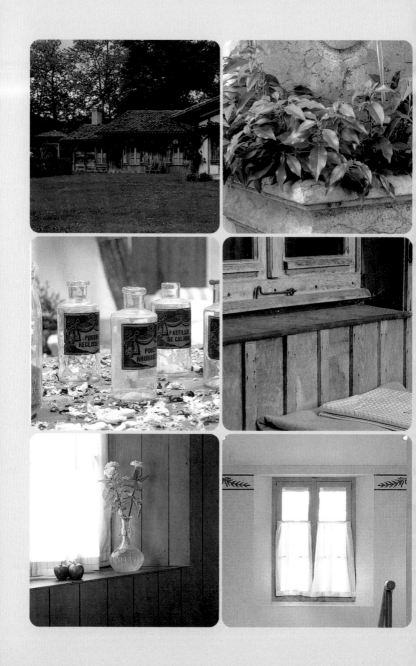

La Ferme Thermale d'Eugénie

197

Address: Eugénie-les-Bains
Landes, France
Tel.: +33 5 58 05 05 05
 +33 5 58 05 06 07
Fax: +33 5 58 51 10 10

Services: Wide-ranging facilities devoted to beauty and health with a large number of treatments. Thermal medicine, individualized programs. Thermal baths activated with plants and flowers. Relaxing and revitalizing treatments, anti-cellulitis treatments, thermal showers with aromatic plant vapors, steam baths, saunas, showers with underwater massages, thermal immersion baths, individual thermal swimming pools, hydromassages, hydromineral cures, herbal infusions, massages, lymphatic drainage linfático...

Photographer: Montse Garriga

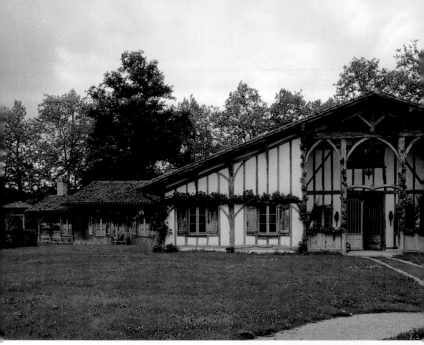

Set in a charming, natural rural setting, this spa offers a unique experience centered on health, relaxation and beauty by recovering rituals that emerged in the Greco-Roman cultures and have remained relevant to this day.

Dieses Heilbad in einer ländlichen, eleganten und ursprünglichen Gegend blickt auf eine lange Erfahrung im Bereich Gesundheit, Entspannung und Schönheit zurück, basierend auf Ritualen der griechisch-römischen Kulturen, die bis heute Bestand haben.

Elle est située dans un décore campagnard charmant. Ses bains offrent une expérience unique pour la santé, la relaxation et la beauté. On y retrouve des rituels datant de l'époque Gréco-Romaine, qui ont gardé jusqu'à nos jours leur efficacité.

Enclavada en un ámbito rural, elegante, genuino y natural, estas termas proponen una experiencia única dedicada a la salud, la relajación y la belleza recuperando todo un ritual que nació con las culturas grecolatinas y se ha mantenido hasta nuestros días.

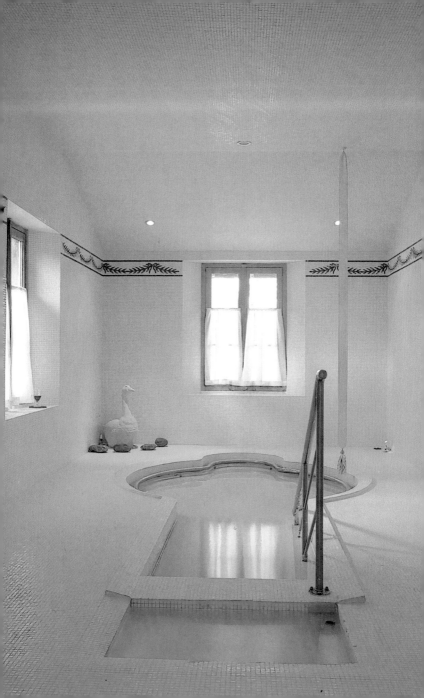

Les Fermes de Marie

Address: Les Fermes de Marie, Les Fermes du Grand Champ
Megève, France
Tel.: +33 4 50 93 03 10
Fax: +33 4 50 93 09 84
www.c-h-m.com
contact@fermesdemarie.com
Services: Face and body beauty treatments (rehydrating, purifying, revitalizing, relaxing, reaffirming... Hydrotherapy, treatments with extracts of mountain plants, natural essences, oils, vegetal serums, balsams, minerals, flowers. Mud baths, milk baths, steam baths, massages (relaxing, Thai...), lymphatic drainage, therapies with stones, reflexology, aromatherapy, sauna. Individualized programs in which it is possible to combine treatments catering to every need. Swimming pools (thermal, individual, covered...). Personalized fitness classes.

Photographer: Montse Garriga

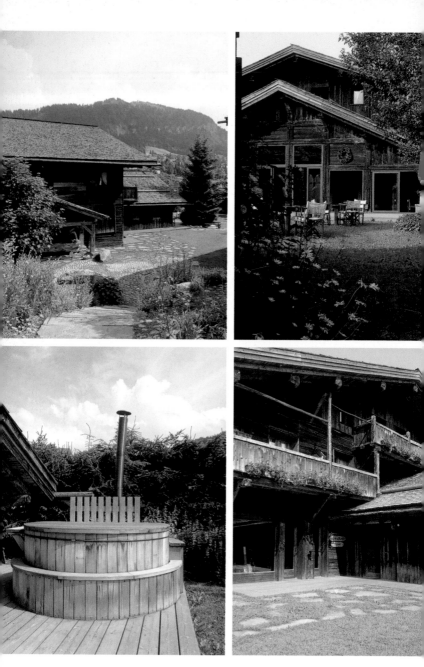

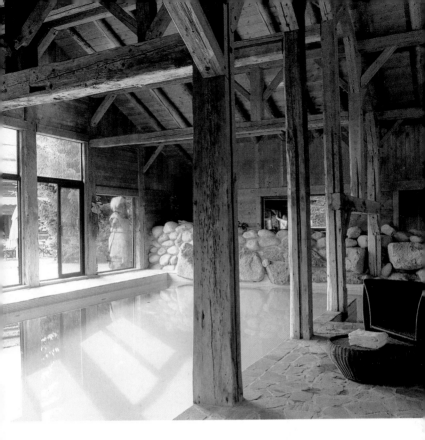

A new dimension in spas and facilities devoted to well-being: this could sum up a stay in this mountain retreat of exceptional natural beauty. An innovative center that is constantly evolving to be able to offer the latest treatments and services.

Eine neue Dimension für Spa und Wellness. So kann man das Erlebnis zusammenfassen, das der Besucher in diesem Zentrum inmitten einer bezaubernden Landschaft hat. Eine moderne Anlage, die ständig ihre Behandlungen und Dienstleistungen weiter entwickelt.

Une dimension nouvelle de bain et d'installations vouées au bien-être : cela résume un séjour dans cette retraite de montagne, d'une beauté exeptionelle. Un centre innovatif en évolution constante offrant les meilleurs traitements et les meilleurs services.

Entrar en una nueva dimensión del spa y las instalaciones destinadas al bienestar. Así podría resumirse la experiencia de pasar por este centro enclavado en un entorno sosegado y de extrema belleza natural. Un espacio innovador y en constante evolución para ofrecer los mejores tratamientos y servicios.

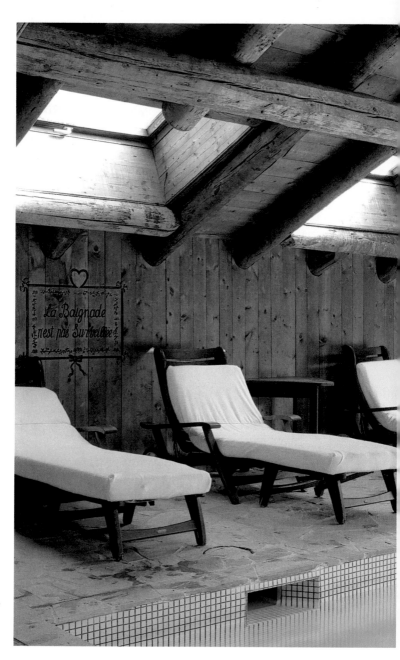

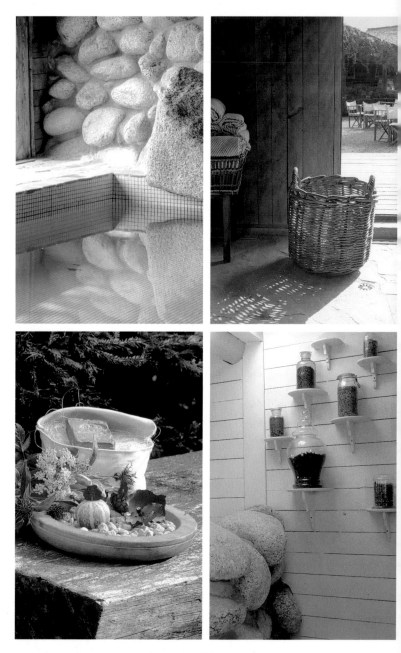

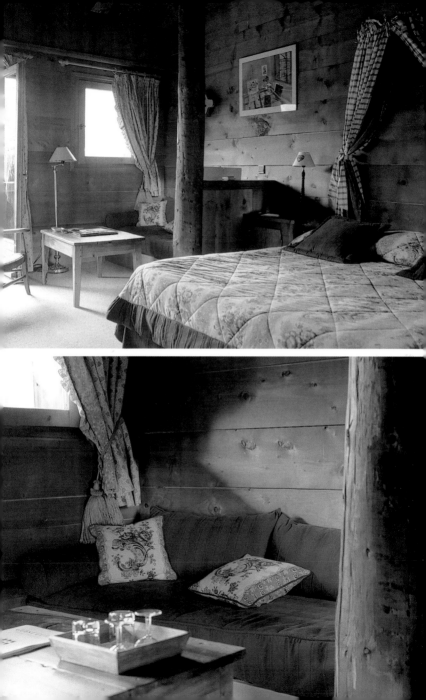

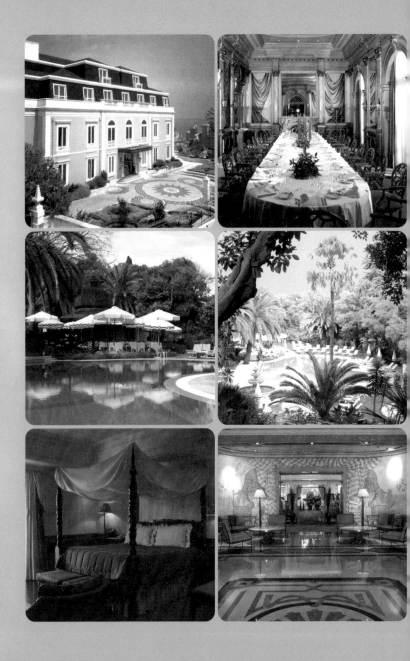

Lapa Palace

Address: Rua do Pau de Bandeira, 4
Lisbon, Portugal
Tel.: +35 1 21 394 94 94
Fax: +35 1 21 395 06 65
www.lapa-palace.com
info@lapa-palace.com
Services: Health and relaxation center. Aromatherapy. Highly experi-
enced professionals assess visitors and conduct a wide variety of
beauty treatments with La Prairie products. Turkish baths, Scottish
hose, sauna, jacuzzi, shiatsu, various types of massages, swimming
pools (outdoor and indoor), solarium, fitness center, golf, tennis and
squash courts, horese riding, private gardens.

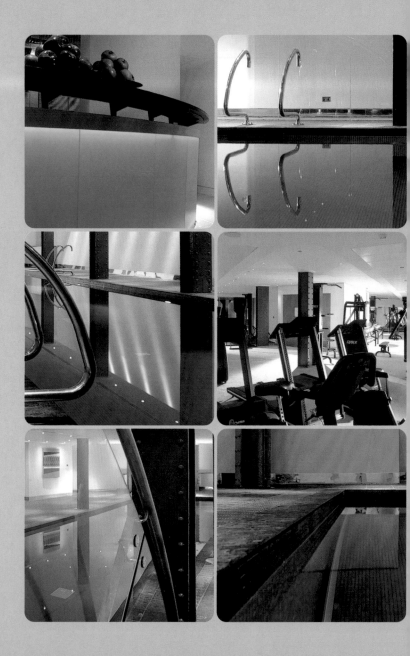

One Aldwych

Address: 1 Aldwych (Covent Garden)
London, England
Tel.: +44 20 7300 1000
Fax: +22 20 7300 1001
www.onealdwych.co.uk
treatements@onealdwych.com
Services: Wide variety of health and beauty treatments, aromatherapy, reflexology, programs for combating cellulitis, postural correction. Relaxation, swimming pool (with underwater music), sauna, steam baths, gym, massage (sports, therapeutic, traditional Indian for unblocking the chakras and relieving tension, migraines...), shiatsu, face and body treatments with minerals and mud from the Dead Sea, body mask (to exfoliate, eliminate toxins and cleanse the skin in depth), manicure, pedicure.

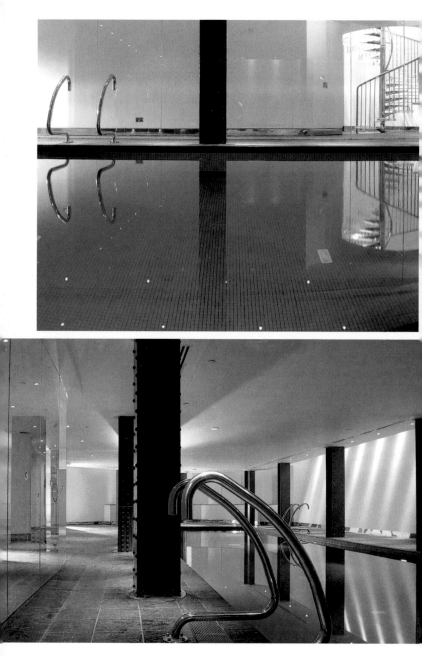

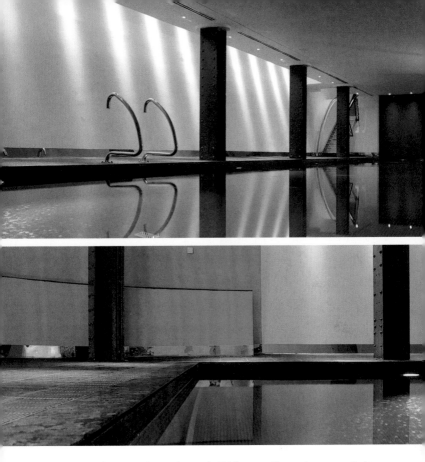

A haven of peace in the midst of London's tumult. Bright, evocative contemporary design conjures up the perfect setting for the pursuit of relaxation. This pleasure is enhanced by an attractive private collection of modern paintings and sculptures.

Eine Insel des Friedens im Herzen des hektischen Londons. Die frische, attraktive und zeitgemäße Ausstattung schaffen eine perfekte Umgebung zum Entspannen. Zu diesem Luxus kommt eine interessante Privatsammlung an Skulpturen und zeitgenössischer Kunst hinzu.

Un havre de paix au cœur du tumulte Londonien. Un design moderne et lumineux, permet d'atteindre le but fixé : la relaxation. Ce plaisir et rehaussé par la présence d'une très belle collection privée de peintures mondernes et de sculptures.

Un remanso de paz en el corazón del bullicio londinense. Brillantes, frescos y sugerentes interiores contemporáneos dibujan el escenario perfecto en el que abandonarse al relax y al bienestar. Todo un lujo al que hay que añadir una atractiva colección privada de esculturas y obras de arte contemporáneo.

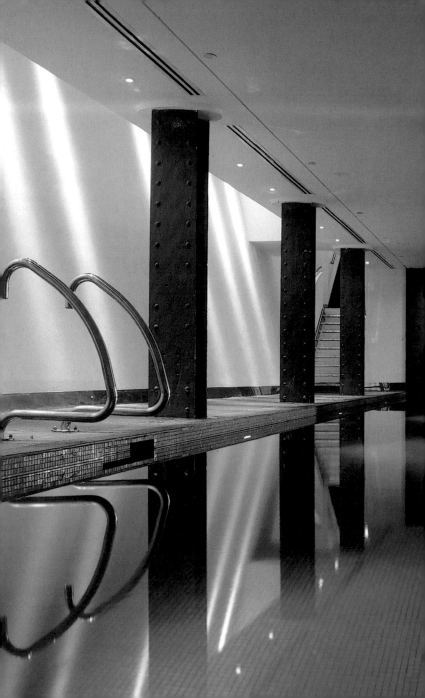

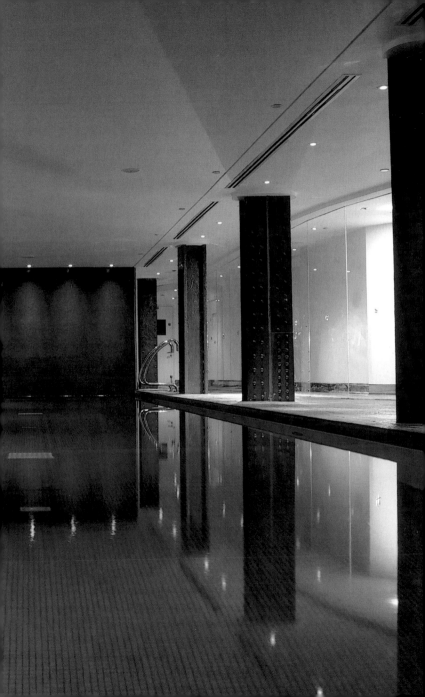

Royal Parc Evian

Address: South Bank of Lake Geneva
Evian-les-Bains Cedex, France
Tel.: + 33 4 50 26 85 00
Fax: +33 4 50 75 61 00
www.royalparcevian.com
reservation@royalparcevian.com
Services: Health and beauty treatments spread over 21,500 square
feet (2000 m²). Thermal pools, five swimming pools (indoors and
open-air), massages (Japanese, anti-cellulitis, purifying, Chinese,
Thai...), lymphatic drainage, shiatsu, hydromassage baths, multi-jet
shower, mud therapy, reflexology, reiki, Korean relaxation, alternative
therapies. Treatments with algae, sea mud, oils and essences, fra-
grances with vegetal extracts, volcanic stones, peelings with Dead
Sea salts. 34 private cabins, weight control and slimming cures,
Swedish sauna, steam baths (traditional hammam). Personalized
programs and packages combining various therapies and treat-
ments. Beauty-related medicine. Fitness center, personal training,
aqua-gym, golf, tennis courts, archery, squash, badminton, cycling,
water skiing, snowboard, horse riding, adventure sports.

Photographer: Montse Garriga

The word "stress" ceases to exist, peace and well-being are all-pervasive in one of the world's most beautiful hotels, on the shores of Lake Geneva, in the French Alps. The beauty of a unique setting and the particularly warm atmosphere prove captivating.

Das Wort Stress verliert an Bedeutung. Ruhe und Wohlbefinden herrschen am Genfer See in den französischen Alpen, wo sich dieser Komplex, eines der schönsten Hotels der Welt, befindet. Eleganz und Schönheit in einer unvergleichlichen, warmen Atmosphäre.

Le mot « stress » cesse d'exister. La paix et le bien-être se répendent dans l'un des hotels les plus magnifique situé sur les rives du Lac Léman, dans les Alpes francaises. La beauté d'un cadre unique et une atmosphère chaleureuse s'avèrent captivants.

La palabra estrés deja de existir y la calma y bienestar lo invaden todo a los pies del lago Léman, en los Alpes franceses, lugar en el que se ubica este complejo –para algunos uno de los hoteles más bellos del mundo. La elegancia y belleza de una atmósfera única y un ambiente cálido y especial recorren e inundan cada uno de sus rincones.

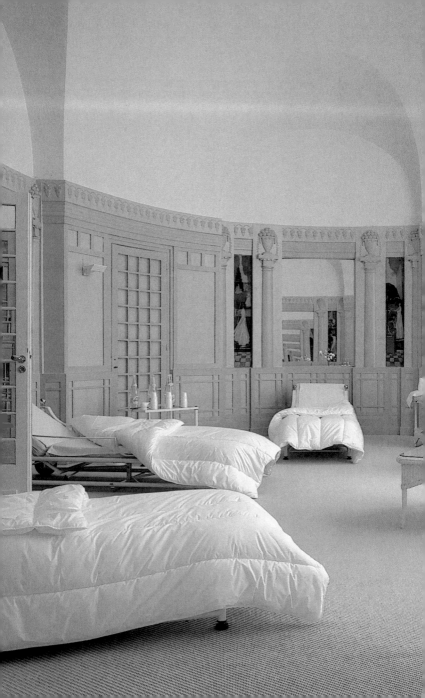

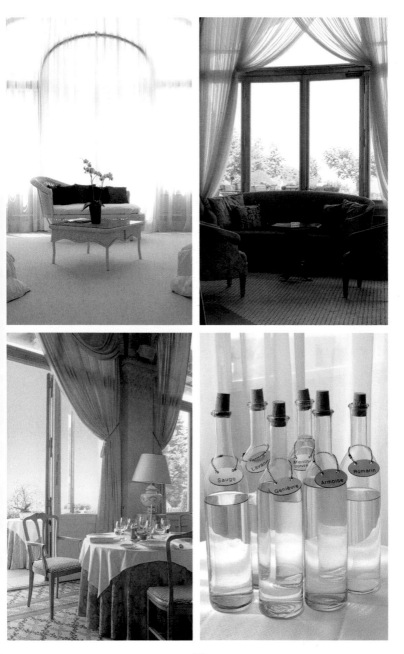

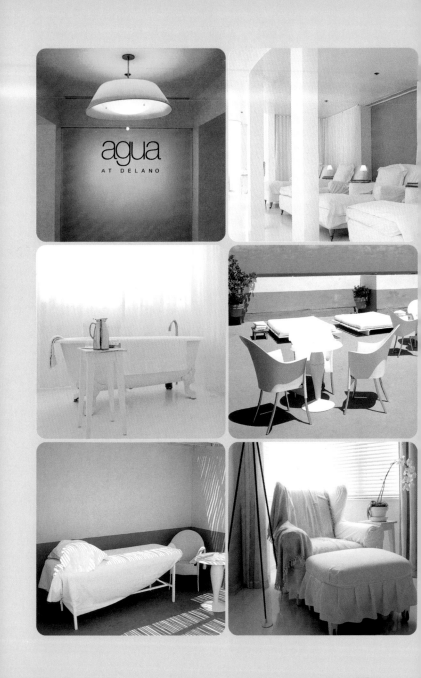

Agua Spa
Delano Hotel

Opening date: 1995
Address: 1685 Collins Avenue
Miami Beach, FL 33139, USA
Tel.: +1 305 672 2000
Fax: +1 305 532 0099
www.delanohotelmiamibeach.com
Services: The Agua spa (in the Delano Hotel) offers a wide range of health and beauty treatments to guarantee physical and mental well-being. Hydrotherapy, massages, jacuzzi, sauna, swimming pools, fitness center.

Architect: PMG Architects – Peter Grumpel, Jury Álvarez
Interior design: Philippe Starck
Photographer: Pep Escoda

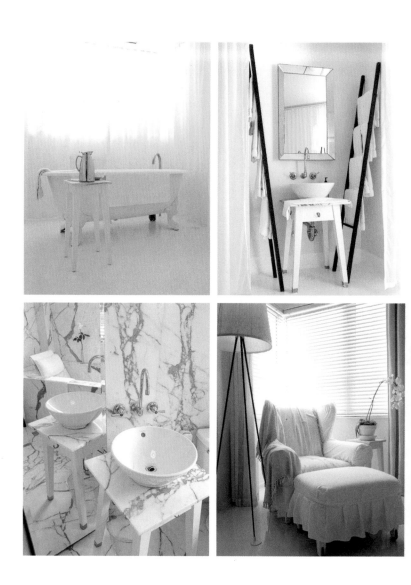

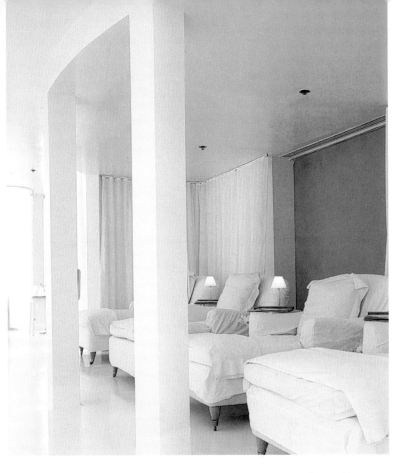

Set in the heart of one of the most lively and visited cities in the United States, this building – a perfect blend of classical architecture and avant-garde interiors – is a veritable oasis of peace and relaxation.

Im Herzen einer der lebendigsten und beliebtesten Städte der USA kombiniert diese Anlage klassische Architektur mit zeitgenössischer und avantgardistischer Ausstattung. Eine Oase der Ruhe und Entspannung.

Situé au cœur de l'une des ville les plus vivante et visitée de USA, ce bâtiment – un mélange parfait d'architecture classique à l'extérieur et d'avant-gardisme à l'intérieur – est une véritable oasis de paix et de relaxation.

Localizado en el corazón de una de las ciudades más vitales y visitadas de los Estados Unidos, este establecimiento –que combina a la perfección la arquitectura clásica de sus volúmenes con unos interiores contemporáneos y vanguardistas– es todo un oasis de calma y relajación.

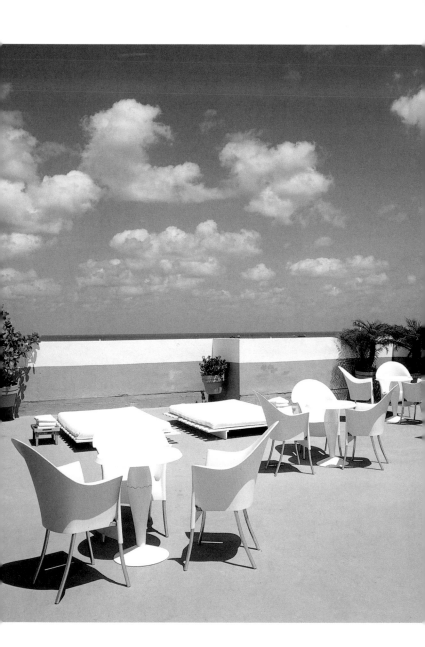

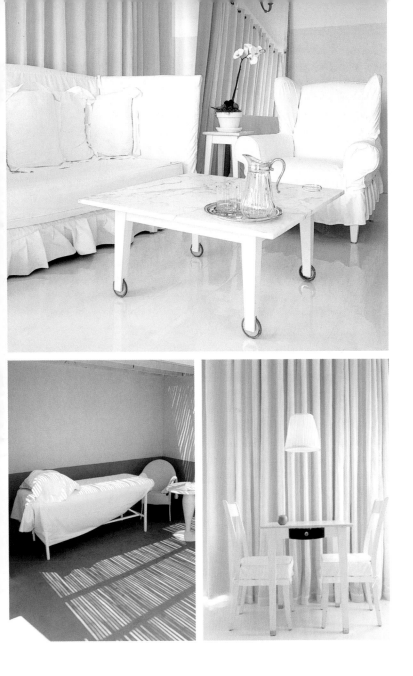

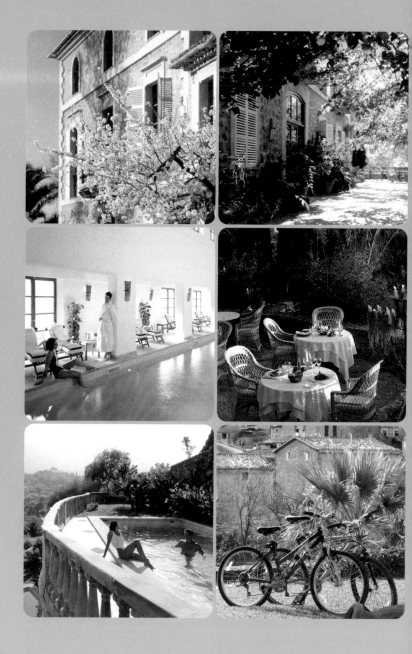

La Residencia

Address: Son Canals s/n Deià, Mallorca, Spain
Tel.: +34 971 63 90 11
Fax: +34 971 63 93 70
laresidencia@hotel-laresidencia.com
www.hotel-laresidencia.com
Services: Spa with indoor swimming pool, two heated outdoor swimming pools, steam bath, sauna, jacuzzi, beauty parlor, tennis court, gym, garden areas, orchard with olives, oranges and lemons, garden and swimming-pool terraces, private art collection.

Le Mirador

Address: 1801 Mont-Pélerin, Switzerland
Tel.: +41 21 925 11 11
Fax: +41 21 925 1112
www.mirador.ch
mirador@attglobal.net
Services: This spa offers more than 40 different treatments, from the most advanced and revolutionary to the most traditional. All kinds of massages and health and beauty treatments to revitalize both mind and body.
Hydrotherapy, relaxation therapies, aromatherapy, mud treatments, steam baths, saunas, Turkish baths, anti-cellulitis and slimming programs... swimming pools (indoor and outdoor),solarium, color therapy, aqua-gym, fitness, manicure, pedicure, hairdresser's.

Photographer: Montse Garriga

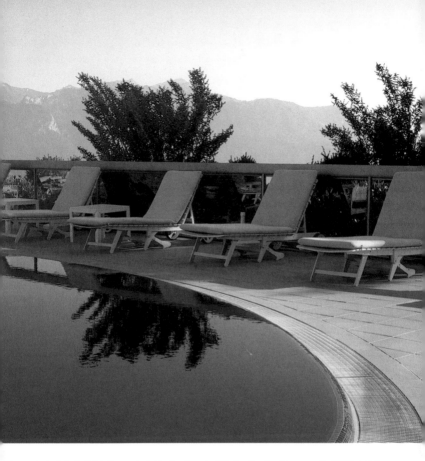

The main building of this luxury hotel in the heart of Switzerland was put up in 1910 and it evokes memories of an age when subtle elegance reigned supreme. The spa's thoroughly equipped facilities specialize in beauty, relaxation and rejuvenation treatments.

Anspielungen auf alte Zeiten und die subtile Eleganz dieses Luxushotels im Herzen der Schweiz aus dem Jahre 1910 bezaubern den Besucher. Das perfekt ausgestattete Spa ist auf Schönheits-, Entspannungs- und Verjüngungskuren spezialisiert.

Cet hôtel situé au cœur de la Suisse a été construit en 1910. Sa réminiscence aux temps anciens et son élégance subtile, charment le visiteur. Ses bains sont parfaitement équipés. Ses spécialités sont la beauté, la relaxation et les cures de rajeunissement.

Reminiscencias de antaño y una sutil elegancia emanan de este hotel de lujo situado en el corazón de Suiza y cuyo edificio principal data de 1910. Las instalaciones de su spa, perfectamente equipadas, están especializadas en tratamientos de belleza, relajación y rejuvenecimiento.

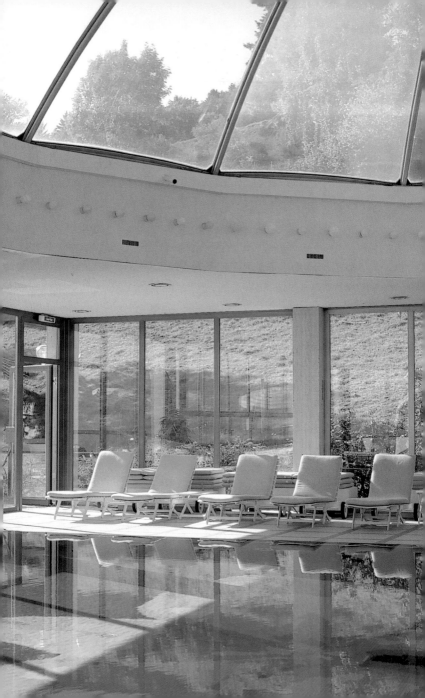

Vista Clara Ranch Resort & Spa

Address: HC 75 BOX III, Galisteo, New Mexico
Tel.: +505 466 4772
Fax: +505 466 1942
www.vistaclara.com
Services: Health and beauty treatments, therapies to combat stress, tension, fatigue, respiratory infections, migraines, allergies... massages (Swedish, sports, four-hand, therapeutic...), in-depth rehydration of the skin, reaffirming and invigorating treatments, treatments with mud, oils and natural essences, shiatsu, saunas, lymphatic drainage, beauty parlor, fitness center, steam baths, Swedish baths, jacuzzi, swimming pools, special diets...

Talasoterapia Hotel Gloria Palace

Address: Las Margaritas, s/n
San Agustín, Maspalomas, Gran Canaria, Canary Islands
Tel.: +34 928 765 689
Fax: +34 928 765 746
www.talasoterapiacanarias.com
www.hotelgloriapalace.com
talasoterapia@hotelgloriapalace.com
Services: Thalassotherapy treatments (sea water at 95 ºF/35 ºC), 29 hydromassage units, medical consultations to draw up thalassotherapy programs, relaxing and therapeutic face and body treatments, sauna, Turkish bath, thermal bath, salt baths, pedicure, manicure, acupuncture, hairdresser's, swimming pools (one for aqua-gym, one with cold water, one for clinical purposes, two heated pools in the gardens and another on the roof), tennis and squash courts, ping-pong, bowls, archery and shooting, shuffle-board. Cosmetics store and private gardens.

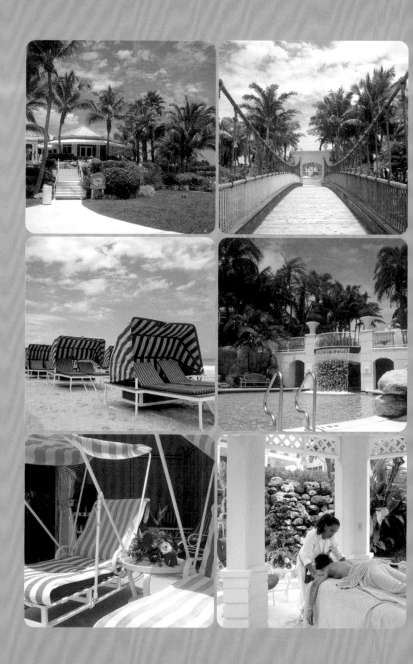

Sheraton Bal Harbour Beach Resort

Address: 9701 Collins Avenue
Bal Harbour, Florida, USA
Tel.: +1 305 868 2594
Fax: +1 305 864 2601
Services: Health and beauty treatments. Wide variety of swimming pools (with cascades and diving, shallow water, for children...), jacuzzis, sauna, massages (Swedish, relaxation, therapeutic...), aromatherapy, shiatsu, reflexology, treatments with mud and paraffin, individual cabins by the beach for massages. Personalized skin care programs for exfoliation, oxygenation and nutrition. Specific packages comprising several treatments and therapies (for newly-weds, couples...)
Fitness club, private beach offering various water sports, e.g. windsurfing... hairdresser's, manicure, pedicure.

Photographer: Pep Escoda

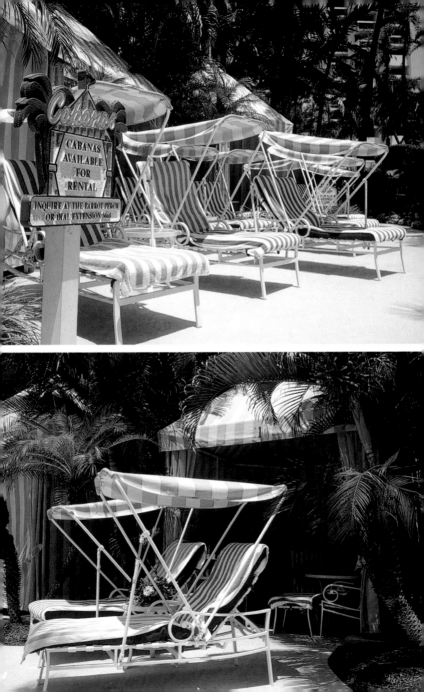

In an idyllic setting on the seashore, these facilities provide the perfect excuse to get back in shape, relax and switch off from the routine and hassles of everyday life. Water lovers will revel in this spa, as it boasts an excellent range of swimming pools.

Diese Anlagen direkt am Meer in einer paradiesischen Umgebung sind der ideale Vorwand, um sich zu erholen und vom Alltag abzuschalten. Wasserliebhaber sollten unbedingt dieses Spa besuchen, in dem es eine ausgezeichnete Auswahl an Schwimmbecken gibt.

Un endroit idyllique en bord de mer. Ces installations offrent une excuse parfaite pour retrouver la forme, relaxer et oublier le stress quotidien. Plusieurs piscines permettent à chacun de découvrir son plaisir de L'eau.

Con el mar a los pies y situadas en un enclave paradisíaco y reconfortante estas instalaciones son la excusa ideal para recuperar el tono vital, relajarse y desconectar de la rutina y el ajetreo diario. Los amantes del agua tienen una cita ineludible con este spa que cuenta con una excelente variedad de piscinas.

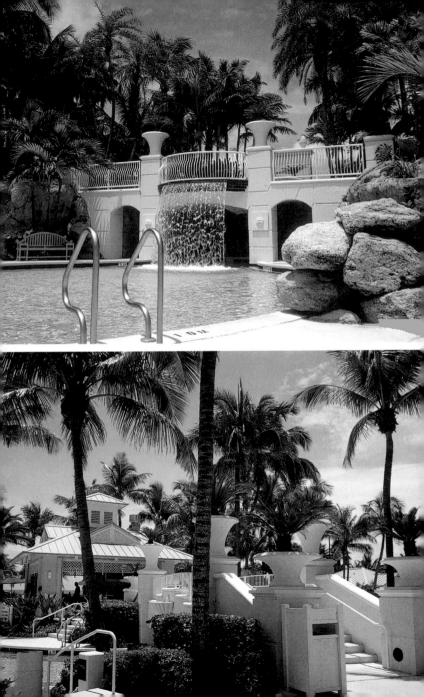

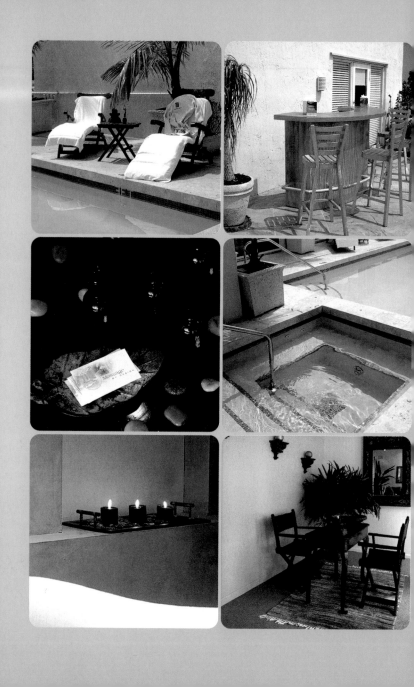

Massage by Design. Mercury Hotel

259

Address: 100 Collins Avenue, Miami Beach, Florida, USA
Tel.: +1 305 532 3112 (spa) / +1 305 398 3000 (hotel)
Fax: +1 305 398 3001
www.mercuryresort.com
info@mercuryresort.com
www.massagebydesign.com
info@massagebydesign.com

Services: An extensive choice of massages and beauty and health treatments to strengthen, invigorate and rejuvenate body and soul. Hot Stone Massage (a traditional technique, with beneficial physical and spiritual effects, using volcanic stones that relax the muscles and eliminate toxins; when combined with aromatic oils the relaxation is total). Swedish massage, shiatsu, yoga, four-hand massage, reflexology, aromatherapy, acupuncture (to combat insomnia, migraine, tension, nervous states and muscular pains, to lose weight and give up smoking). Facial treatments adapted to the needs of particular types of skin. Manicure, pedicure, depilation. Swimming pool, jacuzzi.

Photographer: Pep Escoda

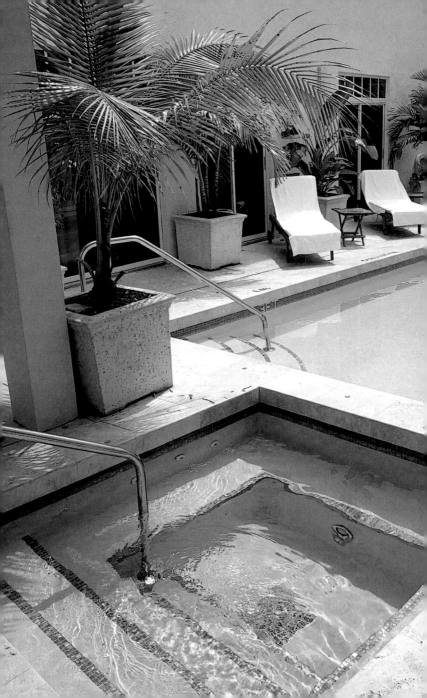

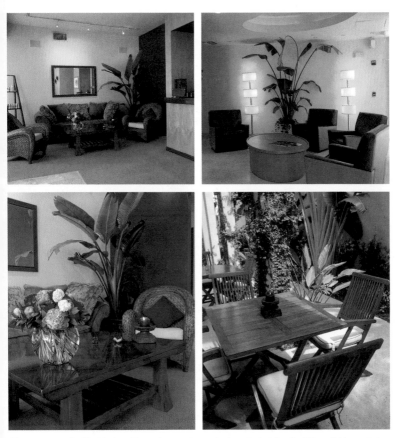

Heaven on earth: that is how it must seem to anybody enjoying the facilities of Massage by Design, the Mercury Hotel's day spa. Its enticing selection of services allows visitors to forget their problems and restore the well-being of their body and mind.

Der Himmel auf Erden. So fühlt sich der Besucher im Massage by Design, dem Day Spa des Hotel Mercury. Ein effizientes und attraktives Angebot von Dienstleistungen lässt alle Probleme vergessen, und stellt das Wohlbefinden von Körper und Geist wieder her.

Le paradis sur terre, c'est à quoi doit ressembler le « Massage by Design Mercury Hotel », pour celui ayant la possibilité d'y jouir de ses commodités. Une gamme très séduisante de services permet aux visiteurs d'oublier leurs problèmes et de rétablir le bien-être pour le corps et l'esprit.

El cielo en la tierra. Así es como se sienten los que pasan por las instalaciones de Massage by Design, el Day Spa del hotel Mercury. La eficaz y atractiva selección de servicios que ofrece permiten olvidarse de todos los problemas y recuperar el bienestar tanto del cuerpo como de la mente.

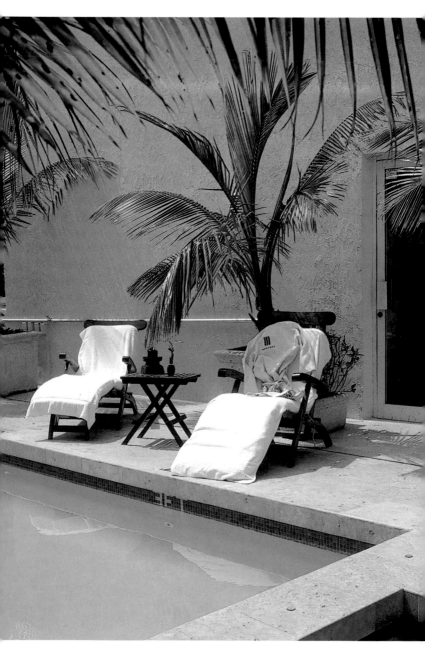

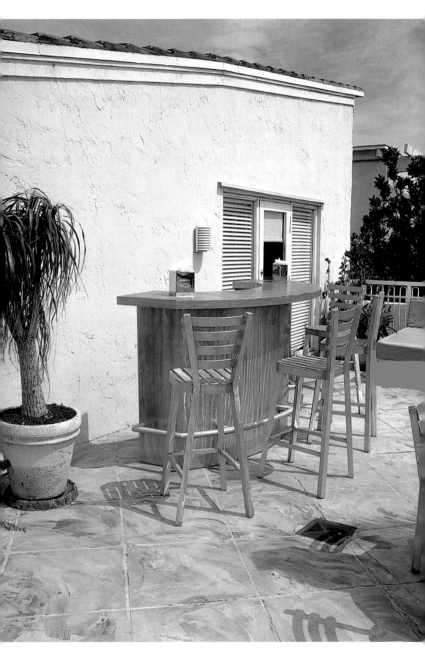

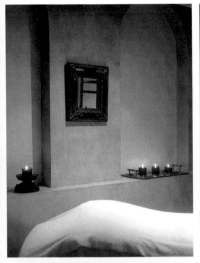

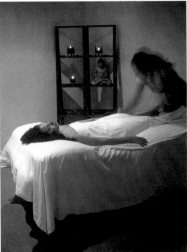

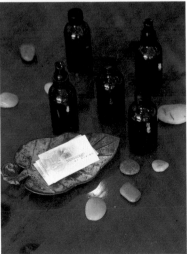

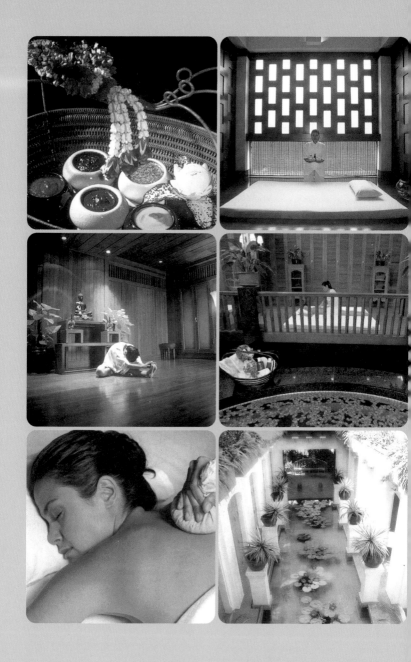

Mandarin Oriental Bangkok

Address: 48 Oriental Avenue
Bangkok, Thailand
Tel.: +66 2 439 7613 4
Fax: +66 2 439 7885
www.mandarinoriental.com
orawanc@mohg.com
Services: Numerous health and beauty treatments to rejuvenate the mind and body. Special programs that include treatments adapted to customers' requirements or preferences. Water therapies. Range of massages (jet-lag, Balinese, relaxing, anti-stress, Swedish, foot, Oriental...), reflexology, aromatherapy, treatments with oils, mud, flowers. Treatments (revitalization, reaffirmation, anti-cellulitis, slimming. Alternative therapies, beauty parlor, hairdresser's. Tennis courts, personalized exercises, aerobic classes.

Grand Hotel Mercure Splendid

Opening date: installations refurbished in 1999
Address: 2, Cours de Verdun, Dax, France
Tel.: +33 5 58 56 70 70
Fax: +33 5 58 74 76 33
H22148@accor-hotels.com
www.mercure.com
www.accorhotels.com
Services: Traditional cures for rheumatism and circulation problems, massages, thermal and nutritional programs to restore and maintain the optimal physical condition, beauty treatments, relaxation, swimming pools, hydromassage, fitness center.

Photographer: Montse Garriga

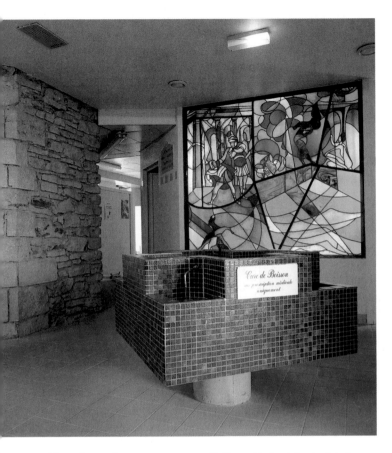

…ax is one of France's most important spa towns, with thermal baths dating back to the time of the Romans. This hotel-spa, built in a sumptuous Art Deco style, is located in the town center and offers a great variety of health and beauty treatments.

…ax ist eines der wichtigsten Heilbäder Frankreichs, das schon in der Römerzeit als ein solches genutzt wurde. Dieses Hotel-Heilbad im üppigen Art déco-Stil befindet sich im Zentrum des Ortes und bietet zahlreiche Schönheits- und Heilbehandlungen an.

…ax est l'une des cité balnéaire les plus importante de France, avec des bains datants déjà de l'époque romaine. Cet hôtel somptueux de style art-déco, est situé au centre ville et offre une grande variété de soins et de traitements de santé et de bauté.

…ax es una de las ciudades termales más importantes de Francia y la historia de su termalismo data de tiempos de los romanos. Este hotel balneario levantado en un suntuoso estilo art-decó se encuentra en pleno centro de la población y ofrece numerosos tratamientos de salud y belleza.

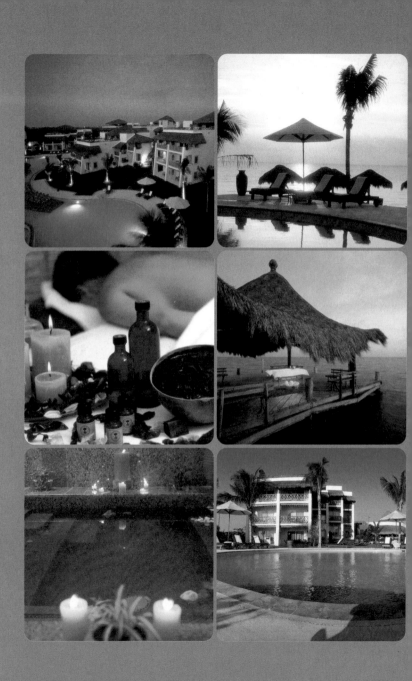

Ceiba de Mar Hotel & Spa

Address: Avda. Niños Héroes, s/n, Puerto Morelos
Riviera Maya, Mexico
Tel.: +52 998 8 72 80 60
Fax: +52 998 8 72 80 61
www.ceibadelmar.com
Services: Fully equipped modern facilities offering a wide range of health and beauty treatments. Massages, hydrotherapy, shiatsu, aromatherapy, reflexology, jacuzzis, swimming pools, saunas, terraces.

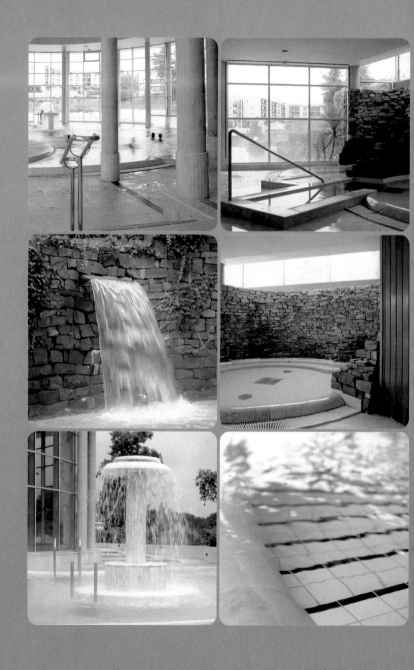

Termas Calicéo

Address: Lac de Christus
Saint-Paul-Lés-Dax, France
Tel.: +33 5 58 90 66 00
Fax: +33 5 58 90 68 68
caliceo@nomade.fr
www.caliceo.com
Services: Health and beauty treatments, relaxation, prenatal courses
with exercises in the swimming pool, water treatments to prepare
mothers-to-be for the arrival of their baby. Slimming programs, treat-
ments to solve circulatory problems. Microbubble seats and beds,
bubble baths alternating hot and cold, pressure jets, geysers, fast
water currents, swimming against the current, steam baths, jacuzzi,
hammam, solarium, sauna, cardio-training circuit. Indoor swimming
pools (with the water at 86 °F (30 °C) and cascades) and two out-
door pools, with spring water at 86-93 °F (30-34 °C), aqua-fitness,
aqua-gym. Gym and fitness center.

Photographer: Montse Garriga

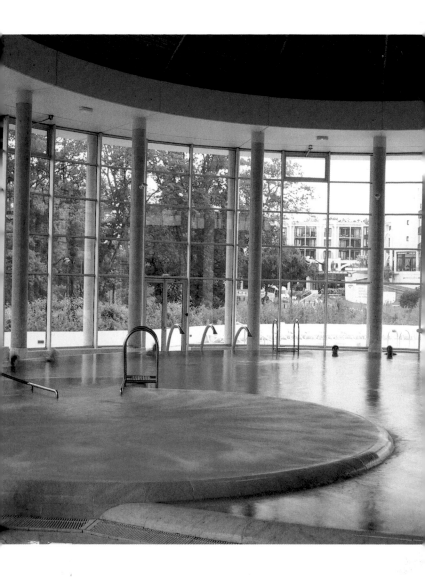

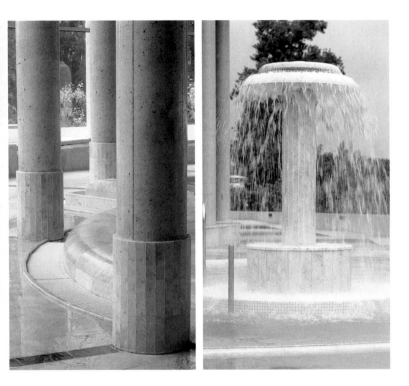

This temple devoted to water built in marble and stone lies between the ocean and the Pyrenees. The properties of water combine with the natural surroundings, the latest techniques and thorough medical controls to produce spectacular results.

Dieses Heilbad zwischen Meer, Pyrenäen und Adour ist ein dem Wasser geweihter Tempel aus Marmor und Stein. Das Wasser in Kombination mit den Kräften der Natur, modernen Techniken und ständiger ärztlicher Betreuung führen zu einzigartigen Ergebnissen.

Ce temple voué à l'eau, construit en marbre et en pierre, se trouve entre l'Océan et les Pyrenées. Les Propriétés de l'eau combinées avec l'environnement naturel, des techniques de poite et un control médical aprofondi, donnent des résultats spectaculaires.

Entre el océano y las montañas, los Pirineos y Adour, se enclava este balneario. Un templo dedicado al agua construido en mármol y piedra. Las propiedades de este elemento unidas a las de la naturaleza, las técnicas más avazadas y unos adecuados controles médicos consiguen resultados espectaculares.

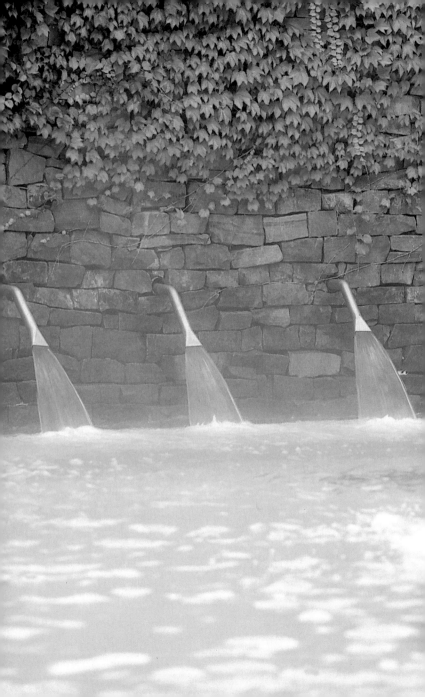

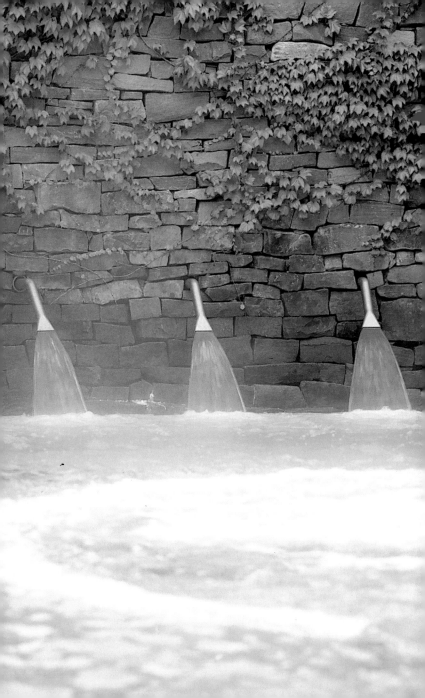

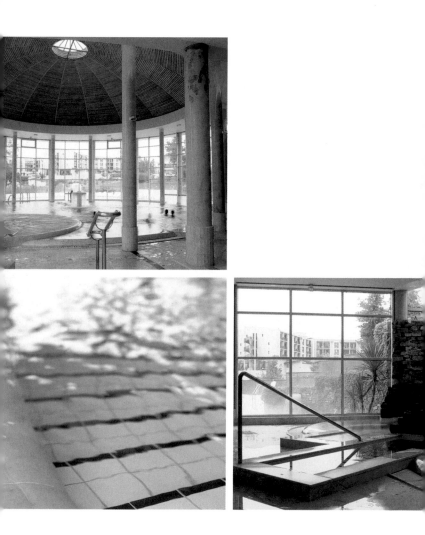

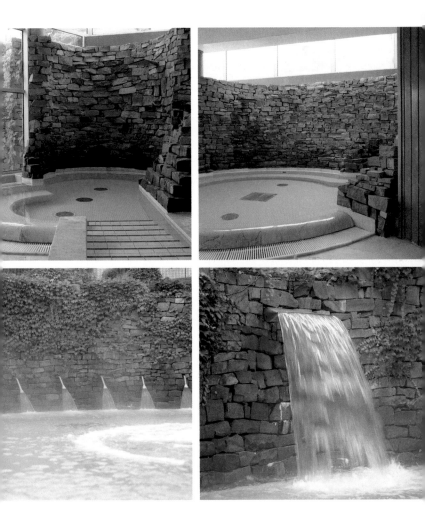

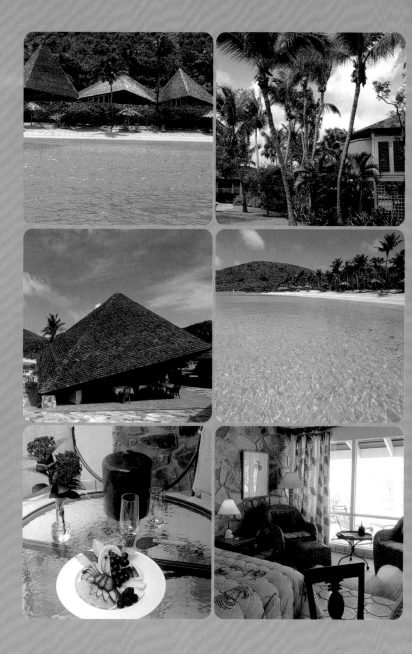

Little Dax Bay

Address: Virgin Gorda
British Virgin Islands
Tel.: +1 809 495 5555
Fax: +1 809 495 5661
Services: The complex offers a wide range of health and beauty treat-
ments for both the face and body, anti-stress programs, massages...
swimming pool, tennis courts, beach (with water sports available:
water skiing, underwater diving...)

Photographer: Pere Planells

Nirvana Spa

Address: 8701 Collins Avenue
Miami Beach, Florida, USA
Tel.: +1 305 867 4850
Fax: +1 305 867 8126
www.nirvanaspamiamibeach.com
nirvana@nirvanaspamiamibeach.com
Services: Face and body health and beauty treatments, alternative
therapies, steam baths, jacuzzis, cold water baths, Turkish baths,
Russian bath, Finnish sauna, Swiss showers, massages, yoga, relax-
ation area, Pilates technique, hypnosis room, chiropractice, physical
rehabilitation center, aromatherapy, paraffin treatments. Beauty par-
lor, fitness, gym, personal training. Tantra private suite (for special
occasions).

Photographer: Pep Escoda

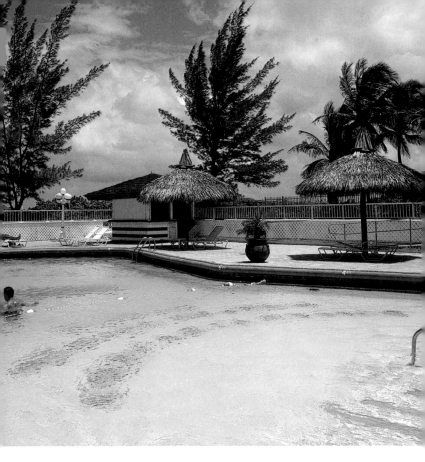

For Buddhists Nirvana represents a sublime state of happiness. Walking into this spa means just that: experiencing inner peace and a deep sense of well-being. Eclecticism and a distinctive mix of styles for a spot brimming with personality.

Für Buddhisten ist das Nirwana ein erhabener Glückszustand und Ziel aller Anstrengungen. In diesem Spa erfährt der Besucher inneren Frieden und tiefes Wohlbefinden. Eklektizismus und eine Mischung aus Stilen und Epochen in einer charaktervollen Umgebung.

Pour les Buddhistes le nirvana représente un état de bonheur sublime. Franchir le seuil de ces bains représente la même chose. Découvrir la paix intérieure, et une sensations profonde de bien-être. Un style eclectique pour un endroit débordant de personnalité.

Para los budistas, el nirvana es un estado sublime de felicidad, representa la meta de todo esfuerzo. Penetrar en este spa significa precisamente eso: experimentar la paz interna y un profundo bienestar. Eclecticismo y una peculiar mezcolanza de estilos y épocas para un espacio lleno de personalidad.

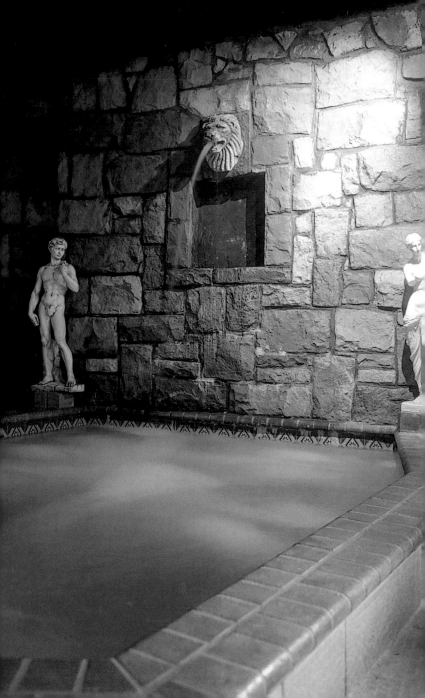

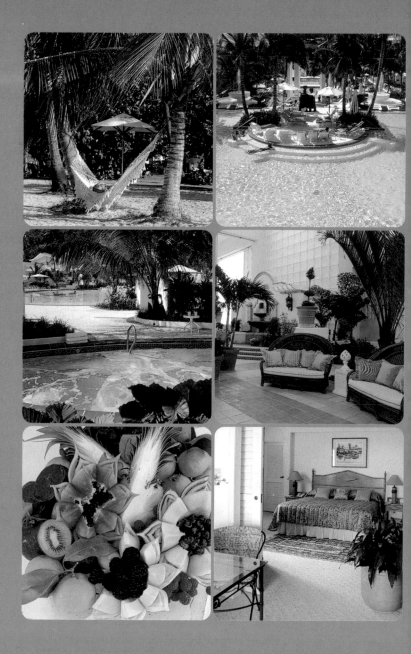

Wyndham El Conquistador Resort & Country Club

Address: 1000 Conquistador Avenue
Fajardo, 00738 Puerto Rico
Tel.: + 1 787 863 1000
Fax: + 1 787 863 6565
www.wyndham.com/ElConquistador
Services: Health and beauty center with numerous treatments. Anti-stress and relaxation programs. Swimming pools (six outdoors, one for children), jacuzzi, fitness center, private beach (water sports, aquatic motorbikes), golf, tennis courts.

Photographer: Pere Planells

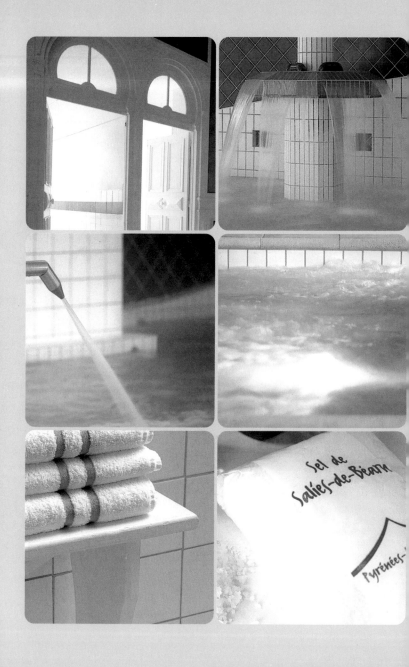

Salíes-de-Bearn

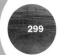

Address: Place du Jardin Public
Salies de Bearn, France
Tel.: + 33 5 59 38 10 11
Fax: + 33 5 59 38 05 84
Services: Its waters are recommended in the treatment of various
pathologies (chronic, organic, psychical, rheumatological, gynecologi-
cal and pediatric), including: rheumatism, arthritis, bone diseases,
neurological pains, gynecological disorders, osteoporosis...
Thermal swimming pools, springs, cascades, saunas, steam bath,
pressure showers, Californian bath, immersion bath, single or multi-
ple locally applied poultice)... Massages (relaxing, therapeutic...),
presotherapy, jacuzzis, mud treatments... gym classes, aerobics,
yoga, aqua-gym...

Photographer: Montse Garriga

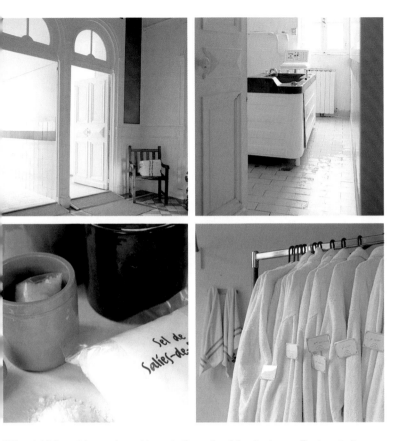

This establishment has a place of honor in the ranks of the great spas. The keys to its success lie in the beneficial properties of its waters, its highly qualified staff and the excellent modernization of its facilities, which has preserved all their charm.

Eines der wichtigsten Heilbäder weltweit. Die wohltuenden Eigenschaften seines Wassers, langjährige Erfahrung und das hochqualifizierte Personal der renovierten Anlagen, die dennoch den Reiz alter Zeiten bewahren, tragen zum Erfolg dieses Bades bei.

Cet établissement a une place d'honneur parmi les plus grandes stations thermales. Les clés de son succès sont : les propriétés bénéfiques de ses eaux, un personnel hautement qualifié ainsi que des installations parfaitement modernisées qui ont gardé tout leur charme.

Esta estación termal ocupa un puesto de honor en la lista de los balnearios más importantes. Las beneficiosas propiedades de sus aguas, la experiencia de un personal altamente cualificado y unas instalaciones convenientemente renovadas pero que mantienen el encanto de siempre son las claves de su éxito.

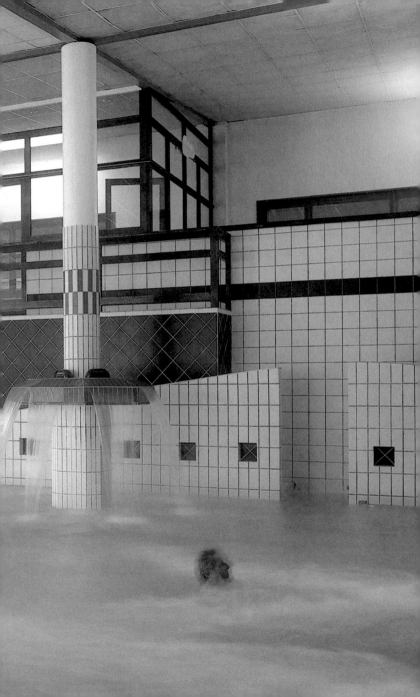

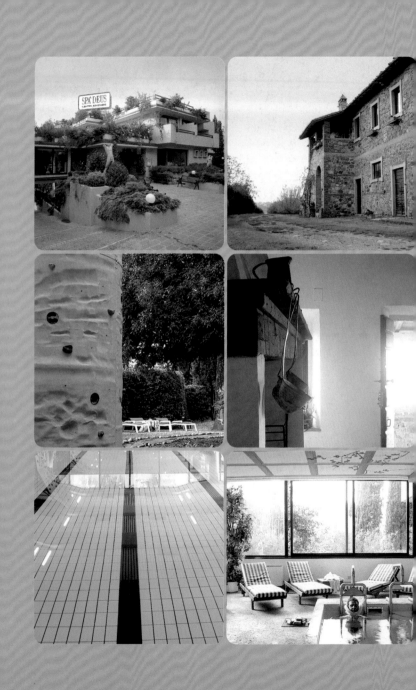

Spa Deus

Address: Via Le Piane, 35
Chianciano, Tuscany, Italy
Tel.: +39 578 63232
Fax: +39 578 64329
www.spadeus.it
info@spadeus.it
Services: Aromatherapy, Ayurveda, massages (Swedish, therapeutic, sporting, relaxation...), water aerobics, tai-chi, balneotherapy, chi-kong, treatments with mud and soil from the Dead Sea, hot stones, hydrotherapies, lomi-lomi, oxygen baths, baths with carbon water (the only ones in Italy), treatments with paraffin, reflexology, shiatsu, yoga, watsu, postural correction with sea water and sulfur, Vichy showers, paraffin mudbaths, Turkish baths, steam baths, slimming programs combined with exercise. Swimming pool, sauna, fitness, gym...

Photographer: Roger Casas

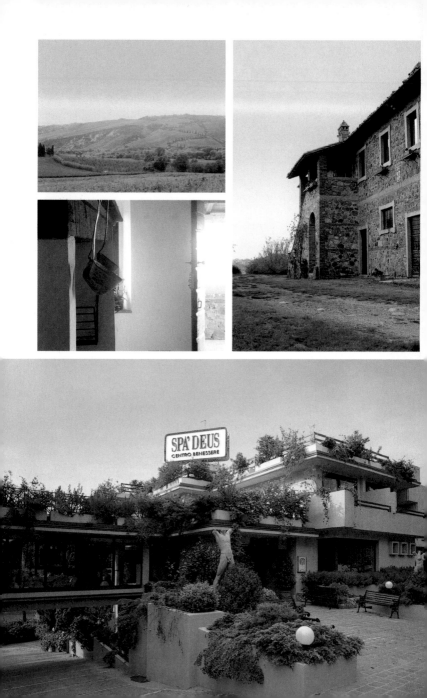

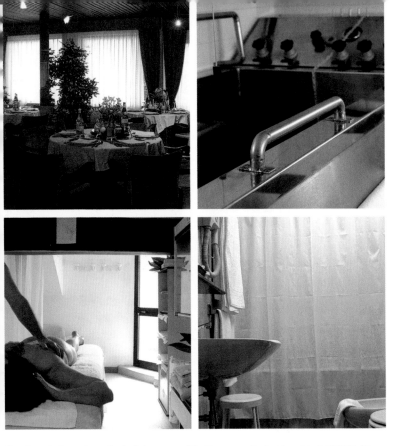

Spa Deus is the only center in Italy governed by the concepts developed in California. Its regular customers include movie stars, models, designers and other public figures. The secret: the combination of the distinctive Californian style and the idyllic surroundings of Tuscany.

Spa Deus ist das einzige italienische Zentrum, das nach kalifornischem System arbeitet. Stammkunden sind Filmstars, Models, Designer usw. Das Geheimnis liegt in der Kombination des kalifornischen Stils mit der idyllischen Umgebung der Toscana.

Spa Deus est le seul centre en Italie étant administré selon un concept développé en Californie. Parmis le hôtes on compte des acteurs, des manequins et des designers très connus. Le secret : une combinaison du style Californien dans le cadre idyllique de la Toscane.

Spa Deus es el único centro basado en las fórmulas y filosofías californianas que opera en Italia. Su clientela regular incluye estrellas de cine, modelos, diseñadores y demás personajes de la vida pública. El secreto: combinar el particular estilo californiano en el idílico entorno de la Toscana.

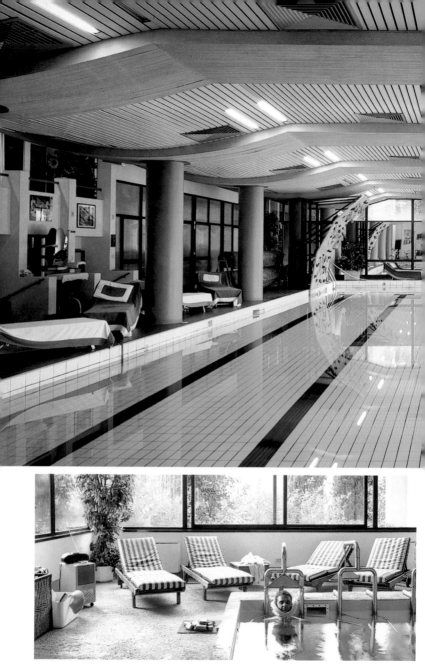

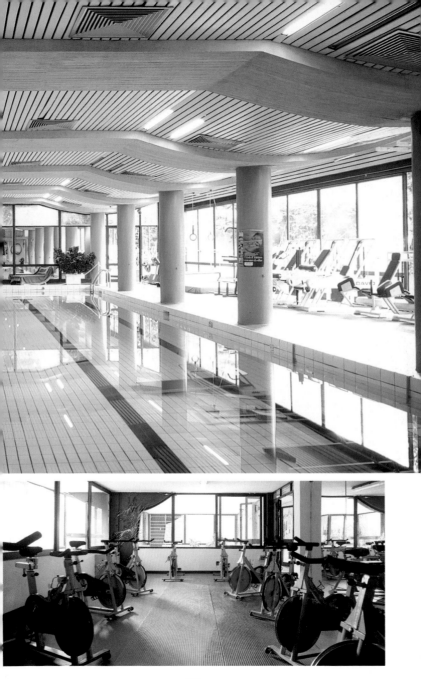

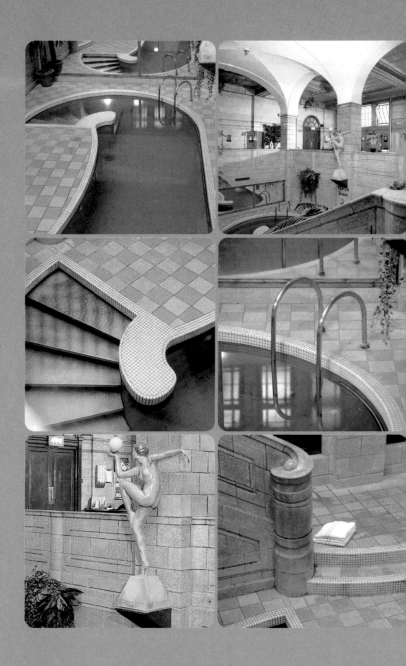

The Porchester Spa

Address: Queensway, London, England
Tel.: +44 20 7792 3980
Fax: +44 20 7641 4493
Services: It offers an extensive range of beauty and health treatments, massages (Swedish, therapeutic...), aromatherapy, reflexology, sauna, 3 Turkish baths, 2 Russian steam rooms, cold-water pool, indoor swimming pool, relaxation. Facial treatments (exfoliation, cleaning of the cutis, facial massage, treatments personalized in accordance with the type of skin...), body treatments (therapies with algae and seawater to activate the circulation of the blood, combat the retention of liquids, eliminate toxins, exfoliation with a special Moroccan glove that removes dead cells and relaxes and revitalizes the skin). Fitness center, gym, beauty parlor (pedicure, manicure, depilation...).

Photographer: Montse Garriga
(Stylist: Geeta Aiyer)

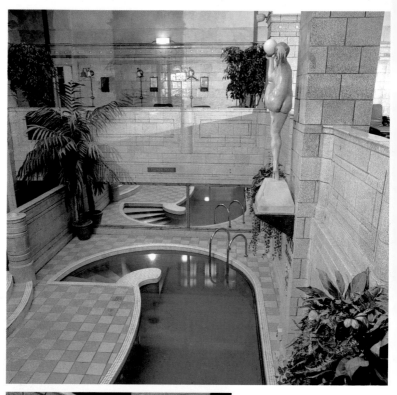

The installations in this city spa in the heart of Westminster are imbued with the seductive elegance of the Art Deco style. Merely crossing its threshold encourages visitors to relax, find peace and recover their strength before returning to the fray outside.

Die Anlagen dieses urbanen Heilbades in Westminster sind in einem prachtvollen und bezaubernden Art déco-Stil gestaltet. Wer dieses Bad betritt, findet Entspannung, Ruhe und kann neue Kräfte tanken, um sich dem Alltag zu stellen.

Au cœur de Westminster, ses bains sont d'une splendeur et d'une élegance style art-déco qui permetent aux visiteurs, sitôt la porte franchie de se relaxer immédiatement. Ils y trouvent le calme et peuvent reprendre des forces avant de retrouver le stress quotidien.

La esplendorosa y envolvente elegancia del estilo art-decó recorre las instalaciones de este balneario urbano situado en el corazón de Westminster. Los que traspasen sus puertas podrán fácilmente relajarse, encontrar la calma y reponer fuerzas para volver a enfrentarse al ajetreo diario.

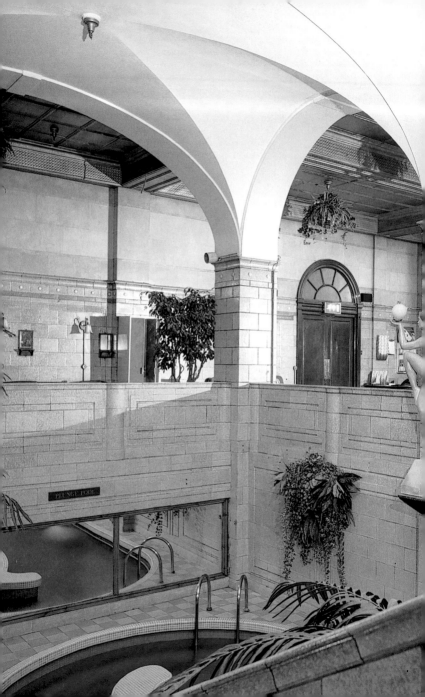

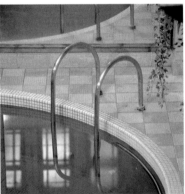

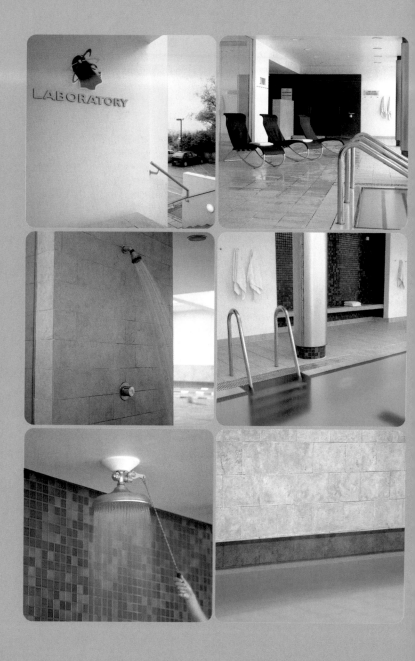

The Laboratory Spa & Health Club

Address: The Avenue Muswell Hill
London, England
Tel.: +44 20 8482 4000
Fax: +44 20 8482 3000
Services: This spa offers a wide variety of health and beauty treatments for both the face and body, as well as alternative therapies. Massages, aromatherapy, yoga. Its facilities also include a gym, fitness area, indoor swimming pool, saunas, relaxation areas, baths, personal classes in swimming and water sports, Pilates technique...

Photographer: Montse Garriga
(Stylist: Geeta Aiyer)

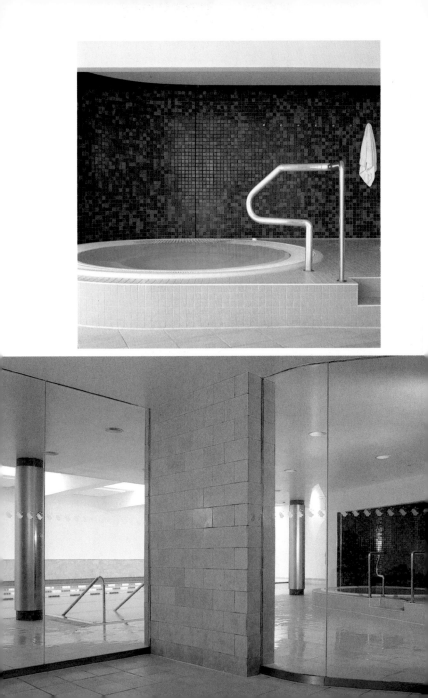

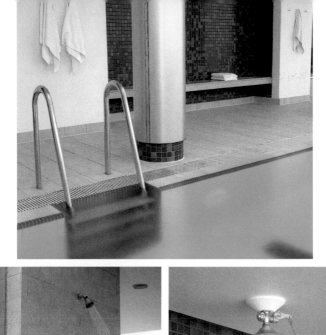

This club was created as a sanctuary devoted to well-being, health and beauty. Its perfectly equipped, state-of-the-art installations can satisfy the requirements of even the most demanding customer.

Dieser Ort sollte ein Tempel für Wellness, Gesundheit und Schönheit werden und die Idee wurde perfekt umgesetzt. In den avantgardistischen und perfekt ausgestatteten Einrichtungen findet der Besucher alles, was er sich erträumt.

Ce club fût créé comme sanctuaire dévoué au bien-être, à la santé et à la beauté. Il est parfaitement equipé. Des installations avantgardistes sont aptes à satisfaire la demande de clients toujours plus exigeants.

Nació con la intención de convertirse en un santuario dedicado al bienestar, la salud y la belleza. Sus instalaciones, vanguardistas y perfectamente equipadas, cumplen con creces la función para la que fueron creadas.

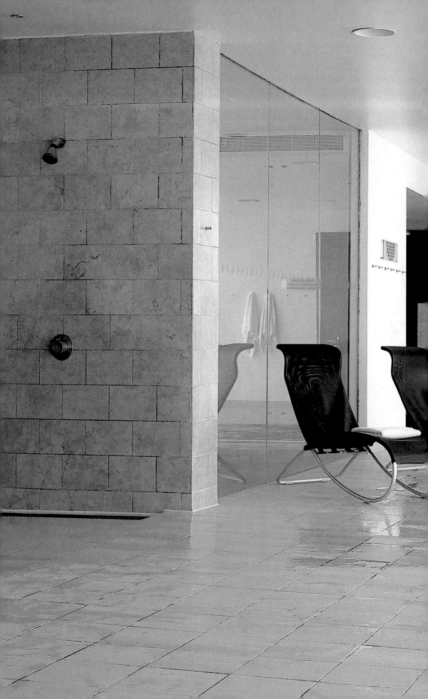

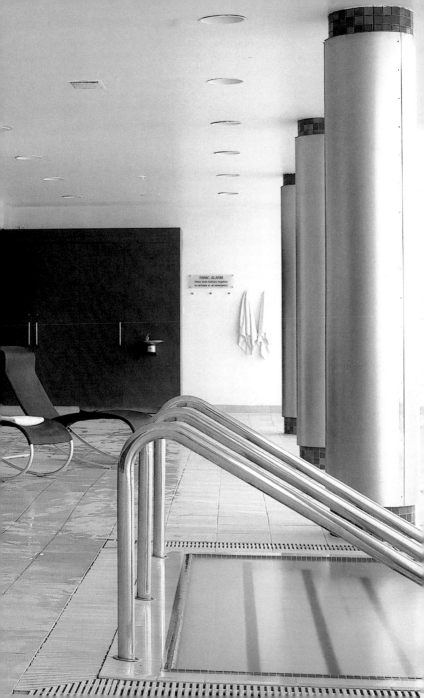

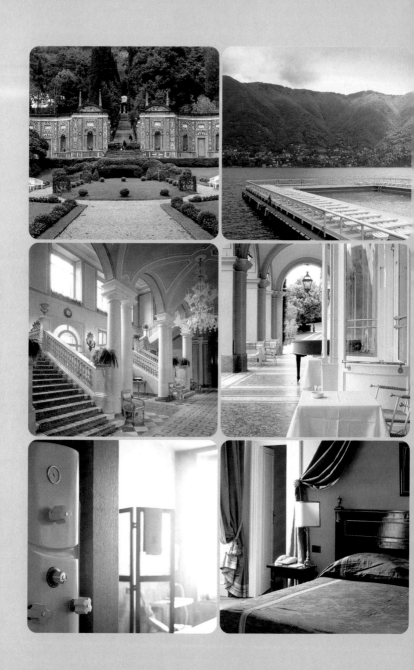

Villa D'Este

Address: Via Regina, 40, Lake Como
22012 Cernobbio, Italy
Tel.: +39 31 3481
Fax: +39 31 348 844
www.villadeste.it
info@villadeste.it
Services: 3 swimming pools (one of them floating on Lake Como),
sports club, a variety of massages, health and beauty treatments
(for the face and body) using a range of exclusive products that are
also available in the center's store, relaxation therapies based on
Zen philosophy, lymphatic drainage, hydrotherapy, Turkish bath,
sauna, jacuzzi, shiatsu, reflexology, aromatherapy, anti-cellulitis treat-
ments, slimming and toning-up treatments, tennis and squash
courts, golf course.

Photographer: Roger Casas

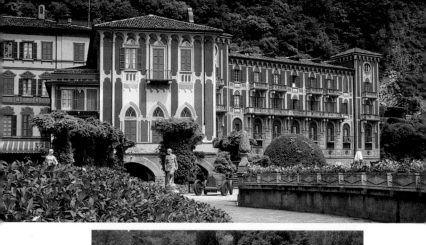

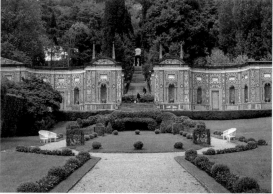

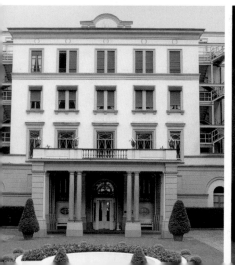

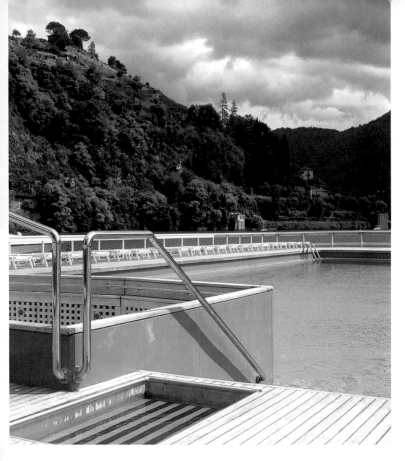

A thorough refurbishment and conversion has turned this 16th-century villa, once the summer residence of Cardinal Tolomeo Gallio, into one of Italy's most renowned and hospitable spas, without detracting from its charm in any way.

Ein gewissenhafter Umbau der Anlagen machte aus der alten Villa des 16. Jahrhunderts, einst Sommerresidenz Kardinal Tolomeo Gallios, eines der bekanntesten und gastfreundlichsten Heilbäders Italiens. Der Ort hat nichts von seinem ursprünglichen Reiz eingebüßt.

Des transformations et une rénovation complète ont fait de cette villa du 16ème siècle, qui était à l'époque la résidence d'été du cardinal Tolomeo Gallio, l'une des maisons les plus renommée d'Italie. Elle n'en a rien perdu de son charme.

Una concienzuda renovación y acondicionamiento de las instalaciones transformó esta antigua villa, construida en el siglo XVI y que en su día fue residencia de verano del Cardenal Tolomeo Gallio, en uno de los balnearios más legendarios y hospitalarios de Italia. El encanto del lugar sigue intacto.

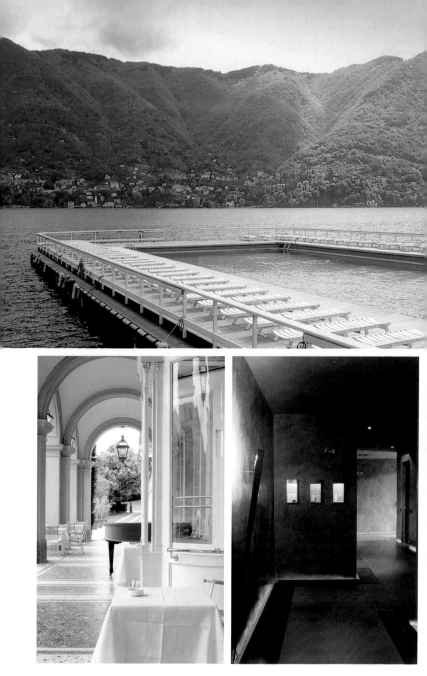

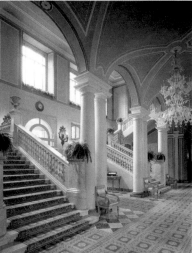

Hayman Hotel

Address: Great Barrier Reef
Queensland, Australia
Tel.: +61 7 4940 1234
Fax: +61 7 4940 1567
www.hayman.com.au
reserve@hayman.com.au
Services: Hydrotherapy, steam baths, saunas, jacuzzis, swimming
pools. Face and body health and beauty treatments, relaxation pro-
grams, rejuvenation, reinvigoration, massages... Private gardens,
squash and tennis courts, golf course, beach, water sports (water
ski, beach tours, boat rides).

Photographer: Pere Planells

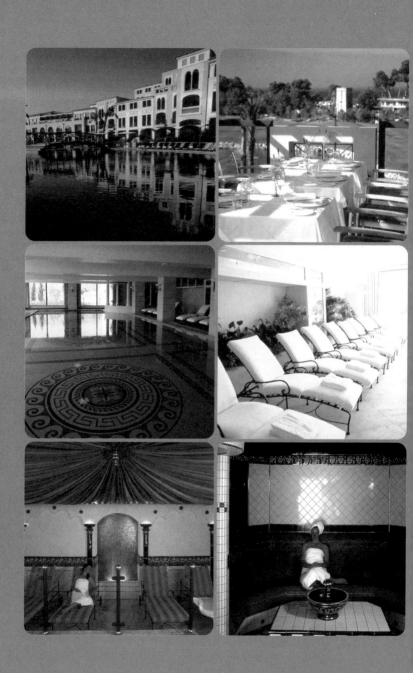

Dorint Royal Golf Resort & Spa Mallorca

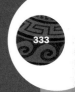

Address: Taula, 2, Camp de Mar
Mallorca, Spain
Tel.: +34 971 136 565
Fax: +34 971 136 070
www.dorint.de/mallorca
info.pmicam@dorint.com
Services: 15,000 square feet (400 m²) devoted to wellness, fitness center (fitted with state-of-the-art equipment), swimming pools (indoors and outdoors), sauna, steam bath, bath with salts, Cleopatra bath, bubble baths, jacuzzi (with integrated lighting and sound system), thalassotherapy, massages. Exclusive beauty treatments in the beauty parlor, designed to stimulate the skin's natural capacity for regeneration and guarantee a refreshed, radiant appearance. Programs with candle flames, as well as experts in corrective surgery. Golf course.

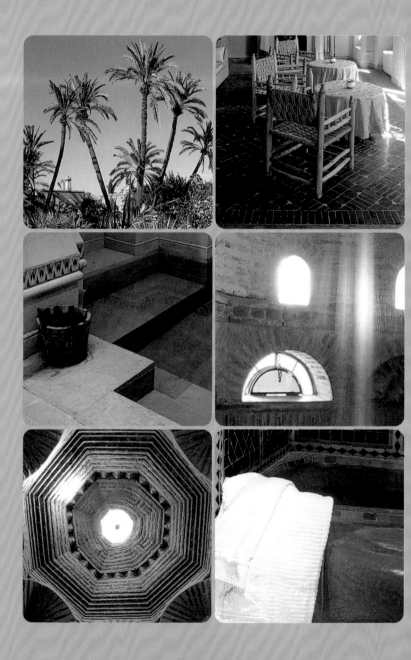

Les Deux Tours

Opening date: 1997
Address: Douar Abiad, 13p513 Marrakech Principale
Morocco
Tel.: + 212 44 32 95 25 /26 /27
Fax: + 212 44 32 95 23
www.deux-tours.com
deuxtour@iam.net.ma
Services: Swimming pools, saunas, Turkish baths, massages, private
terraces.

Architect: Charles Boccara
Photographer: Pere Planells

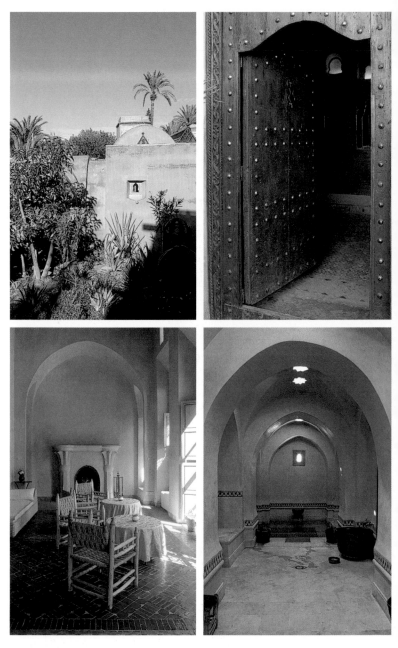

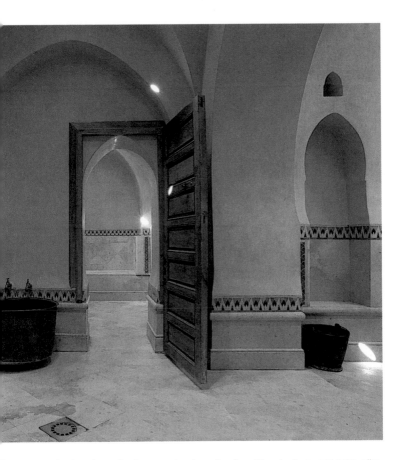

This spa nestles in a dream landscape only a few miles from Marrakech, among palm, olive and orange trees, roses, bougainvilleas and exquisite gardens. The architectural elegance and serenity gives a foretaste of the carefree well-being on offer within.

Inmitten einer Traumlandschaft voller Palmen, Rosen, Bougainvillea, Oliven- und Orangenbäumen sowie wundervoller Gärten in der Nähe von Marrakesch. Die elegante und gelassene Architektur der Anlage sorgt für Entspannung und Wohlbefinden.

Ce bain, logé dans un paysage de rêve à deux pas de Marrakech est entouré de palmiers, d'oliviers, d'orangers, de rosiers et de bougainvillées, dans un jardin merveilleux. L'architecture élégante et seraine offre un avant goût d'un bien-être insouciant.

Se enclava en un paisaje de ensueño entre palmerales, rosales, buganvillas, olivos, naranjos y bellos jardines a escasos kilómetros de Marrakech. El alarde de elegancia y serenidad arquitectónica de sus volúmenes es sólo un preámbulo del sosiego y bienestar que se experimentan durante la estancia.

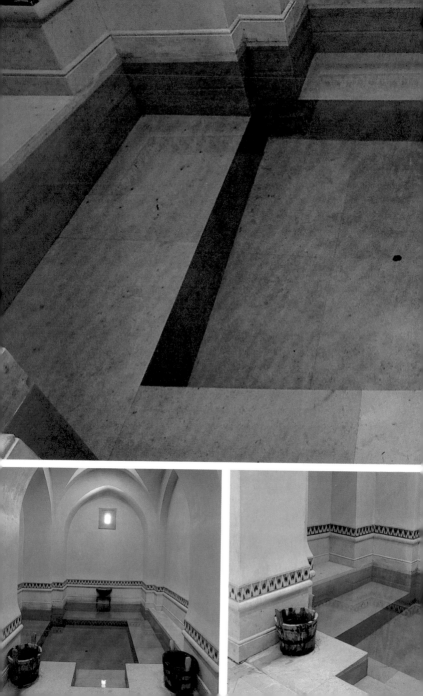

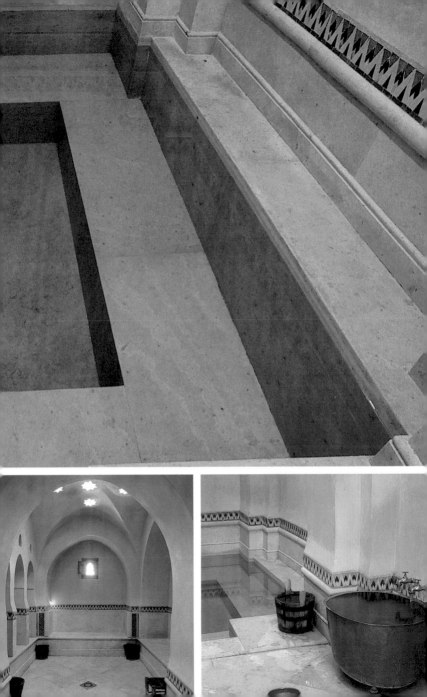

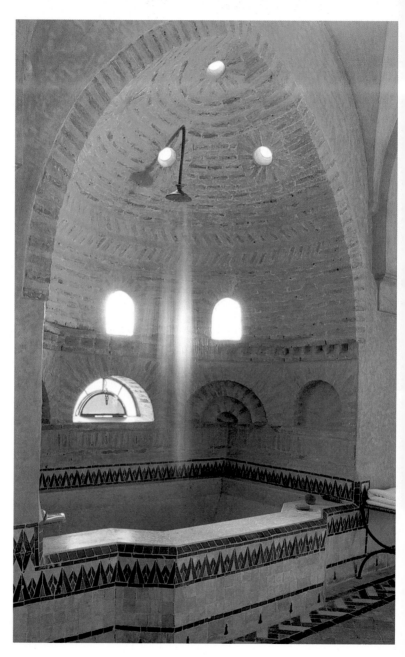

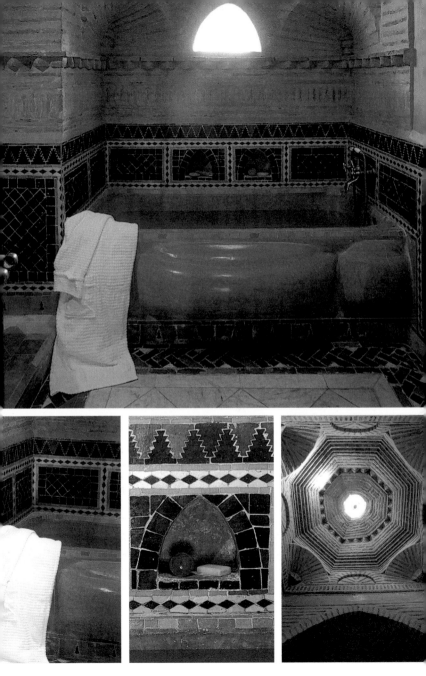

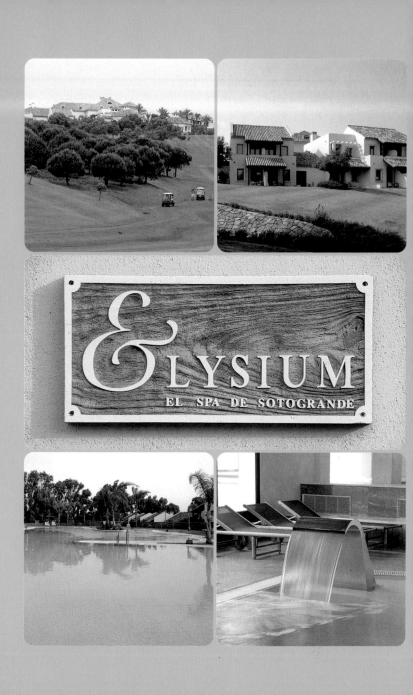

Spa Elysium
(Almenara Golf-Hotel & spa)

Opening date: 1999
Address: Urbanización Sotogrande, Avda. de Almenara, s/n
San Roque, Cadiz, Spain
Tel.: +34 956 58 20 00
Fax: +34 956 58 20 01
sotogrande@sotogrande.es
www.nh-hoteles.es
Services: Face treatments ("Thalgo" facial hygiene, analysis of the
cutis, basic cleaning of the cutis, overall face cure, make-up as treat-
ment, specific treatment of the eyes, all with Sisley products... face
massage, lymphatic drainage, dyeing of eyebrows and eyelashes,
setting waves in eyelashes, specific face masks...). Body treatments
(body peeling and "Thalgo" hydration, bust and anti-cellulitis treat-
ment with Sisley's "Phytoaromatic" products, cleansing of the back
with peeling and mask, seaweed wraps, sea mud wrap, "Frigi-Thalgo"
(cold bandages with marine serum), "Thalgoslim" local wrap...). Bath
with ultrasound/algae/salts, bath with aromatic oils. Massages
(therapeutic, relaxing, four-handed Ayurvedic, sports...). Foot reflexol-
ogy, osteopathy, reiki, presotherapy, ultrasound, endermology ...
Beauty-orientated medicine. Dynamic swimming pool, underwater
massage circuit, hydromassage, Turkish bath, jacuzzis, sauna, aero-
bics room, large bodybuilding room, hairdresser's...
The Almenara Golf-Hotel and Spa is part of the NH hotel chain and is
located in the heart of the Almenara golf course; it has 148 large
rooms and 10 suites.
Photographer: Pere Planells

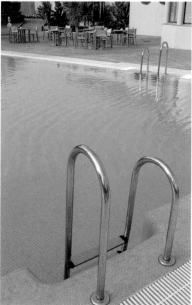

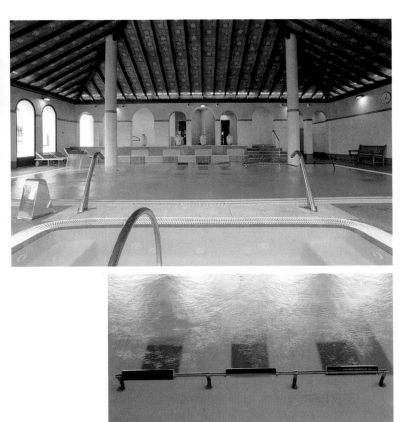

This complex in southern Andalusia is surrounded by some of the best golf courses in Europe. Well-being and relaxation are guaranteed in the Elysium, the spa in the Almenara Golf-Hotel. Finding the way to a healthy, more satisfying life is really very simple.

Dieser Komplex liegt im südlichen Andalusien und in seiner Nähe befinden sich einige der besten Golfplätze Europas. In Elysium, dem Spa des Almenara Golf-Hotel, wird für Wohlbefinden und Entspannung bestens gesorgt. Dort ist es einfach, ein gesünderes und glücklicheres Leben zu führen.

Ce hôtel au sud de l'Andalousie est entouré de plusieurs places de golf comptant parmis les meilleures d'Europe. Bien-être et relaxation sont garantis à l'Elysium et aux bains de l'Almarana Golf-Hôtel ; on y retrouve facilement un mode de vie plus sain et satisfaisant.

Situado en el sur de Andalucía, este complejo está rodeado de algunos de los mejores campos de golf de Europa. En el Elysium, el spa del Almenara Golf-Hotel, el bienestar y el relax están a asegurados. Encontrar el camino hacia una vida más sana y satisfactoria es, simplemente, sencillo.

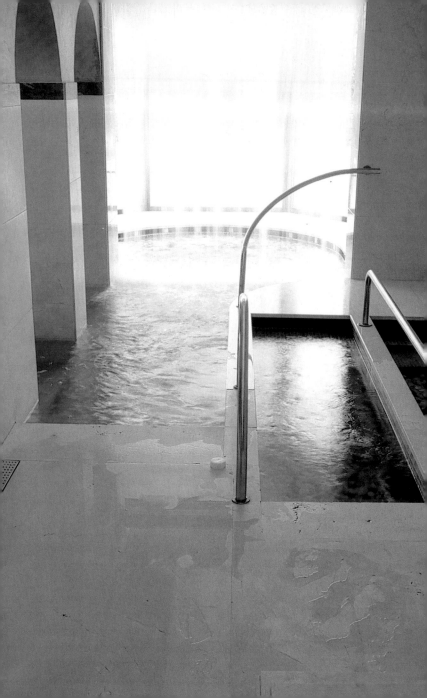

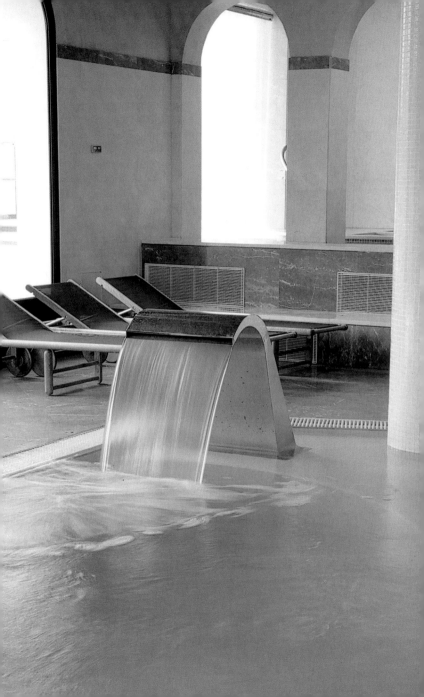

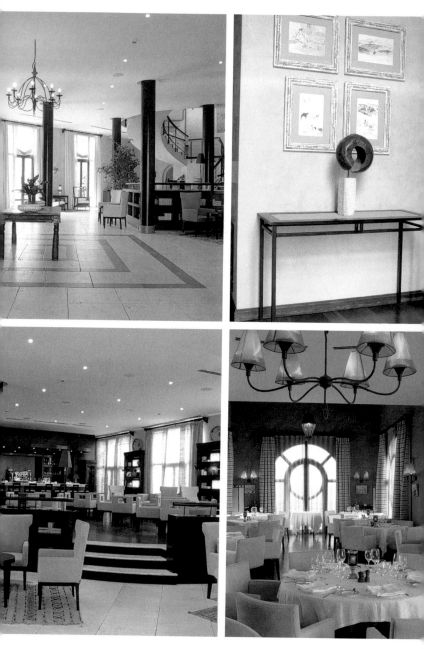

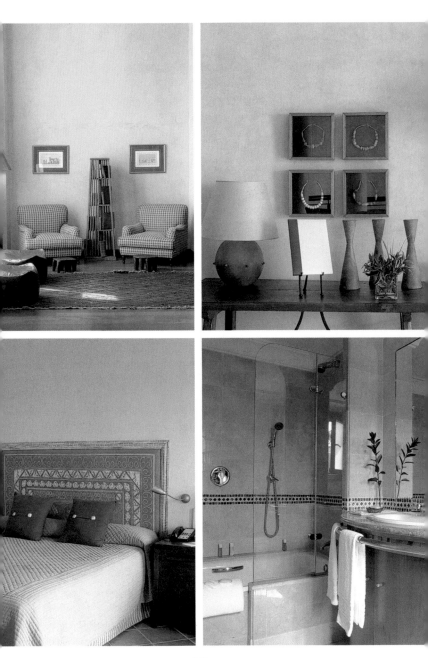

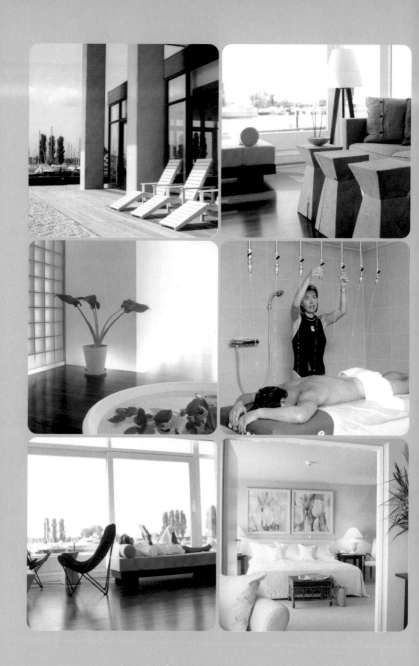

Newport Health Hotel & Spa

Opening date: 1998
Address: Labradorstroom, 75
De Huizen, Amsterdam, Holland
Tel.: +31 35 528 96 52 / +31 35 523 33 04 (hotel)
Fax: +31 35 528 96 11 / +31 35 523 33 06 (hotel)
www.newport-health-spa.nl
www.newporthotel.nl
info@newport-health-spa.nl
Services: Ayurveda, relaxation therapies (with special areas for yoga, meditation...), tae-bo, sauna, solarium, massages, lymphatic drainage, relaxing water massage, hot stones, steam baths, foot baths, swimming pool, beauty and health treatments, anti-stress programs, hydrotherapy. Fitness center.

Sagamore Hotel

Opening date: 2002
Address: 1671 Collins Avenue
Miami Beach, Florida, USA
Tel.: +1 305 535 8088
Fax: +1 305 535 8185
www.sagamorehotel.com
ingo@sagamorehotel.com
Services: Complete, modern and advanced facilities that include an
extensive and varied range of treatments, therapies and specific pro-
grams geared to relaxation, beauty and health. Swimming pool,
sauna, jacuzzi, fitness center.
The hotel boasts an attractive collection of contemporary art.

Photographer: Pep Escoda

Located in a six-story building built in 1948 in Miami's Art Deco district, this complex has been suitably refurbished to provide visitors with all the facilities of a modern and revolutionary fitness center and spa.

Im Art déco-Viertel von Miami gelegenes, sechsstöckiges Gebäude aus dem Jahr 1948, das komplett umgebaut wurde und seinen Besuchern alle Dienstleistungen eines modernen und fortschrittlichen Fitnesszentrums und Heilbads anbietet.

Situé dans un bâtiment de six étages construit en 1948 dans le quartier Art Deco de Miami, ce complexe a été rénové, offrant des installations dignes de ce centre de fitness révolutionnaire et moderne.

Ubicado en el distrito art-decó de Miami y en un edificio de seis plantas construido en 1948, este complejo, convenientemente renovado, ha adaptado sus instalaciones para poner al alcance del visitante todos los servicios de un moderno y revolucionario centro de fitness y balneario.

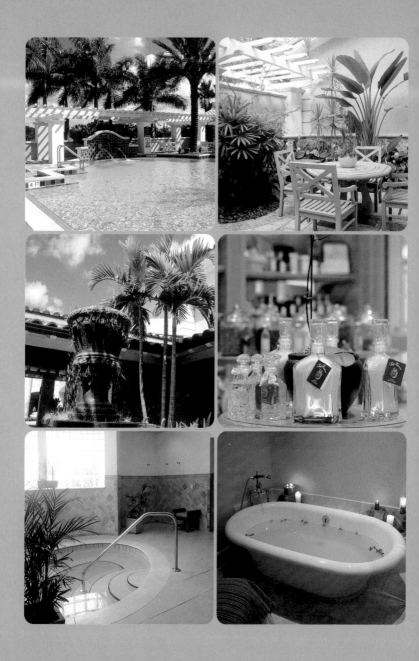

The Diplomat Country Club & Spa

Address: 501 Diplomat Parkway
Hallandale Beach, Florida, USA
Tel.: +1 954 883 4000
Fax: +1 954 883 4009
Services: Swimming pools, saunas, steam baths. Health and beauty treatments. Massages (Swedish, sporting, specially designed for pregnant women...), aromatherapy, reflexology. Thermal treatments, as well as treatments with algae, mud, essences, oils, herbs, mineral salts... thalassotherapy, Vichy showers. Nutritional and slimming programs, personalized programs.
Fitness center (qualified staff make an individualized in-depth analysis to provide a full assessment and achieve greater flexibility, cardiovascular resistance...) Beauty parlor and hairdresser's. Store selling the products used in the spa's therapies and treatments. Golf course, tennis court.

Photographer: Pep Escoda

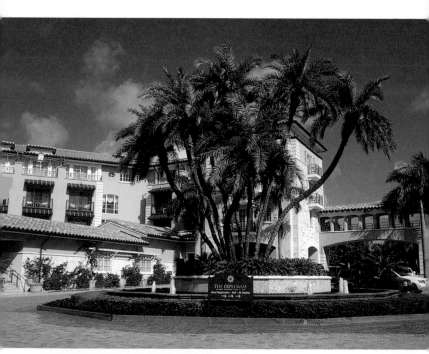

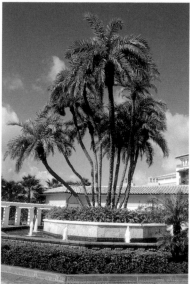

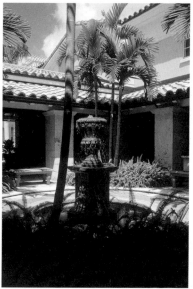

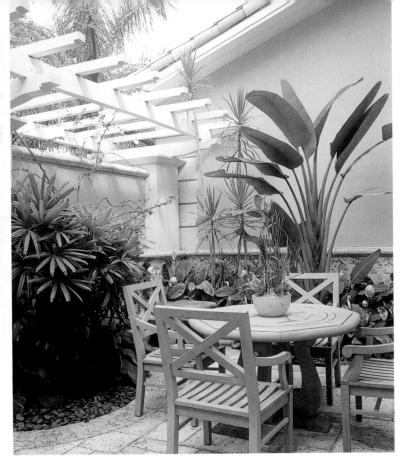

The elegance of the traditional Italian villas that inspired this building harmoniously blend with the innovative and superbly equipped facilities, offering a wide range of treatments geared to health, beauty and well-being.

Dieser Komplex ist von der Eleganz alter italienischer Villen inspiriert und harmonisch mit modernen und perfekt ausgestatteten Anlagen kombiniert, in denen eine große Auswahl an Behandlungen für Gesundheit, Schönheit und Entspannung angeboten werden.

Ce bâtiment construit dans l'élégance traditonelle de villas Italiennes, est équipé des installations les plus modernes, offrant une grande gamme de traitements voués à la santé, la beauté et le bien-être.

La elegancia de las antiguas villas italianas –construcciones en las que se inspira este recinto– armonizan sin desentonar con unas instalaciones innovadoras y perfectamente equipadas que ofrecen una gran variedad de tratamientos destinados a garantizar la salud, la belleza y el bienestar.

NO DIVING

WARNING
NO
LIFEGUARD
ON DUTY

4 FT. 9 IN.

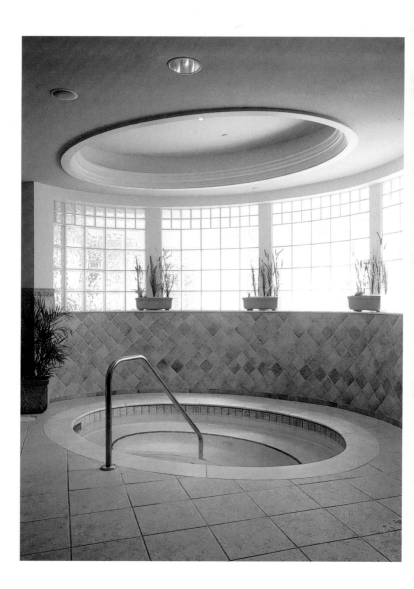

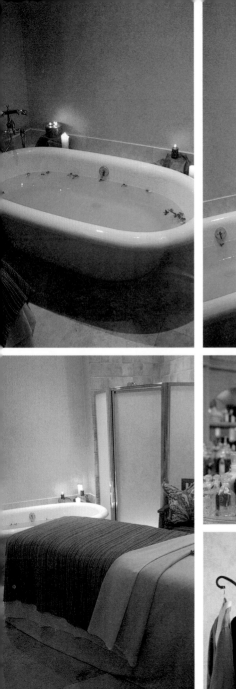
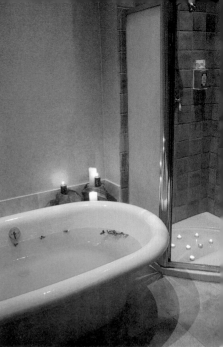

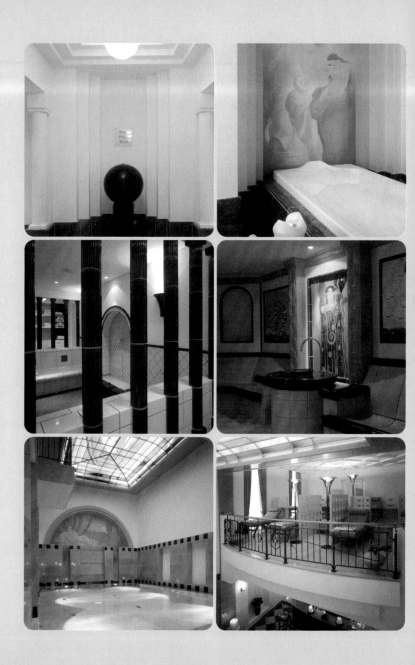

Dorint
Baden Baden

Address: Werderstraße 1
76530 Baden-Baden, Germany
Tel.: +49 7221 30 120
Fax: +49 7221 30 121
www.dorint.de/baden-baden
info.zccbad@dorint.com
Services: 8,600 square feet (800 m²) devoted to health, beauty and wellness.
Fitness center (equipped with state-of-the-art apparatuses), swimming pools, thermal pools, Finnish sauna, steam bath, bath with salts, bubble bath, jacuzzi, water treatments, inhalations, thalassotherapy, algae baths, aromatherapy, several types of massages. Personalized diet and anti-cellulitis treatments to improve circulation. Exclusive treatments in the beauty parlor that stimulate the skin's natural regenerating capacity and ensure a refreshed, radiant appearance (Shiseido and Biodroga products), diagnosis of the skin, lymphatic drainage, relaxing baths, steam area, manicure, make-up, permanent pedicure. Personalized programs and service packages.

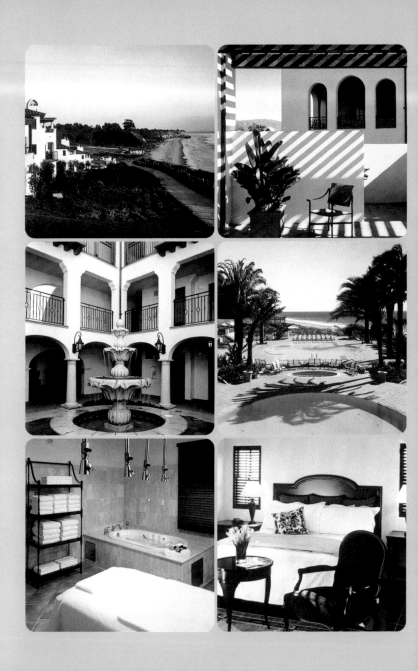

Bacara Resort & Spa

Opening date: 2000
Address: 8301 Hollister Avenue
Santa Barbara, California, USA
Tel.: +1 805 968 0100 / +1 877 422 4245
Fax: +1 805 968 1800
www.bacararesort.com
Services: 36 individual treatment booths, including 4 private suites. A range of massages (both outdoors and inside the center), personalized health and beauty programs, fitness classes, various hydrotherapy treatments, Swedish showers, saunas, swimming pools, relaxation areas, shiatsu, reflexology, yoga, water aerobics... Beauty parlor, product store, golf courses. As it is in open countryside beside the sea, the Bacara also offers the possibility of practicing various water and adventure sports and going for hikes.

Hotel Mónica

Address: Galcerán Marquet, 1-3
Cambrils, Tarragona, Spain
Tel.: +34 977 79 10 00
Services: Sauna, jacuzzis, swimming pools, massages, gardens and terraces, medical service, squash, table tennis, gym.

Architect: Gonzalo Gracia Iturbide
Photographer: Pep Escoda

Side Hotel

Opening date: 2001
Address: Drehban 49
20354 Hamburg, Germany
Tel.: + 49 40 30 99 90
Fax: + 49 40 30 99 93 99
www.side-hamburg.de
info@side-hamburg.de
Services: Face and body health and beauty treatments, massages, lymphatic drainage, sauna, treatments with mud, jacuzzis, swimming pool, gym.

Architect: Stömer Architekten
Interior design: Matteo Thun
Photographer: Gunnar Knechtel

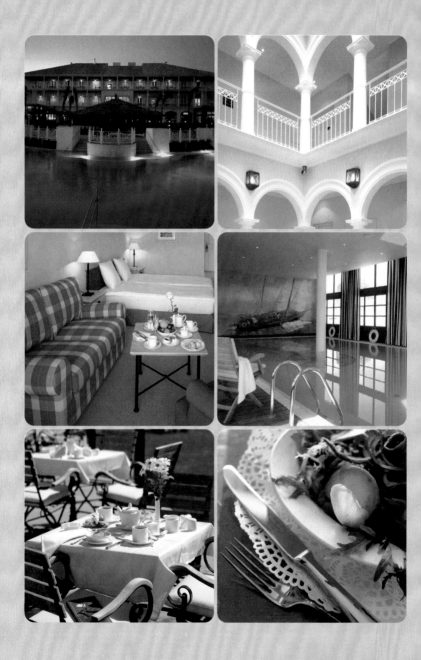

Ofra Resort Hotel Mallorca

Address: Arquitecto Francisco Casas, 18
Portals Nous, Mallorca, Spain
Tel.: +34 971 70 77 77
Fax: +34 971 70 76 76
www.ofra-resort-hotel.com
golf@ofra-resort-hotel.com
Services: Fitness and wellness center. Indoor and outdoor swimming pool, jacuzzi, Finnish sauna, caldarium, steam bath, solarium, massages, hydrojet, holistic Shanti, beauty parlor, hairdresser's, golf. Sports facilities are available close to the hotel (tennis, squash, windsurf, sailing, underwater diving...).

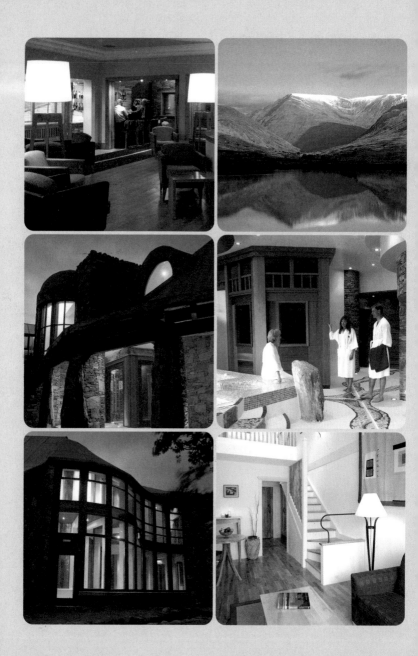

Delphi Mountain Resort Spa

Address: Delphi Moun, Leenane, Co. Galway, Ireland
Tel.: +353 95 42987
Fax: +353 95 42303
www.delphiescape.com
delphigy@iol.ie
Services: Health and beauty treatments and alternative therapies. Yoga, tai-chi, relaxation areas, spa and hydrotherapy, sauna, steam baths, massages, aromatherapy...

Architect: Frank Ennis & Associates

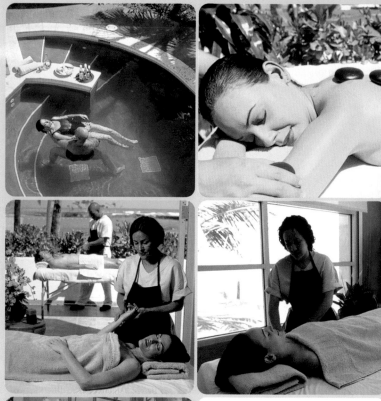

OLAS SPA

& Health Club at the Caribe Hilton

Olas Spa & Health Club at the Caribe Hilton

Address: Los Rosales, San Gerónimo Grounds
San Juan, Puerto Rico
Tel.: +787 977 5500
Fax: +787 977 5505
Services: Numerous face and body treatments to guarantee total well-being. Massages (various types: Swedish, Balinese, four-hand, Indian...), yoga, shiatsu, hydrotherapies, body exfoliation with sea salts, milk, mud, natural essences... aromatherapy, natural health and beauty remedies, reflexology, weight control, nutrition, alternative therapies, swimming pool, personalized programs...

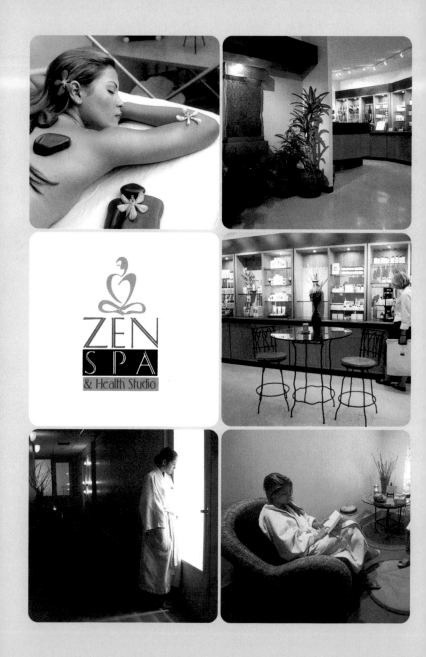

Zen Spa

Address: 1054 Ashford Avenue
Condado, Puerto Rico
Tel.: +722 84 33
Fax: +722 84 56
www.zen-spa.com
relax@zen-spa.com
Services: Wide range of massages (Swedish, therapeutic, Ayurvedic, Thai...), aromatherapy, shiatsu, yoga, tai-chi, Pilates technique, relaxation areas, treatments for expectant mothers, health and beauty treatments for the face and body. Individualized programs combining various therapies and services. Anti-stress cures to combat tension... Acupressure, treatments with paraffin, algae, mud, oils, plants, natural essences... Hydrotherapy, aerobics, gymnasium, cardiovascular training, static bicycles, personal training, kickboxing. Beauty parlor and hairdresser's. Store with a stock of the products used in the spa.

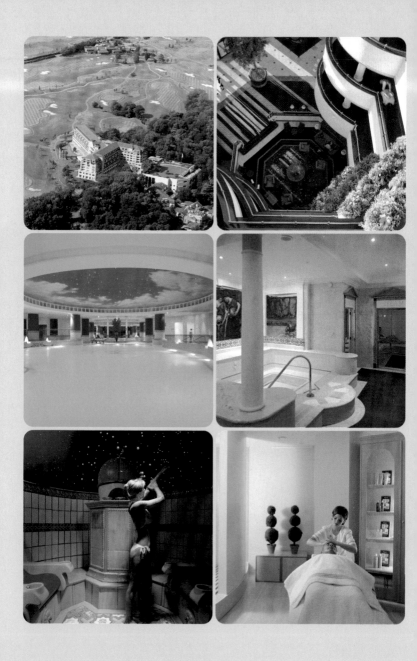

The Celtic Manor Resort

Address: Coldra Woods
Newport, Gwent, Wales, United Kingdom
Tel.: +44 16 33 413 000
Fax: +44 16 33 412 910
www.celtic-manor.com
postbox@celtic-manor.com
Services: Health and beauty center with numerous face and body treatments and services with Clarins and Elemis products. Alternative therapies, massages (relaxing, Swedish...), sauna, steam baths, hydrotherapy, rasul, mud treatments, lymphatic drainage, milk baths (like those of Cleopatra) and baths with oils and natural essences. Individualized programs and combined therapies, swimming pools, fitness center, aerobics classes, gym...

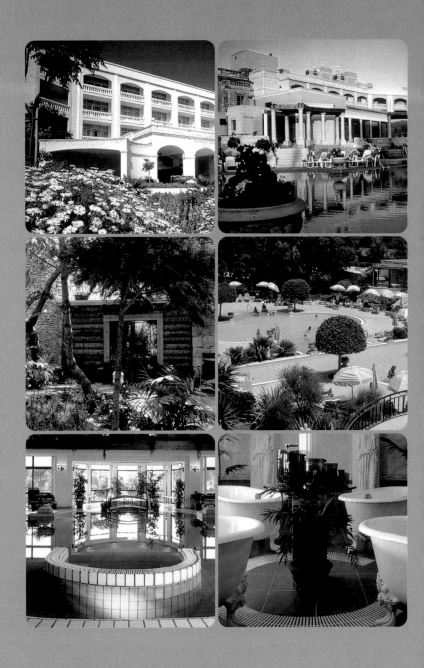

Atheneaum Spa Corinthia Palace Hotel

Address: De Paule Avenue, San Anton, Malta
Tel.: +356 440 301
Fax: +356 465 713
www.corinthia.com
palace@corinthia.com
Services: Aromatherapy, reiki, iris analysis, therapies with oxygen, homeopathy, acupuncture, rasul, aromatherapy bath, sauna, steam baths, mud and seaweed treatments, numerous health and beauty treatments, anti-cellulitis and slimming programs, hydrotherapies, swimming pools, jacuzzis, massages (relaxing, therapeutic, Chinese...), chiropractice, osteopathy, rehabilitation and anti-stress therapies. Fitness center (personal training), tai-chi, yoga, aqua-gym, tennis and squash courts...

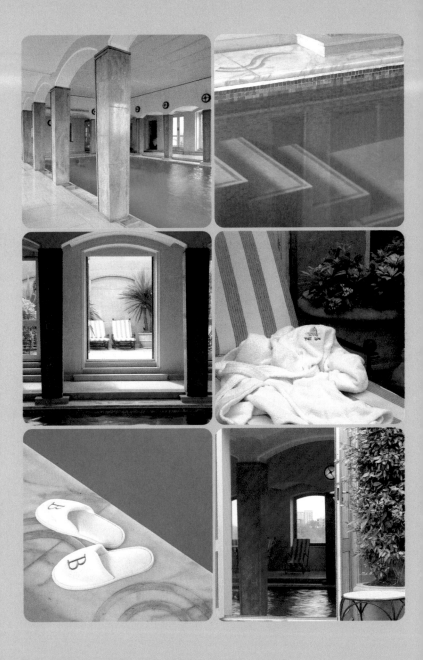

The Berkeley Health Club & Spa

Address: Wilton Place, Knightbridge
London, England
Tel.: +44 20 7201 1699
Fax: +44 20 7201 1698
info@the-berkeley.co.uk
www.savoy-group.co.uk/berkeley/facilities/spa.asp
Services: In the Berkeley it is possible to enjoy all kinds of therapies
and treatments for relaxation, health and beauty with products by
Christian Dior. It is also a pioneer in alternative treatments like
stone massage with hot stones and a wide range of Indonesian
treatments, such as the Javanese Lulur (the traditional exfoliation rit-
ual combined with massage which was performed in the palaces to
prepare a bride for her wedding). Shiatsu, reiki, aromatherapy, reflex-
ology, massages, face and body treatments and a host of services
devoted to beauty and wellness, including dermatological therapies.
The facilities include a swimming pool and gym.

Architect: (of the original building) Brian O'Rourke, 1972
Photographer: Montse Garriga
(Stylist: Geeta Aiyer)

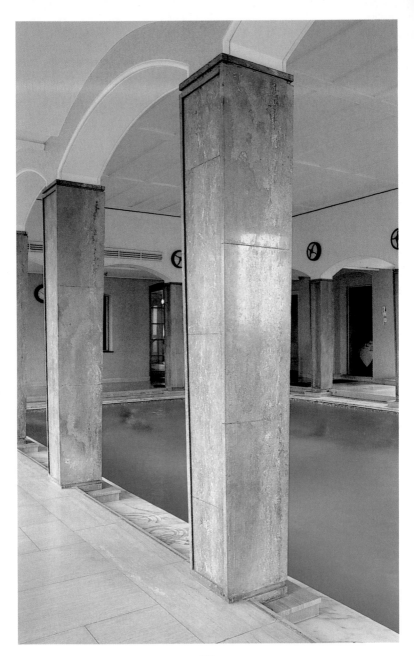

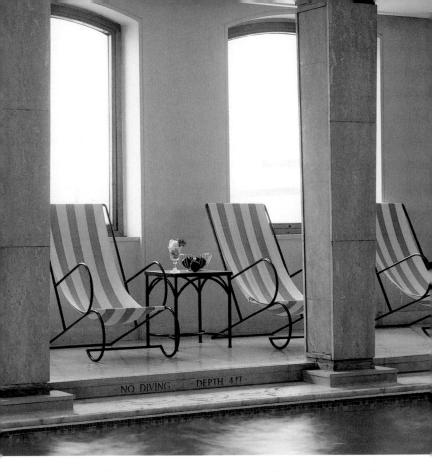

A swimming pool with a roof opening onto the London sky, with spectacular views of Hyde Park and Knightsbridge, is just one of this spa's many attractions – it is also one of the few spas that offer treatments with products by Christian Dior.

Ein Swimmingpool, von dem aus man den Himmel über London sieht und spektakuläre Blicke auf den Hyde Park und Knightsbridge genießt. Dieses Spa ist eines der wenigen in der Welt, die Behandlungen mit Produkten von Christian Dior anbietet.

Une piscine au toit s'ouvrant sur le ciel londonien avec une vue spectaculaire sur le Hyde Park et le Knightsbridge n'est que l'une des attractions de ces bains. C'est également l'un des rares endroits offrant des traitements avec des produits Christian Dior.

Una piscina cuyo techo se abre sobre el cielo de Londres e invita a contemplar unas espectaculares vistas de Hyde Park y Knightsbridge. Este es sólo uno de los muchos atractivos que presenta este spa, uno de los únicos en el mundo que ofrece tratamientos con productos de Christian Dior.

Elemis

Opening date: 2001
Address: 2-3 Lancashire Court, Mayfair
London, England
Tel.: +20 7499 4995
Fax: +20 7499 9558
elemisdayspa@elemis.com
www.elemis.com
Services: This day-time spa offers treatment programs called "Ritual Packages"; they include the Absolute Spa Ritual, the Arabian Jewel Ritual, the Jasmine Lulur Ritual, Cleopatra's Ritual... Massages (Hawaiian, Chinese, Thai, Ayurvedic, Swedish...) shiatsu, reiki, reflexology, aromatherapy.
Face and body treatments and therapies designed for relaxing, combating stress and tension, recovering serenity, beauty and equilibrium. The Elemis also has a store where it is possible to acquire the products created especially for and by the spa.

Photographer: Montse Garriga
(Stylist: Geeta Aiyer)

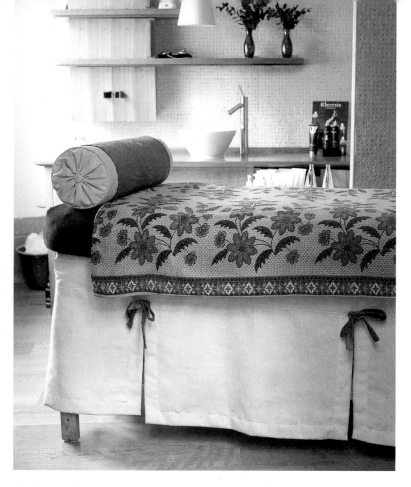

The Elemis is the entrance to an enchanting, relaxing world of perfumes, colors and textures that evoke exotic countries like Morocco, Thailand, India, Bali and Polynesia. A feast for all the senses.

Ein Aufenthalt in Elemis ist, als ob man in eine magische und entspannende Welt voller Aromen, Farben und Texturen eindringt, die an exotische Orte wie Marokko, Thailand, Indien, Bali oder Polynesien erinnert ... Eine Entdeckungsreise für die Sinne.

L'Elemis est le portail d'un monde de parfums, de couleurs, de sensations et un décor évoquant des contrées exotiques tels que le Maroc, la Thailande, les Indes, Bali et la Polynésie. Une joissance des sens.

Entrar en el Elemis es penetrar en un mundo mágico y relajante con aromas, colores y texturas que evocan lugares exóticos como Marruecos, Tailandia, India, Bali o Polinesia... Todo un descubrimiento para los sentidos.

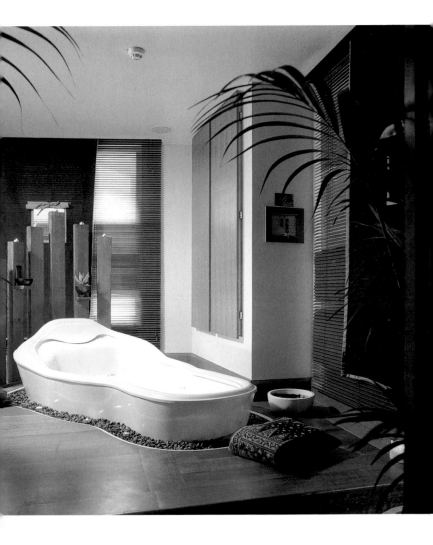